Drawing on the Right Side of the Brain

A Course in Enhancing Creativity and Artistic Confidence

Betty Edwards

J. P. Tarcher, Inc. Los Angeles Distributed by Houghton Mifflin Co. Boston Copyright © 1979 by Betty Edwards All rights reserved Library of Congress Catalog No.: 78-62794

ISBN:

0-87477-087-4 (case) 0-87477-088-2 (paper)

Cover drawing: John Boomer Instructional drawings: Betty Edwards Design: John Brogna Typeset in Jansen by Gutenberg 2000

Manufactured in the United States of America

Published by J. P. Tarcher, Inc. 9110 Sunset Blvd. Los Angeles, California 90069

Acknowledgments

To Anne and Brian

I wish to thank the many individuals who have patiently helped and encouraged me in writing this book. Special thanks go to Dr. J. William Bergquist for his unfailingly good advice and generous assistance. Others who gave special help are:

Anne Bomeisler Brian Bomeisler John Farrell Winifred Wasden Kathryn Bomeisler Lynn Tyner Jeremy Tarcher Janice Gallagher John Brogna

My colleagues at Venice High School; Los Angeles Trade-Technical College; California State University, Long Beach; and University of California at Los Angeles Extension.

I also wish to express gratitude to my students for their many contributions to this book.

Contents

r × *	Preface	vi
	1. Drawing and the Art of Bicycle Riding	1
	2. Expressing Yourself in Drawing: The Nonverbal Language of Art	19
R	3. Your Brain: The Right and Left of It	25
Y	4. Crossing Over: Experiencing the Shift From Left to Right	45
IEDE A	5. Drawing on Memories: Your History as an Artist	61
	6. Getting Around Your Symbol System: Meeting Edges and Contours	81

7. Perceiving the Shape of a Space: The Positive Aspects of Negative Space	ce 97
8. Branching Out in All Directions: Perspective in a New Mode	115
9. Fitting It All Together: The Place of Proportion	133
10. Facing Forward: Portrait Drawing With Ease	153
11. Moving Into the Third Dimension Seeing Light, Drawing Shade	: 179
12. The Zen of Drawing:Drawing Out the Artist Within	191
Postscript: Teachers & Parents	195
Art Students	198
Glossary	200
Bibliography	203
Index	206

Preface

rawing on the Right Side of the Brain is the result of a ten-year search for a new method of teaching art to individuals of many ages and occupations. The question that started me off on the search was a genuine puzzlement; if drawing is as easy and pleasurable as it has always seemed to me, why is it that most of my students find learning to draw so difficult?

From an early age, perhaps the age of eight or nine, I was able to draw fairly well. I think I was one of those few children who accidentally stumbles upon a way of seeing that enables one to draw well. I can still remember saying to myself, even as a young child, that if I wanted to draw something, I had to do "that." I never defined "that," but I was aware of having to gaze at whatever I wanted to draw for a time until "that" occurred. Then I could draw with a fairly high degree of skill for a child.

I received a lot of reinforcement for my ability to draw. People would say, "Isn't it lovely that Betty is so artistic? Well, her grandmother did watercolors, you know, and her mother is quite artistic. It's just a natural talent for her, I guess — a special gift." Like all children, I loved being praised as someone special and was in grave danger of believing the praise. But in the back of my mind, I felt it was misplaced. I knew that drawing was easy and that all anyone had to do was to look at things in that certain way.

Years later when I started teaching, I tried to communicate my way of thinking about drawing to my students. It didn't work very well, and, to my distress, out of a class of thirty or so students only a few learned to draw.

At that point I began to look inward, observing myself while drawing, trying to find out what I was doing when I experienced that different kind of seeing. I also began to ask questions of the students. One thing I noticed was that the few students who did learn to draw didn't improve gradually — they improved *dramatically*. One week they would still be fumbling with stereotypic, childlike images. The next week, suddenly they could draw well.

I quizzed the students. "What are you doing now in your drawing that you weren't doing last week when you were still having problems?" Nearly always, students said something to the effect that they were "just *looking* at things." But no matter how many questions I asked them, they seemed unable to find words to describe specifically what they were doing differently.

Then I picked up a new clue. I have always done a lot of demonstration drawing in my classes, and it was my wish during the demonstrations to explain to students what I was doing — what I was looking at, why I was drawing things in certain ways. I often found, however, that I would simply stop talking right in the middle of a

sentence. I would hear my voice stop and I would think about getting back to the sentence, but finding the words again would seem like a terrible chore — and I didn't really want to anyhow. But, pulling myself back at last, I would resume talking — and then find that I had lost contact with the drawing, which suddenly seemed confusing and difficult. Thus I picked up a new bit of information: I could either talk or draw, but I couldn't do both at once.

More clues to the process of drawing presented themselves, often purely by chance. One day when the students were having a particularly difficult time with figure drawing, I handed around a reproduction of a master drawing and — on impulse — told the students to draw the image upside down. They turned the reproduction upside down and copied it that way. To our great surprise (mine and the students'), the drawings were excellent. This didn't make sense to me. The lines, after all, are the same lines, whether right-side-up or upside-down. Why should it be easier for the students to draw an image in that unusual orientation?

Working with negative space provided more clues — and more questions. I found that students could draw better by looking not at the form they wanted to draw but instead by looking at the space around the form. Again, I was puzzled. Why should looking at spaces produce good drawings of forms? I continued to think about my own drawing process, but the answer to the problem, the organizing principle that would pull it all together, continued to elude me.

About ten years ago I began to read a wide range of books about the so-called "split-brain" studies carried out during the 1950s and 60s at the California Institute of Technology by Roger W. Sperry and his associates. Briefly stated, the Cal Tech group determined that both hemispheres of the human brain are involved in

higher cognitive functions and that the two hemispheres employ different methods or modes of processing information.

That work provided me with the sudden illumination that an individual's ability to draw was perhaps mainly controlled by the ability to shift to a different-from-ordinary way of processing visual information — to shift from verbal, analytic processing (in this book called "left-mode" or "L-mode") to spatial, global processing (which I have called "right-mode" or "R-mode"). With this illumination, parts of the puzzle — why some students learned to draw more easily than others — fell into place for me.

Since then, and especially during my doctoral studies, I have been formulating the basic premise and sequence of drawing exercises that make up this book. My premise is that developing a new way of seeing by tapping the special functions of the right hemisphere of your brain can help you learn to draw, and the sequence of exercises is designed to do just that. In time, I am sure, my cognitive-shift model of teaching, which encourages mental shifts from verbal, logical thinking to a more global, intuitive mode, will be further developed by teachers and researchers in art and applied in other fields. Regardless of the degree to which future science may eventually confirm the strict cerebral lateralization or separation of brain functions into what I have termed left-mode and rightmode, the two cognitive modes and the related principles presented in this book have empirically been proven to be successful with students at all levels and therefore hold up irrespective of how strictly lateralized the brain mechanisms may be. In its present form, the model has provided me with a method of teaching that solves the problem I started out with: how to enable all of the students in a class instead of just a few to learn the skill of drawing.

Drawing and the Art of Bicycle Riding

rawing is a curious process, so intertwined with seeing that the two can hardly be separated. Ability to draw depends on ability to see the way an artist sees, and this kind of seeing can marvelously enrich your life.

In many ways, teaching drawing is somewhat like teaching someone to ride a bicycle. It is very difficult to explain in words. In teaching someone to ride a bicycle, you might say, "Well, you just get on, push the pedals, balance yourself, and off you'll go."

Of course, that doesn't explain it at all, and you are likely finally to say, "I'll get on and show you how. Watch and see how I do it."

And so it is with drawing. Most art teachers and drawing textbook authors exhort beginners to "change their ways of looking at things" and to "learn how to see." The problem is that this different way of seeing is as hard to explain as how to balance a bicycle, and the teacher often ends by saying, in effect, "Look at these examples and just keep trying. If you practice a lot, eventually you may get it." While nearly everyone learns to ride a bicycle, many individuals never solve the problems of drawing. To put it more precisely, most people never learn to *see* well enough to draw.

DRAWING AS A MAGICAL ABILITY

Because only a few individuals seem to possess the ability to see and draw, artists are often regarded as persons with a rare Godgiven talent. To many people, the process of drawing seems mysterious and somehow beyond human understanding.

Artists themselves often do little to dispel the mystery. If you ask an artist (that is, someone who draws well as a result of either long training or chance discovery of the artist's way of seeing), "How do you draw something so that it looks real — say a portrait or a landscape?" the artist is likely to reply, "Well, I just have a gift for it, I guess," or "I really don't know. I just start in and work things out as I go along," or "Well, I just *look* at the person (or the landscape) and I draw what I see." The last reply seems like a logical and straightforward answer. Yet, on reflection, it clearly doesn't explain the process at all, and the sense that the skill of drawing is a vaguely magical ability persists (Figure 1-1).

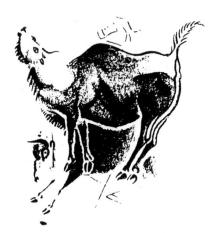

Fig. 1-1. *Bellowing Bison*. Paleolithic cave painting from Altamira, Spain. Drawing by Brevil. Prehistoric artists were probably thought to have magic powers.

While this attitude of wonder at artistic skill causes people to appreciate artists and their work, it does little to encourage individuals to try to learn to draw; and it doesn't help teachers explain to students the process of drawing. Often, in fact, people even feel that they shouldn't take a drawing course because they don't know already how to draw. This is like deciding that you shouldn't take a French class because you don't already speak French, or that you shouldn't sign up for a course in carpentry because you don't know how to build a house.

DRAWING AS A LEARNABLE, TEACHABLE SKILL

You will soon discover that drawing is a skill that can be learned by every normal person with average eyesight and average eyehand coordination — with sufficient ability, for example, to thread a needle or catch a baseball. Contrary to popular opinion, manual skill is not a primary factor in drawing. If your handwriting is readable, or if you can print legibly, you have ample dexterity to draw well.

We need say no more here about hands, but about eyes we cannot say enough. Learning to draw is more than learning the skill itself; by studying this book you will learn how to see. That is, you will learn how to process visual information in the special way used by artists. That way is different from the way you usually process visual information and seems to require that you use your brain in a different way than you ordinarily use it.

You will be learning, therefore, something about how your brain handles visual information. Recent research has begun to throw new scientific light on that marvel of capability and complexity, the human brain. And one of the things we are learning is how the special properties of our brains enable us to draw pictures of our perceptions.

Drawing and Seeing

The magical mystery of drawing ability seems to be, in part at least, an ability to make a shift in brain state to a different mode of seeing/perceiving. When you see in the special way in which experienced artists see, then you can draw. This is not to say that the drawings of great artists such as Leonardo da Vinci or Rembrandt are not still wondrous because we may know something

Roger N. Shepard, Professor of Psychology at Stanford University, recently described his personal mode of creative thought during which research ideas emerged in his mind as unverbalized, essentially complete, long-sought solutions to problems.

"That in all of these sudden illuminations my ideas took shape in a primarily visual-spatial form without, so far as I can introspect, any verbal intervention is in accordance with what has always been my preferred mode of thinking. . . . Many of my happiest hours have since childhood been spent absorbed in drawing, in tinkering, or in exercises of purely mental visualization."

-Roger N. Shepard Visual Learning, Thinking, and Communication

"Learning to draw is really a matter of learning to see — to see correctly — and that means a good deal more than merely looking with the eye."

-Kimon Nicolaides The Natural Way to Draw Gertrude Stein asked the French artist Henri Matisse whether, when eating a tomato, he looked at it the way an artist would. Matisse replied:

"No, when I eat a tomato I look at it the way anyone else would. But when I paint a tomato, then I see it differently."

> —Gertrude Stein Picasso

"The painter draws with his eyes, not with his hands. Whatever he sees, if he sees it *clear*, he can put down. The putting of it down requires, perhaps, much care and labor, but no more muscular agility than it takes for him to write his name. Seeing *clear* is the important thing."

-Maurice Grosser

The Painter's Eye

"It is in order to really see, to see ever deeper, ever more intensely, hence to be fully aware and alive, that I draw what the Chinese call 'The Ten Thousand Things' around me. Drawing is the discipline by which I constantly rediscover the world.

"I have learned that what I have not drawn, I have never really seen, and that when I start drawing an ordinary thing, I realize how extraordinary it is, sheer miracle."

—Frederick Franck
The Zen of Seeing

about the cerebral process that went into their creation. Indeed, scientific research makes master drawings seem even more remarkable because they seem to cause a *viewer* to shift to the artist's mode of perceiving. But the basic skill of drawing is also accessible to everyone who can learn to make the shift to the artist's mode and see in the artist's way.

THE ARTIST'S WAY OF SEEING: A TWOFOLD PROCESS

Drawing is not really very difficult. Seeing is the problem, or, to be more specific, shifting to a particular way of seeing. You may not believe me at this moment. You may feel that you are seeing things just fine and that it's the drawing that is hard. But the opposite is true, and the exercises in this book are designed to help you make the mental shift and gain a twofold advantage: first, to open access by conscious volition to the right side of your brain in order to experience a slightly altered mode of awareness; second, to see things in a different way. Both will enable you to draw well.

Many artists have spoken of seeing things differently while drawing and have often mentioned that drawing puts them into a somewhat altered state of awareness. In that different subjective state, artists speak of feeling transported, "at one with the work," able to grasp relationships that they ordinarily cannot grasp. Awareness of the passage of time fades away, and words recede from consciousness. Artists say that they feel alert and aware yet are relaxed and free of anxiety, experiencing a pleasurable, almost mystical activation of the mind.

DRAWING ATTENTION TO STATES OF CONSCIOUSNESS

The slightly altered consciousness state of feeling transported, which most artists experience while doing drawing, painting, sculpting, or any kind of art work, is a state probably not altogether unfamiliar to you. You may have observed in yourself slight shifts in your state of consciousness while engaged in much more ordinary activities than art work.

For example, most people are aware that they occasionally slip from ordinary waking consciousness into the slightly altered state of daydreaming. As another example, people often say that reading takes them "out of themselves." And other kinds of activities which apparently produce a shift in consciousness state are meditation, jogging, needlework, typing, listening to music, and, of course, drawing itself.

Also, I believe that driving on the freeway probably induces a slightly different subjective state that is similiar to the drawing state. After all, in freeway driving we deal with visual images, keeping track of relational, spatial information, sensing complex components of the overall traffic configuration. Many people find that they do a lot of creative thinking while driving, often losing track of time and experiencing a pleasurable sense of freedom from anxiety. These mental operations may activate the same parts of the brain used in drawing. Of course, if driving conditions are difficult, if we are late or if someone sharing the ride talks with us, the shift to the alternative state doesn't occur. The reasons for this we'll take up in Chapter Three.

The key to learning to draw, therefore, is to set up conditions that cause you to make a mental shift to a different mode of information processing — the slightly altered state of consciousness — that enables you to see well. In this drawing mode you will be able to draw your perceptions even though you may never have studied drawing. Once the drawing mode is familiar to you, you will be able to consciously control the mental shift.

DRAWING ON YOUR CREATIVE SELF

I see you as an individual with creative potential for expressing yourself through drawing. My aim is to provide the means for releasing that potential, for gaining access at a conscious level to your inventive, intuitive, imaginative powers that may have been largely untapped by our verbal, technological culture and educational system. I am going to teach you how to draw, but drawing is only the means, not the end. Drawing will tap the special abilities of the right side of your brain, the side that is *right* for drawing. By learning to draw you will learn to see differently and, as the artist Rodin lyrically states, to become a confidant of the natural world, to awaken your eye to the lovely language of forms, to express yourself in that language.

In drawing, you will delve deeply into a part of your mind too often obscured by endless details of daily life. From this experience you will develop your ability to perceive things freshly in their totality, to see underlying patterns and possibilities for new

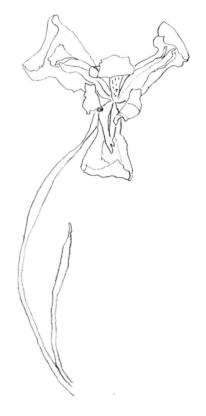

"The artist is the *confidant* of nature. Flowers carry on dialogues with him through the graceful bending of their stems and the harmoniously tinted nuances of their blossoms. Every flower has a cordial word which nature directs towards him."

-Auguste Rodin

"When the artist is alive in any person, whatever his kind of work may be, he becomes an inventive, searching, daring, self-expressive creature. He becomes interesting to other people. He disturbs, upsets, enlightens, and opens ways for a better understanding. Where those who are not artists are trying to close the book, he opens it and shows there are still more pages possible."

—Robert Henri The Art Spirit combinations. Creative solutions to problems, whether personal or professional, will be accessible through new modes of thinking and new ways of using the power of your whole brain.

Drawing, pleasurable and rewarding though it is, is but a key to open the door to other goals. My hope is that *Drawing on the Right Side of the Brain* will help you expand your powers as an individual through increased awareness of your own mind and its workings. The multiple effects of the exercises in this book are intended to enhance your confidence in decision making and problem solving. The potential force of the creative, imaginative side of your brain is almost limitless, and through drawing you can come to know this powerful self and make it known to others. Through drawing, *you* are made visible. The German artist Albrecht Dürer said, "From this, the treasure secretly gathered in your heart will become evident through your creative work."

Keeping the real goal in mind, let us begin to fashion the key.

MY APPROACH: A PATH TO CREATIVITY

The exercises and instructions in this book have been designed specifically for people who cannot draw at all, who may feel that they have little or no talent for drawing, and who may feel doubtful that they could ever learn to draw — but who think they might like to learn. The approach of this book is different from other drawing instruction books in that the exercises are aimed at opening access to skills *you already have* but that are simply waiting to be released.

Creative persons from fields other than art who want to get their working skills under better control and learn to overcome blocks to creativity will benefit from working with the techniques presented here. Teachers and parents will find the theory and exercises useful in helping children to develop their creative abilities. At the end of the book, I have supplied a brief postscript which offers some general suggestions for adapting my methods and materials to children. A second postscript is addressed to art students.

This book is based on a course of nine lessons which I have been teaching for about five years to individuals of widely ranging ages and occupations. Nearly all of the students begin the course with very few drawing skills and with very strong anxiety about their potential drawing ability. Almost without exception, the students achieve a high level of skill in drawing and gain confidence to go on developing their expressive drawing skills in other courses or by practice on their own.

An intriguing aspect of the often remarkable gains most students achieve is the rapid rate of improvement in drawing skills. It's my belief that if persons untrained in art can learn to make the shift to the artist's mode of seeing — that is, the right-hemisphere mode — those individuals are then able to draw without further instruction. To put it another way, you already know how to draw, but old habits of seeing interfere with that ability and block it. The exercises in this book are designed to remove the interference and unblock the ability.

While you may not be specifically interested in becoming a fulltime working artist, the exercises will provide insights into the way your mind, or your two minds work — singly, cooperatively, one against the other. And, as many of my students have told me, their lives seem richer because they are seeing better and seeing more.

Realism as a Means to an End

Most of the exercises in the book are intended to increase your ability to draw *realistically* — that is, to enable you to see and draw some object or person in the real world with a high degree of similarity to the observed image. I do not mean to imply in any way that realistic drawing is to be valued above other kinds of art, however. In a sense, realistic drawing is a stage to be passed through, ideally at around age ten to twelve.

The value of achieving realistic drawing skills has three aspects. First, through realism you will learn to see deeply and profoundly. Second, you will gain a kind of confidence in your creative abilities that, for many nonartists, cannot be gained any other way. Even professional artists — individuals holding jobs as art teachers, designers, commercial artists, working painters, and sculptors — have enrolled in my courses and have confided to me their genuine distress at their "guilty secret": that they cannot draw. Concealment of their inability sometimes requires complex and funny — but sad — strategies and subterfuges. An effective way out of their distress is to unblock potential abilities for realistic drawing. Using the methods in this book helps students — artists and nonartists alike — to unblock, thereby increasing their confidence to explore other kinds of art that call

"To be shaken out of the ruts of ordinary perception, to be shown for a few timeless hours the outer and the inner world, not as they appear to an animal obsessed with words and notions, but as they are apprehended, directly and unconditionally, by Mind at Large — this is an experience of inestimable value to everyone."

> — Aldous Huxley The Doors of Perception

"To me, moving into more naturalism was a freedom. I thought, if I want to I could paint a portrait; this is what I mean by freedom. Tomorrow if I want, I could get up, I could do a drawing of someone, I could draw my mother from memory, I could even paint a strange little abstract picture. It would all fit in to my concept of painting as an art. A lot of painters can't do that - their concept is completely different. It's too narrow; they make it much too narrow. A lot of them, like Frank Stella, who told me so, can't draw at all. But there are probably older painters, English abstract painters, who were trained to draw. Anybody who'd been in art school before I had must have done a considerable amount of drawing. To me, a lot of painters were trapping themselves; they were picking such a narrow aspect of painting and specializing in it. And it's a trap. Now there's nothing wrong with the trap if you have the courage to just leave it, but that takes a lot of courage."

-David Hockney

into play the powerful functions of the whole brain. And third, you will learn to shift to a new mode of thinking, a mode of vast potential for insightful, creative problem solving.

Why Faces?

A number of the exercises and instructional sequences in this book are designed to enable you to draw recognizable portraits. Let me explain why I think portrait drawing is useful as a subject for beginners in art. Broadly speaking, *all drawing is the same*. One drawing task is no harder than any other. The same skills and ways of seeing are involved in drawing still-life setups, land-scapes, the figure, random objects, even imaginary subjects, *and* portrait drawing. *It's all the same thing*: you see what's out there (imaginary subjects are "seen" in the mind's eye) and you draw what you see.

Why, then, have I selected portrait drawing for some of the exercises? For three reasons. First, beginning students of drawing often *think* that drawing human faces is the hardest of all kinds of drawing. Thus, when students see that they *can* draw portraits, they feel confident and their confidence enhances progress. A second, more important, reason is that the right hemisphere of the human brain is specialized for recognition of faces. Since the right brain is the one we will be trying to gain access to, it makes sense to choose a subject that the right brain is used to working with. And third, faces are fascinating! Once you have drawn a person, you will really have seen that individual's face. As one of my students said, "I don't think I ever actually *looked* at anyone's face before I started drawing. Now, the oddest thing is that *everyone* looks beautiful to me."

Drawing Materials

The materials required for the exercises in this book are quite simple. You will need some inexpensive bond typing paper (not the erasable kind, because pencil lines smear on it) or a pad of inexpensive drawing paper. You will also need a pencil and an eraser. A number 4B drawing pencil is pleasant to use, as the lead is smooth and makes a clear, dark line, but an ordinary number 2 writing pencil is nearly as good. At a later time, you may want to add other materials — perhaps a stick of charcoal, a felt-tip pen, pencils with colored leads in browns, grays, etc. For

most of the specific exercises, however, paper, pencil, and an eraser are sufficient.

The Exercises: One Step at a Time

Over the years of teaching, I have experimented with various progressions, sequences, and combinations of exercises. The sequence set out in this book has proved to be the most effective in terms of student progress. The first three chapters present some of the theory that underlines my instruction, including a brief account of some of the recent research on human brain-hemisphere functions, which I have applied to the problem of teaching individuals how to draw.

When you begin the exercises in Chapter Four you'll have some background in how the exercises have been set up and why they work. The sequence is designed to enhance success at every step of the way and to provide access to a new mode of information processing with as little upset to the old mode as possible. Therefore, I ask you to read the chapters in the order presented and to do the exercises as they appear.

I have limited the recommended exercises to a minimum number, but if time permits, do more drawings than are suggested: seek your own subjects and devise your own exercises. The more practice you provide for yourself, the faster you will progress. To this end, in addition to the exercises that appear in the text, supplementary exercises often appear in the margin. Doing these exercises will reinforce both your skills and your confidence.

For most of the exercises, I recommend that you read through all of the directions before you start drawing and, where directed, view the examples of students' drawings before beginning. Keep all of your drawings together in a folder or large envelope, so that by the time you've come to the end of the book you can review your own progress.

Definitions of Terms

A glossary of terms appears at the end of the book. Certain terms are defined fairly extensively in the text, and the glossary contains other terms not so extensively defined. Words that are commonly used in everyday language, such as "value" and "composition," have very specific, and often different, meanings

Preinstruction Drawings

Before you begin: Use pencil and inexpensive paper. Each drawing may take ten, fifteen, or twenty minutes, or longer if you wish. Be sure to date the drawings, as they will provide a record of your present level of drawing skill.

Drawing one: Draw a picture of a person without looking at anyone. There are no specific directions for this drawing, only the general direction to "draw a person."

Drawing two: Draw a picture of someone — the head only. Draw someone watching TV or sleeping, or draw yourself by looking in a mirror. Do not use a photograph.

Drawing three: Draw a picture of your own hand. If you are right-handed, draw your left hand in whatever position you choose. If you are left-handed, draw your right hand.

Drawing four: Draw a picture of a chair by looking at a real chair, not a photograph.

After you finish: On the back of each drawing, write your assessment of the drawing — what is pleasing to you and displeasing to you about each drawing. These comments will be interesting to you at the end of the set of exercises.

in art terminology. I suggest that you glance through the glossary before starting to read the chapters.

PREINSTRUCTION DRAWINGS: A VALUABLE RECORD OF YOUR ART SKILLS

At this point, and before you read further, I would like you to do four preinstruction drawings to provide a *before* record of your drawing ability — that is, before you are "contaminated" by the theory that follows. This request usually comes as bad news to beginning students; the anxiety level goes up and tension mounts. But if you do them now, by the time you get to the first instructed drawing in Chapter Four you will feel confident that you *can* learn to draw and you will be ready to try.

The drawings have proved to be invaluable in aiding students to see and recognize their own progress. A kind of amnesia seems to set in as drawing skills improve. Students forget what their drawing was like before instruction. Moreover the degree of *criticism* keeps pace with progress. Even after considerable improvement, students are sometimes critical of their latest drawing because it's "not as good as da Vinci's." The *before* drawings provide a realistic gauge of progress. After you do the drawings, put them away and we will look at them again later on in the light of your newly acquired skills.

STUDENT SHOWING: A Preview of Before-and-After Drawings

Now I would like to show you some drawings done by my students. The drawings show typical changes in students' drawing ability from the first lesson (before instruction) to the last lesson, about two months later. Most of the students whose drawings are reproduced attended a three-hour class once each week for nine weeks and received approximately the same instructions included in this book.

As you can see, the before-and-after drawings in the following Student Showing demonstrate that the students have transformed their ways of seeing and drawing. The changes are significant enough that it almost seems as though two different persons have done the drawings.

Learning to perceive is the basic skill that the students acquired during the nine lessons. The change you see in their ability to

Drawing and the Art of Bicycle Riding

John Boomer January 3, 1978

John Boomer March 5, 1978

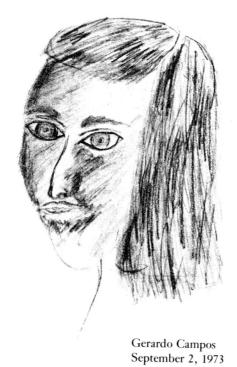

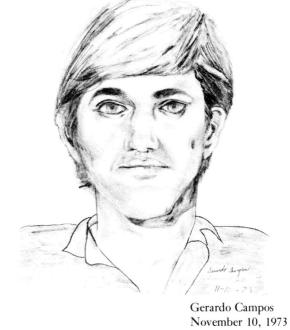

Alice Abel September 28, 1976

Alice Abel November 16, 1976

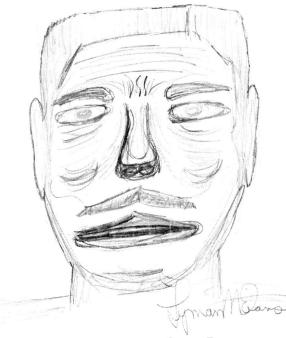

Lyman Evans April 2, 1978

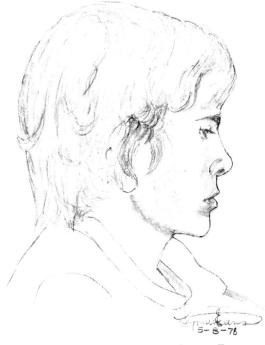

Lyman Evans May 8, 1978

Ken Darnell February 5, 1974

Having completed the original course, Ken produced this drawing about a year later.

Fig. 1-2.

Fig. 1-3.

draw possibly reflects an equally significant change in their ability to see. Regard the drawings from that standpoint: as a visible record of the students' improvement in perceptual skills.

Almost without exception, my students achieve similar gains — and so will you. In fact, the drawings in this showing and subsequent showings are typical of most students' work.

GETTING CONNECTED WITH THE DRAWING PAPER

As an antidote to the high-anxiety preinstruction drawings, try the following exercises to loosen up your drawing hand.

Nothing is more intimidating to a beginning drawing student — or to many experienced artists for that matter — than a clean, white, unmarred piece of drawing paper. One way to get around that is to just start drawing — boldly, freely, confidently. For an exercise in getting used to drawing materials and overcoming the intimidation of unmarked paper, lay out a sheet of pristine whiteness and take your pencil in hand.

Draw a free, bold line near the edges of the paper, going all around the four edges, rounding the corners, not lifting the pencil from the paper (Figure 1-2). Now cross the paper with first vertical and then horizontal lines, checking the distance between the line and the edge and to nearby adjacent lines. Cross back over some lines, darkening them, emphasizing them, playing with the patterns. *Invent* the moves as you go along, knowing that you create the line and that the line, the paper, and the shapes you make will lead you naturally into your next move.

Try another sheet, perhaps this time with diagonal lines as well as the lines that reinforce the edges (Figure 1-3). Then another, with circles. And one with diamonds. And one with any other lines you wish. The drawing by the French artist Eugene Delacroix in Figure 1-4 shows the power of playful lines.

SUMMING UP

I have described to you the basic premise of this book — that drawing is a teachable, learnable skill which can provide a twofold advantage. By gaining access to the part of your mind that works in a style conducive to creative, intuitive thought, you will learn a fundamental skill of the visual arts: how to put down on paper what you see in front of your eyes. Second, through

Fig. 1-4. *Une Femme d'Alger*. The French artist, Eugène Delacroix, in a lithograph imbued with the antic spirit, played with lines to build his image. Courtesy of The Metropolitan Museum of Art, Harris Brisbane Dick Fund, 1928.

learning to draw with the method presented in this book you will gain the ability to think more creatively in other areas of your life.

How far you go with these skills after you complete the course will depend on other traits such as energy and curiosity. But first things first! The potential is there. It's sometimes necessary to remind ourselves that Shakespeare at some point learned to write a line of prose, Beethoven learned the musical scales, and as you see in Figures 1-5 and 1-6, Van Gogh learned how to draw.

"There is something antic about creating, although the enterprise be serious. And there is a matching antic spirit that goes with writing about it, for if ever there was a silent process, it is the creative one. Antic and serious and silent."

—Jerome Bruner On Knowing: Essays for the Left Hand

"To empty one's mind of all thought and refill the void with a spirit greater than oneself is to extend the mind into a realm not accessible by conventional processes of reason."

> —Edward Hill The Language of Drawing

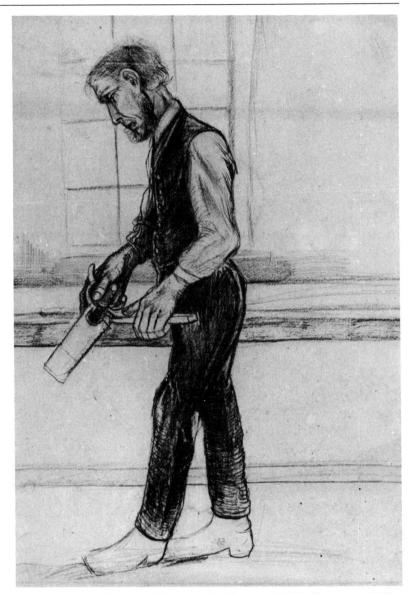

Fig. 1-5. Vincent Van Gogh (1853-1890), *Carpenter* (1880). Courtesy of Rijksmuseum Kröller-Müller, Otterlo.

Van Gogh worked as an artist only during the last ten years of his life, from the age of 27 until he died at 37. During the first two years of that decade, Van Gogh did drawings only, teaching himself how to draw. As you can see in the drawing of the *Carpenter*, he struggled with problems of proportion and placement of forms. By 1882, however — two years later — in his *Woman Mourning*, Van Gogh had overcome his difficulties with drawing and increased the expressive quality of his work.

Fig. 1-6. Vincent Van Gogh, Woman Mourning (1882). Courtesy of Rijksmuseum Kröller-Müller, Otterlo.

Expressing Yourself in Drawing: The Nonverbal Language of Art

he purpose of this book is to teach you basic skills in seeing and drawing. The purpose of this book is *not* to teach you to express yourself, but instead to provide you with the skills which will *release* you from stereotypic expression. This release in turn will open the way for you to express your individuality — your essential uniqueness — *in your own way*, using your own particular drawing style.

If, for a moment, we could regard your handwriting as a form of expressive drawing, we could say that you are already expressing yourself with a fundamental element of art: line.

On a sheet of paper, right in the middle of the sheet, write your own name the way you usually sign your name. Next, regard your signature from the following point of view: you are looking at a *drawing* which is your original creation — shaped, it is true, by the cultural influences of your life, but aren't the creations of every artist shaped by such influences?

Every time you write your name, you have expressed yourself through the use of line. The line you use in your signature is the same basic element that Picasso used to "write" the drawing in Figure 2-1. Your signature, "drawn" many times over, is expressive of you, just as Picasso's line is expressive of him. The line can be "read" because, in writing your name, you have used the nonverbal language of art. Let's try reading a line. Tell me, what is this person like?

You would probably agree that Dale G. Smith is more likely to be extroverted than introverted, more likely to wear bright colors than subtle ones, and, at least superficially, is likely to be outgoing, talkative, even dramatic. Of course, these assumptions may or may not be correct, but the point is that this is how most people would read the nonverbal expression of the signature, because that's what Dale Smith is (nonverbally) saying.

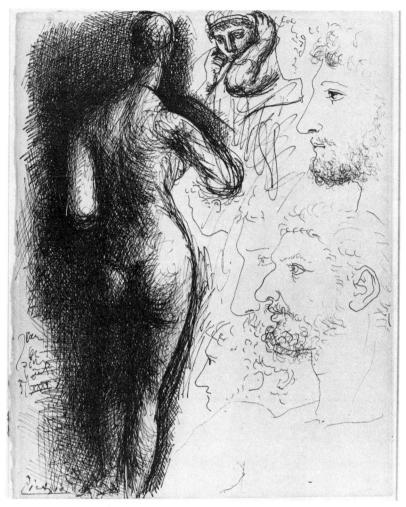

Fig. 2-1. Pablo Picasso (1881-1973), *Sketch Page*. Courtesy of the Museum of Fine Arts, Boston, The Arthur Mason Knapp Fund.

Let's look at another Dale G. Smith.

Jale I. Smith
ou were asked what this person is like, you

If you were asked what this person is like, you would probably say conservative, quiet, reliable, perhaps somewhat unadventurous. And what of another Dale G. Smith? This time, respond to the message *without words*.

De Dometh

And another.

And another.

Now regard your own signature and respond to the nonverbal message of its line. Write your name in three different ways, each time responding to the message. Next, think back on how

Pale G. Smith

the name that was formed by the "drawings" did not change. What, then, were you responding to?

You were seeing and responding to the *felt*, individual qualities of each "drawn" line or set of lines. You responded to the felt speed of the line, the size and spacing of the marks, the muscle tension or lack of tension of the artist, which is precisely communicated in the line, the directional pattern or lack of pattern — in other words, to the whole signatures and all of their parts at once. A person's signature is an individual expression so unique to the writer that it is identified legally as being "owned" by that single person and none other.

you responded differently to each of these signatures; recall that

Torii Kiyotada (active 1723-1750), Actor Dancing, and Torii Kiyonobu I (1664-1729), Woman Dancer (c. 1708). Courtesy of The Metropolitan Museum of Art, Harris Brisbane Dick Fund, 1949. Line expresses two different kinds of dances in the two Japanese prints. Try to visualize each dance. Can you hear the music in your imagination? Try to see how the character of the line creates the quality of the music and controls your response to the drawing.

Your signature, however, does more than identify you. It also expresses *you* and your individuality, your creativity. Your signature is *true* to yourself. In this sense, you already speak the nonverbal language of art: you are using the basic element of drawing, line, in an expressive way, unique to yourself.

In the chapters to follow, therefore, we won't dwell on what you can do already. Instead, the aim is to teach you *how to see* so that you can use your expressive, individual line to draw your perceptions.

DRAWING AS A MIRROR AND METAPHOR FOR THE ARTIST

The object of drawing is not only to show what you are trying to portray, but also to show *you*. Paradoxically, the more clearly you can perceive and draw what you see in the external world, the more clearly the viewer can see *you*, and the more you can know about yourself. Thus, as in Figure 2-2, drawing becomes a metaphor for the artist.

Because the exercises focus on expanding your perceptual powers, your individual style — your unique and valuable manner of drawing — will emerge intact. As your skills in seeing increase, your ability to draw what you see will increase, and you will observe your style forming. Guard it, nurture it, cherish it, for your style expresses you. As with the Zen master-archer, the target is yourself.

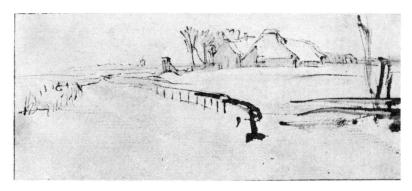

Fig. 2-2. Rembrandt Van Rijn (1606-1669), Winter Landscape (c. 1649). Courtesy of the Fogg Art Museum, Harvard University.

Rembrandt drew this tiny landscape with a rapid calligraphic line. Through it we sense Rembrandt's visual and emotional response to the deeply silent winter scene. We see, therefore, not only the landscape; we see *through* the landscape to Rembrandt himself.

"The art of archery is not an athletic ability mastered more or less through primarily physical practice, but rather a skill with its origin in mental exercise and with its object consisting in mentally hitting the mark.

"Therefore, the archer is basically aiming for himself. Through this, perhaps, he will succeed in hitting the target — his essential self."

—Herrigel

Your Brain: The Right and Left of It

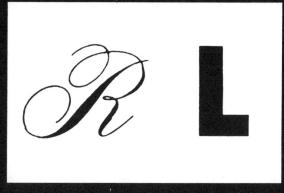

"Every creative act involves . . . a new innocence of perception, liberated from the cataract of accepted belief."

—Arthur Koestler The Sleepwalkers

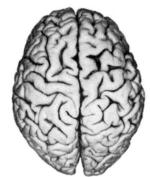

Fig. 3-1.

creative person is one who can process in new ways the information directly at hand — the ordinary sensory data available to all of us. A writer needs words, a musician needs notes, an artist needs visual perceptions, and all need some knowledge of the techniques of their crafts. But a creative individual intuitively sees possibilities for transforming ordinary data into a new creation, transcendent over the mere raw materials.

Time and again, creative individuals have recognized the differences between the two processes of gathering data and trans forming those data creatively. Recent discoveries about how the brain works are beginning to illuminate that dual process. Getting to know both sides of your brain is an important step in liberating your creative potential.

Some recent research on the human brain will be reviewed in this chapter, research that has greatly expanded existing theories about the nature of human consciousness. The new discoveries are directly applicable to the task of freeing human creative abilities.

GETTING TO KNOW BOTH SIDES OF YOUR BRAIN

Seen from above, the human brain resembles the halves of a walnut—two similar appearing, convoluted, rounded halves connected at the center (Figure 3-1). The two halves are called the "left hemisphere" and the "right hemisphere."

The human nervous system is connected to the brain in a crossed-over fashion. The left hemisphere controls the right side of the body, the right hemisphere controls the left side. If you suffer a stroke or accidental brain damage to the left half of your brain, for example, the right half of your body will be most seriously affected and vice versa. Because of this crossing over of the nerve pathways, the left hand is connected to the right hemisphere; the right hand, to the left hemisphere, as shown in Figure 3-2.

THE DOUBLE BRAIN

In the brains of animals, the cerebral hemispheres (the two halves of the brain) are essentially alike, or symmetrical, in func-

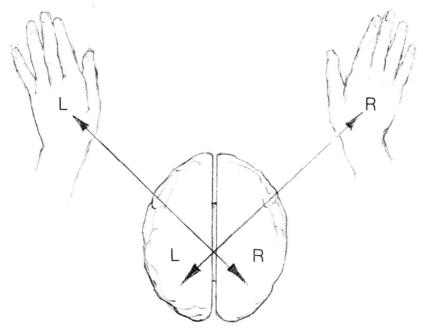

Fig. 3-2. The crossover connections of left-hand to right-hemisphere, right-hand to left-hemisphere.

tion. Human cerebral hemispheres, however, develop asymmetrically in terms of function. The most noticeable outward effect of the asymmetry of the human brain is handedness.

For the past one-hundred fifty years or so, scientists have known that the function of language and language-related capabilities is mainly located in the left hemispheres of the majority of individuals — approximately 98 percent of right-handers and about two thirds of left-handers. Knowledge that the left half of the brain is specialized for language functions was largely derived from observations of the effects of brain injuries. It was apparent, for example, that an injury to the left side of the brain was more likely to cause a loss of speech capability than an injury of equal severity to the right side.

Because speech and language are so closely linked to thinking, reasoning, and the higher mental functions that set human beings apart from the other creatures of the world, nineteenth-century scientists named the left hemisphere the dominant or *major* hemisphere; the right brain, the subordinate or *minor* hemisphere. The general view, which prevailed until fairly recently, was that the right half of the brain was less advanced, less

evolved than the left half—a mute twin with lower-level capabilities, directed and carried along by the verbal left hemisphere.

A long-time focus of neuroscientific study has been the functions, unknown until fairly recently, of a thick nerve cable composed of millions of fibers that cross-connect the two cerebral hemispheres. This connecting cable, the *corpus callosum*, is shown in the diagrammatic drawing of half of a human brain, Figure 3-3. Because of its large size, tremendous number of nerve fibers, and strategic location as a connector of the two hemispheres, the corpus callosum gave all the appearances of being an important structure. Yet enigmatically, available evidence indicated that the corpus callosum could be completely severed without observable significant effect. Through a series of animal studies during the 1950s, conducted mainly at the California Institute of Technology by Roger W. Sperry and his students, Ronald Myers, Colwyn Trevarthen, and others, it was established that a main function of the corpus callosum was to provide communication between the two hemispheres and to allow transmission of memory and learning. Furthermore, it was determined that if the connecting cable was severed the two brain halves continued to function independently, thus explaining in part the apparent lack of effect on behavior and functioning.

Fig. 3-3. A diagram of one half of a human brain, showing the corpus callosum and related commissures.

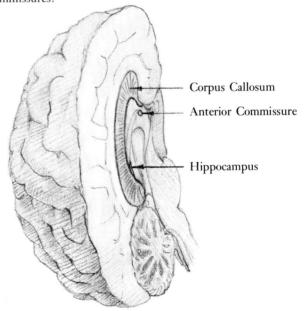

Then during the 1960s, extension of similar studies to human neurosurgical patients provided further information on the function of the corpus callosum and caused scientists to postulate a revised view of the relative capabilities of the halves of the human brain: that both hemispheres are involved in higher cognitive functioning, with each half of the brain specialized in complementary fashion for different *modes* of thinking, both highly complex.

Because this changed perception of the brain has important implications for education in general and for learning to draw in particular, I'll briefly describe some of the research often referred to as the "split-brain" studies. The research was mainly carried out at Cal Tech by Sperry and his students Michael Gazzaniga, Jerre Levy, Colwyn Trevarthen, Robert Nebes, and others.

The investigation centered on a small group of individuals who came to be known as the *commissurotomy*, or "split-brain," patients. They are persons who had been greatly disabled by epileptic seizures that involved both hemispheres. As a last-resort measure, after all other remedies had failed, the incapacitating spread of seizures between the two hemispheres was controlled by means of an operation, performed by Phillip Vogel and Joseph Bogen, that severed the corpus callosum and the related commissures, or cross-connections, thus isolating one hemisphere from the other. The operation yielded the hoped-for result: the patients' seizures were controlled and they regained health. In spite of the radical nature of the surgery, the patients' outward appearance, manner, and coordination were little affected; and to casual observation their ordinary daily behavior seemed little changed.

The Cal Tech group subsequently worked with these patients in a series of ingenious and subtle tests that revealed the separated functions of the two hemispheres. The tests provided surprising new evidence that each hemisphere, in a sense, perceives its own reality — or perhaps better stated, perceives reality in its own way. The verbal half of the brain — the left half — dominates most of the time in individuals with intact brains as well as in the split-brain patients. Using ingenious procedures, however, the Cal Tech group tested the patients' separated right hemispheres and found evidence that the right, nonspeaking half of the brain also experiences, responds with feelings, and processes information on its own. In our own brains, with intact

Journalist Maya Pines writes that theologians and others interested in the problem of human identity have followed scientific research on the halves of the brain with great interest. As Pines notes, they soon realize that "all roads lead to Dr. Roger Sperry, a California Institute of Technology psychobiology professor who has the gift of making — or provoking — important discoveries."

—Maya Pines The Brain Changers

"The main theme to emerge . . . is that there appear to be two modes of thinking, verbal and nonverbal, represented rather separately in left and right hemispheres, respectively, and that our educational system, as well as science in general, tends to neglect the nonverbal form of intellect. What it comes down to is that modern society discriminates against the right hemisphere."

—Roger W. Sperry "Lateral Specialization of Cerebral Function in the Surgically Separated Hemispheres," 1973

"The data indicate that the mute, minor hemisphere is specialized for Gestalt perception, being primarily a synthesist in dealing with information input. The speaking, major hemisphere, in contrast, seems to operate in a more logical, analytic, computer-like fashion. Its language is inadequate for the rapid complex syntheses achieved by the minor hemisphere."

—Jerre Levy −R. W. Sperry 1968 corpus callosa, communication between the hemispheres melds or reconciles the two perceptions, thus preserving our sense of being one person, a unified being.

In addition to studying the right/left separation of inner mental experience created by the surgical procedure, the scientists examined the different ways in which the two hemispheres process information. Evidence accumulated showing that the mode of the left hemisphere is verbal and analytic, while that of the right is nonverbal and global. New evidence found by Jerre Levy in her doctoral studies showed that the mode of processing used by the right brain is rapid, complex, whole-pattern, spatial, and perceptual - processing that is not only different from but comparable in complexity to the left brain's verbal, analytic mode. Additionally, Levy found indications that the two modes of processing tend to interfere with each other, preventing maximal performance; and she suggested that this may be a rationale for the evolutionary development of asymmetry in the human brain - as a means of keeping the two different modes of processing in two different hemispheres.

Based on the evidence of the split-brain studies, the view came gradually that *both* hemispheres use high-level cognitive modes which, though different, involve thinking, reasoning, and complex mental functioning. Over the past decade, since the first statement in 1968 by Levy and Sperry, scientists have found extensive supporting évidence for this view, not only in braininjured patients but also in individuals with normal, intact brains.

A few examples of the specially designed tests devised for use with the split-brain patients might illustrate the separate reality perceived by each hemisphere and the special modes of processing employed. In one test, two different pictures were flashed for an instant on a screen, with a split-brain patient's eyes fixed on a midpoint so that scanning both images was prevented. Each hemisphere, then, received *different* pictures. A picture of a spoon on the left side of the screen went to the right brain; a picture of a knife on the right side of the screen went to the verbal left brain, as in Figure 3-4. When questioned, the patient gave *different responses*. If asked to *name* what had been flashed on the screen, the confidently articulate left hemisphere caused the patient to say, "knife." Then the patient was asked to reach behind a curtain with his left hand (right hemisphere) and pick out what had been flashed on the screen. The patient then picked

Fig. 3-4. A diagram of the apparatus used to test visual-tactile associations by split-brain patients. Adapted from Michael S. Gazzaniga, "The Split Brain in Man."

out a spoon from a group of objects that included a spoon and a knife. If the experimenter asked the patient to identify what he held in his hand behind the curtain, the patient might look confused for a moment and then say, "a knife." The right hemisphere, knowing that the answer was wrong but not having sufficient words to correct the articulate left hemisphere, continued the dialogue by causing the patient to mutely shake his head. At that, the verbal left hemisphere wondered aloud, "Why am I shaking my head?"

In another test that demonstrated the right brain to be better at spatial problems, a male patient was given several wooden shapes to arrange to match a certain design. His attempts with his right hand (left hemisphere) failed again and again. His right hemisphere kept trying to help. The right hand would knock the left hand away; and finally, the man had to *sit* on his left hand to keep it away from the puzzle. When the scientists finally suggested that he use both hands, the spatially "smart" left hand had to shove the spatially "dumb" right hand away to keep it from interfering.

As a result of these extraordinary findings over the past fifteen years, we now know that despite our normal feeling that we are one person — a single being — our brains are double, each half with its own way of knowing, its own way of perceiving external reality. In a manner of speaking, each of us has two minds, two consciousnesses, mediated and integrated by the connecting cable of nerve fibers between the hemispheres.

We have learned that the two hemispheres can work together

in a number of ways. Sometimes they cooperate with each half contributing its special abilities and taking on the particular part of the task that is suited to its mode of information processing. At other times, the hemispheres can work singly; with one half "on," the other half more or less "off." And it seems that the hemispheres may also conflict, one half attempting to do what the other half "knows" it can do better. Furthermore, it may be that each hemisphere has a way of keeping knowledge from the other hemisphere. It may be, as the saying goes, that the right hand truly does not know what the left hand is doing.

The Double Reality of Split-brain Patients

But what, you might ask, does all this have to do with learning how to draw? Recent research on human brain-hemisphere functions and on the information-processing aspects of vision indicates that ability to draw may depend on whether you have access to the capabilites of the "minor," or subdominant, right hemisphere — whether you are able to "turn off" the dominant verbal left brain and "turn on" the right. How does this help a person to draw? It appears that the right brain perceives — processes visual information — in the way one needs to see in order to draw, and that the left brain perceives in ways that seem to interfere with drawing.

LANGUAGE CLUES

In hindsight, we realize that human beings must have had some sense of the differences between the halves of the brain, because our languages contain numerous words and phrases suggesting, for example, that the left side of a person has different characteristics from the right side. These terms indicate not just differences in location but differences in fundamental traits or qualities. For example, if we want to compare *unlike* ideas, we say, "On the one hand . . . on the other hand . . ." "A left-handed compliment," meaning a sly dig, indicates the differing qualities we assign to left and right.

Keep in mind, however, that these phrases generally speak of hands, but because of the crossover connections of hands and hemispheres, the terms can be *inferred* also to mean the hemispheres that control the hands. Therefore, the examples of familiar terms in the next section refer specifically to the left and right

bands but in reality also refer inferentially to the opposite *brain balves* — the right brain connected to the left hand, the left brain to the right hand.

The Bias of Language and Customs

Words and phrases concerning concepts of left and right permeate our language and thinking. The right hand (meaning also the left hemisphere) is strongly connected with what is good, just, moral, proper. The left hand (therefore the right hemisphere) is strongly linked with concepts of anarchy and feelings that are out of conscious control — somehow bad, immoral, dangerous.

Until very recently, the ancient bias against the left hand/right hemisphere sometimes even led parents and teachers of left-handed children to try to force the children to use their right hands for writing, eating, and so on — a practice that often caused problems lasting into adulthood.

Throughout human history, terms with connotations of *good* for the right-hand/left hemisphere and connotations of *bad* for the left-hand/right hemisphere appear in most languages around the world. The Latin word for left is *sinister*, meaning "bad," "ominous," "sinister." The Latin word for right is *dexter* from which comes our word "dexterity," meaning "skill" or "adroitness."

The French word for "left" — remember that the left hand is connected to the right hemisphere — is *gauche*, meaning "awkward" from which comes our word "gawky." The French word for right is *droit*, meaning "good," "just," or "proper."

In English, "left" comes from the Anglo-Saxon *lyft*, meaning "weak" or "worthless." The left hand of most right-handed people is in fact weaker than the right, but the original word also implied lack of moral strength. The derogatory meaning of "left" may reflect a prejudice of the right-handed majority against a minority of people who were different, that is, left-handed. Reinforcing this bias, the Anglo-Saxon word for "right," *reht* (or *riht*) meant "straight" or "just." From *reht* and its Latin cognate *rectus* we derived our words "correct" and "rectitude."

These ideas also affect our political thinking. The political right, for instance, admires national power, is conservative, resists change. The political left, conversely, admires individual autonomy and promotes change, even radical change. At their

Nasrudin was sitting with a friend as dusk fell. "Light a candle," the man said, "because it is dark now. There is one just by your left side." "How can I tell my right from my left in the dark, you fool?" asked the Mulla.

—Indries Shah The Exploits of the Incomparable Mulla Nasrudin

Parallel Ways of Knowing

intellect intuition convergent divergent digital analogic secondary primary abstract concrete directed free propositional imaginative analytic relational lineal nonlineal rational intuitive sequential multiple analytic holistic objective subjective successive simultaneous -J.E. Bogen

"Some Educational Aspects of Hemisphere Specialization"

The Duality of Yin and Yang

Yin Yang feminine masculine negative positive moon sun darkness light yielding aggressive left side right side cold warm spring autumn summer winter unconscious conscious right brain left brain emotion reason

> -I Ching or Book of Changes, a Chinese Taoist work

extremes, the political right is fascist, the political left is anarchist.

In the context of cultural customs, the place of honor at a formal dinner is on the host's right-hand side. The groom stands on the right in the marriage ceremony, the bride on the left — a nonverbal message of the relative status of the two participants. We shake hands with our right hands; it seems somehow wrong to shake hands with our left hands.

Under "left handed," the dictionary lists as synonyms "clumsy," "awkward," "insincere," "malicious." Synonyms for "right handed," however, are "correct," "indispensable," and "reliable." Now, it's important to remember that these terms were all made up, when languages began, by some persons' left hemispheres — the left brain calling the right bad names! And the right brain — labeled, pinpointed, and buttonholed — was without a language of its own to defend itself.

TWO WAYS OF KNOWING

Along with the opposite connotations of left and right in our language, concepts of the *duality*, or two-sidedness, of human nature and thought have been postulated by philosophers, teachers, and scientists from many different times and cultures. The key idea is that there are two parallel "ways of knowing."

You probably are familiar with these ideas. As with the left/right terms, they are embedded in our languages and cultures. The main divisions are, for example, between thinking and feeling, intellect and intuition, objective analysis and subjective insight. Political writers say that people generally analyze the good and bad points of an issue and then vote on their gut feelings. The history of science is replete with anecdotes about researchers who try repeatedly to figure out a problem and then have a dream in which the answer presents itself as a metaphor intuitively comprehended by the scientist. The statement by Henri Poincaré is a vivid example of the process.

In another context, people occasionally say about someone, "The words sound okay, but something tells me not to trust him (or her)." Or, "I can't tell you in words exactly what it is, but there is something about that person that I like (or dislike)." These statements are intuitive observations that both sides of the brain are at work, processing the *same information* in *two different ways*.

THE TWO MODES OF INFORMATION PROCESSING

Inside each of our skulls, therefore, we have a double brain with two ways of knowing. The dualities and differing characteristics of the two halves of the brain and body, intuitively expressed in our language, have a real basis in the physiology of the human brain. Because the connecting fibers are intact in normal brains, we rarely experience at a conscious level conflicts revealed by the tests on split-brain patients.

Nevertheless, as each of our hemispheres gathers in the same sensory information, each half of our brains may handle the information in different ways: the task may be divided between the hemispheres, each handling the part suited to its style. Or one hemisphere, often the dominant left, will "take over" and inhibit the other half. The left hemisphere analyzes, abstracts, counts, marks time, plans step-by-step procedures, verbalizes, makes rational statements based on logic. For example, "Given numbers a, b, and c — we can say that if a is greater than b, and b is greater than c, then a is necessarily greater than c." This statement illustrates the left-hemisphere mode: the analytic, verbal, figuring-out, sequential, symbolic, linear, objective mode.

On the other hand, we have a second way of knowing: the right-hemisphere mode. We "see" things in this mode that may be imaginary — existing only in the mind's eye — or recall things that may be real (can you image your front door, for example?). We see how things exist in space and how the parts go together to make up the whole. Using the right hemisphere, we understand metaphors, we dream, we create new combinations of ideas. When something is too complex to describe, we can make gestures that communicate. Psychologist David Galin has a favorite example: try to describe a spiral staircase without making a spiral gesture. And using the right hemisphere we are able to draw pictures of our perceptions.

The Ah-ha! Response

In the right-hemisphere mode of information processing, we use intuition and have leaps of insight — moments when "everything seems to fall into place" without figuring things out in a logical order. When this occurs, people often spontaneously exclaim, "I've got it" or "Ah, yes, now I see the picture." The classic

The nineteenth century mathematician Henri Poincaré described a sudden intuition that gave him the solution to a difficult problem:

"One evening, contrary to my custom, I drank black coffee and could not sleep. Ideas rose in crowds; I felt them collide until pairs interlocked, so to speak, making a stable combination." [That strange phenomenon provided the intuition that solved the troublesome problem. Poincaré continued,] "It seems, in such cases, that one is present at his own unconscious work, made partially perceptible to the overexcited consciousness, yet without having changed its nature. Then we vaguely comprehend what distinguishes the two mechanisms or, if you wish, the working methods of the two egos."

Dr. J. William Bergquist, a mathematician and specialist in the computer language known as APL, proposed in a paper given at Snowmass, Colorado, in 1977 that we can look forward to computers which combine digital and analog functions in one machine. Dr. Bergquist dubbed his machine "The Bifurcated Computer." He stated that such a computer would function similarly to the two halves of the human brain.

"The left hemisphere analyzes over time, whereas the right hemisphere synthesizes over space."

> —Jerre Levy "Psychobiological Implications of Bilateral Asymmetry"

Many creative people seem to have intuitive awareness of the separate-sided brain. For example, Rudyard Kipling wrote the following poem, entitled "The Two-Sided Man," over fifty years ago.

Much I owe to the lands that grew— More to the Lives that fed— But most to the Allah Who gave me Two

Separate sides to my head. Much I reflect on the Good and the True

In the faiths beneath the sun But most upon Allah Who gave me Two

Sides to my head, not one.

I would go without shirt or shoe,
Friend, tobacco or bread,
Sooner than lose for a minute the two
Separate sides of my head!

—Rudyard Kipling

"Approaching forty, I had a singular dream in which I almost grasped the meaning and understood the nature of what it is that wastes in wasted time."

> —Cyril Connolly The Unquiet Grave: A Word Cycle by Palinuris

example of this kind of exclamation is the exultant cry, "Eureka!" (I have found it!) attributed to Archimedes. According to the story, Archimedes experienced a flash of insight while bathing that enabled him to formulate his principle of using the weight of dispaced water to determine the weight of solid objects.

This, then, is the right-hemisphere mode: the intuitive, subjective, relational, holistic, time-free mode. This is also the disdained, weak, left-handed mode which in our culture has been generally ignored. For example, most of our educational system has been designed to cultivate the verbal, rational, on-time left hemisphere, while half of the brain of every student is virtually neglected.

HALF A BRAIN IS BETTER THAN NONE: A WHOLE BRAIN WOULD BE BETTER

With their sequenced verbal and numerical classes, the schools you and I attended were not equipped to teach the righthemisphere mode. The right hemisphere is not, after all, under very good verbal control. You can't reason with it. You can't get it to make logical propositions such as "This is good and that is bad, for a, b, and c reasons." It is metaphorically left-handed, with all the ancient connotations of that characteristic. The right hemisphere is not good at sequencing - doing the first thing first, taking the next step, then the next. It may start anywhere, or take everything at once. Furthermore, the right hemisphere hasn't a good sense of time and doesn't seem to comprehend what is meant by the term "wasting time" as does the good, sensible left hemisphere. The right brain is not good at categorizing and naming. It seems to regard the thing as-it-is, at the present moment of the present; seeing things for what they simply are, in all of their awesome, fascinating complexity. It is not good at analyzing and abstracting salient characteristics.

Even today, though educators are increasingly concerned with the importance of intuitive and creative thought, school systems in general are still structured in the left-hemisphere mode. Teaching is sequenced: students progress through grades one, two, three, etc., in a linear direction. The main subjects learners study are verbal and numerical: reading, writing, arithmetic. Time schedules are followed. Seats are set in rows. Learners converge on answers. Teachers give out grades. And everyone senses that something is amiss. The right brain — the dreamer, the artificer, the artist — is lost in our school system and goes largely untaught. We might find a few art classes, a few shop classes, something called "creative writing," and perhaps courses in music; but it's unlikely that we would find courses in imagination, in visualization, in perceptual or spatial skills, in creativity as a separate subject, in intuition, in inventiveness. Yet educators value these skills and have apparently hoped that students would develop imagination, perception, and intuition as natural consequences of a training in verbal, analytic skills.

Fortunately, such development often does occur almost in spite of the school system — a tribute to the survival capacity of the right brain. But the emphasis of our culture is so strongly slanted toward rewarding left-brain skills that we are surely losing a very large proportion of the potential ability of the other halves of our children's brains. Scientist Jerre Levy has said — only partly humorously — that American scientific training through graduate school may entirely *destroy* the right hemisphere. We certainly are aware of the effects of inadequate training in verbal, computational skills. The verbal left hemisphere never seems to recover fully, and the effects may handicap students for life. What happens, then, to the right hemisphere which is hardly trained at all?

Perhaps now that neuroscientists have provided a conceptual base for right-brain training, we can begin to build a school system that will teach the whole brain. Such a system will surely include training in drawing skills — an efficient, effective way to gain access to right-brain functions.

IMAGING IN THE RIGHT MODE

One of the marvelous capabilities of the right brain is imaging: seeing an imaginary picture with your mind's eye. The brain is able to conjure an image and then "look" at it, "seeing" it as if it is "really there." The terms for this ability, *visualizing* and *imaging* are used almost interchangeably, although to me the term visualizing tends to carry the idea of a *moving* image, while imaging seems to connote a still picture.

Both visualizing and imaging are important components of the skill of drawing. To draw something, an artist looks at the object or person, "takes" a mental picture, holds the image in memory, then looks down at the paper to draw. Another look, another *held* image, further drawing, and so on.

"To make biological survival possible, Mind at Large has to be funneled through the reducing valve of the brain and nervous system. What comes out the other end is a measly trickle of the kind of consciousness which will help us to stay alive on the surface of this particular planet. To formulate and express the contents of this reduced awareness, man has invented and endlessly elaborated those symbol-systems and implicit philosophies which we call languages."

—Aldous Huxley The Doors of Perception As an illustration of this right-brain skill, I've set up some brief preliminary exercises to demonstrate the power of imaging as a device for understanding and remembering complex information. To simplify the terminology of brain-hemisphere functions, I'll be using the notations "L-mode" and "R-mode" throughout the rest of the book. Imaging will make the terms more meaningful to you.

First: take a mental picture (a "photograph" in the mind) of each of the two graphic images:

L-mode is the "right-handed," lefthemisphere mode. The L is foursquare, upright, sensible, direct, true, hardedged, unfanciful, forceful.

R-mode is the "left-handed," right-hemisphere mode. The R is curvy, flexible, more playful in its unexpected twists and turns, more complex, diagonal, fanciful.

By these two images I mean to designate the two different modes of consciousness in which one type or the other of information-processing styles seems to predominate. In all kinds of activities, the brain uses both hemispheres, perhaps at times with the halves alternating in "leading," perhaps at times each carrying an equal share of a task. L-mode is inferred to be predominantly linear, verbal, symbolic, and analytic as in the first column of the accompanying list. R-mode is inferred to be predominantly spatial, holistic, nonverbal, and intuitive as shown in the second column of the list. (See page 40.)

It will aid your understanding of the drawing instructions that follow if you have a firm grasp of these two modes. Therefore, do the following exercises in *imaging*:

- 1. Image the foursquare, bold L. See it with your mind's eye with its straight sides and right angle. Now enlarge the image, adding another form so you can see the comparison of sizes: image the L as large as a pyramid or the Empire State Building. Now see the L in color, any color. Now attach to the L, in any way you like, the characteristics of the L-mode style: words, numbers, time, mathematical equations, diagrams, maps, books; perhaps images of mathematicians, lawyers, scientists, accountants. The images can be whatever you decide on. You will remember the images longer and more clearly if you make them up yourself. Most important, locate the L-mode in your own skull by placing your hand (either hand will do) on the left side of your bead: reduce the size of the image and imagine that you are placing the L-mode image inside the left half of your brain.
- 2. Now image the curvy R. See it in your mind's eye with its complex curves. Enlarge it or make it smaller if you wish. Add other forms so you can see the relationship of sizes. Then attach the functions characteristic of the right-hemisphere *style*: perhaps images of persons who are painting, drawing, playing melodies, sculpting, dreaming with a sense of timelessness. Because these functions are less distinct in true right-hemisphere style than the L-mode functions, this may tax your imaging powers. How do you image non-time? Perhaps, as a surrealist artist such as Dali would, as a clock without a face. How do you image analogs, things that are alike? How do you image the *ah-ha!* response? Take some time for this, until you can call up a picture in your mind of the R-mode. Then place your hand on the *right side* of your skull and image again the R-mode inside the right half of your brain.

Now, shift the images to opposite sides: the mathematician, scientist, etc., can move across the corpus callosum to the R-mode in order to image and dream of new inventions; the artist and musician, to the L-mode in order to analyze esthetic problems.

3. Do this several times until you can feel yourself shifting from one image to the other, first to the left side of your brain with the L-image, then to the right side with the R-image. This practice in making a mental shift from L to R will help you during the drawing exercises to make the mental shift to drawing mode (R-mode).

The Russian scientist Leonid Ponomarev eloquently describes our two ways of knowing:

"It has long been known that science is only one of the methods of studying the world around us. Another — complementary method is realized in art. The joint existence of art and science is in itself a good illustration of the complementarity principle. You can devote yourself completely to science or live exclusively in your art. Both points of view are equally valid, but, taken separately, are incomplete. The backbone of science is logic and experiment. The basis of art is intuition and insight. But the art of ballet requires mathematical accuracy and, as Pushkin wrote, 'Inspiration in geometry is just as necessary as in poetry.' They complement rather than contradict each other. True science is akin to art, in the same way as real art always includes elements of science. They reflect different, complementary aspects of human experience and give us a complete idea of the world only when taken together. Unfortunately, we do not know the 'uncertainty relation' for the conjugate pair of concepts 'science and art'. Hence we cannot assess the degree of damage we undergo from a one-sided perception of life."

> —Leonid Ponomarev In Quest of the Quantum

A Comparison of Left-Mode and Right-Mode Characteristics

Verbal: Using words to name, describe, define.

Analytic: Figuring things out step-by-step and part-by-part.

Symbolic: Using a symbol to *stand for* something. For example, the drawn form stands for *eye*, the sign + stands for the process of addition.

Abstract: Taking out a small bit of information and using it to represent the whole thing.

<u>Temporal</u>: Keeping track of time, sequencing one thing after another: Doing first things first, second things second, etc.

Rational: Drawing conclusions based on *reason* and *facts*.

Digital: Using numbers as in counting.

Logical: Drawing conclusions based on logic:
one thing following another in logical order
— for example, a mathematical theorem or
a well-stated argument.

<u>Linear</u>: Thinking in terms of linked ideas, one thought directly following another, often leading to a convergent conclusion.

Nonverbal: Awareness of things, but minimal connection with words.

Synthetic: Putting things together to form wholes.

<u>Concrete</u>: Relating to things as they are, at the present moment.

<u>Analogic</u>: Seeing likenesses between things; understanding metaphoric relationships.

Nontemporal: Without a sense of time.

Nonrational: Not requiring a basis of reason or facts; willingness to suspend judgment.

Spatial: Seeing where things are in relation to other things, and how parts go together to form a whole.

Intuitive: Making leaps of insight, often based on incomplete patterns, hunches, feelings, or visual images.

Holistic: Seeing whole things all at once; perceiving the overall patterns and structures, often leading to divergent conclusions.

IMAGING CROSSOVER CONNECTIONS: BRAIN AND BODY

The drawing exercises to come, designed to help you gain access to R-mode, will be more effective if you clearly understand the crossover connections of the brain halves and body halves. By doing these exercises you will be able to evoke easily an image of these connections, rather than having to think about them in words.

- 1. Image connections between your left brain and the right side of your body. Image the connections in any way you wish as tubes, electrical currents, wires, whatever. Now image the pathways *in a color*, say blue or red, going from the left brain to every part of the right side of your body.
- 2. Next, shift to the other side. Image the connections between your right brain and the left side of your body in a *different* color, perhaps green or yellow.
- 3. Now image the whole system and its crossover connections.

THE ENCHANTED LOOM

One of the most famous word-pictures of the brain was formed by the English scientist Sir Charles Sharrington. He pictured the brain as "an enchanted loom where millions of flashing shuttles weave a dissolving pattern, always a meaningful pattern though never an abiding one. . . ."

- 1. Visualize in your mind's eye the magic loom inside your head, with its myriad flashing shuttles now coalescing in one part of your brain dissolving, darkening, then streaming across to another part in an everchanging pattern: glowing and subsiding, glowing and subsiding.
- 2. Now imagine that you can control the pattern and can cause the flashing shuttles to gather in one part, then to dissolve and gather in another part. Imagine them gathering first on one side then on the other. Imagine that this gathering causes an actual physical sensation inside your brain, a slight change in pressure, a minute shift in weight, a slight warming or cooling, a faint buzzing sound.

Watching the Loom

Psychologists have reported that many individuals seem to be able to "stand back" and become aware of their varying mental states as if they are watching their brains at work. These imaging exercises and some of the later drawing exercises will help you In response to an inquiry into the working methods of mathematicians by Jacques Hadamard, Albert Einstein wrote a letter to Hadamard in which he said, "The words or the language, as they are written or spoken, do not seem to play any role in my mechanism of thought. The psychical entities which seem to serve as elements in thought are certain signs and more or less clear images which can be 'voluntarily' reproduced and combined."

—Jacques Hadamard The Psychology of Invention in the Mathematical Field

Bob Samples, a teacher, author, and humanist philosopher, provides an imaging exercise in his book on teaching, *The Wholeschool Book*:

"Let us pretend for a moment that each of us has within our heads not just one meadow — but two. Two distinctly different meadows. Since they are both meadows, certainly they have some qualities in common. But still there are distinct differences about them. To show you how separate they are, visualize a wide and swiftly flowing river between them. That's it — a river between them, flowing from one hemisphere to the other.

"The awesome feature of this river is that it flows both ways at once. Substance from one meadow can instantly flow into the other. However, as soon as it arrives, it is transformed into the ecology of that new meadow."

Psychologist Charles T. Tart, discussing alternate states of consciousness, has said, "Many meditative disciplines take the view that . . . one possesses (or can develop) an Observer that is highly objective with respect to the ordinary personality. Because it is an Observer that is essentially pure attention/ awareness, it has not characteristics of its own." Professor Tart goes on to say that some persons who feel that they have a fairly well-developed Observer "feel that this Observer can make essentially continuous observations not only within a particular d-SoC (discrete state of consciousness) but also during the transition between two or more discrete states."

—Charles T. Tart "Putting the Pieces Together"

"In prose, the worst thing one can do with words is to surrender to them. When you think of a concrete object, you think wordlessly, and then, if you want to describe the thing you have been visualizing, you probably hunt about till you find the exact words that seem to fit it. When you think of something abstract you are more inclined to use words from the start, and unless you make a conscious effort to prevent it, the existing dialect will come rushing in and do the job for you, at the expense of blurring or even changing your meaning. Probably it is better to put off using words as long as possible and get one's meaning clear as one can through pictures or sensations."

—George Orwell "Politics and the English Language"

develop this hidden "Observer," to use psychologist Charles Tart's term, thus becoming more aware at a conscious level of slightly shifting brain states. This in turn will help you to "turn on" the R-mode state that enables artists to see and draw.

SETTING UP THE CONDITIONS FOR THE L→R SHIFT

The exercises in the next chapter are specifically designed to cause a mental shift from L-mode to R-mode. The basic assumption of the exercises is that the nature of the task can influence which hemisphere will be in control and "take on" the job while inhibiting the other hemisphere. As I said, scientists postulate that the hemispheres either alternate being "on" — an "on" condition in one hemisphere causing an "off" condition in the other — or they are both "on," but with one hemisphere controlling the action (the overt behavior). But the question is, what factors determine which hemisphere will be "on" and/or controlling?

Through studies with animals, split-brain patients, and individuals with intact brains, scientists believe that the control question may be decided mainly in two ways. One way is *speed*: which hemisphere gets to the job the quickest? A second way is *motivation*: which hemisphere cares most or likes the task the best? And conversely: which hemisphere cares least and likes the job the least?

Since drawing a perceived form is largely a right-brain function, we must keep the left brain out of it. Our problem is that the left brain is dominant and speedy and is very prone to rush in with words and symbols, even taking over jobs which it is not good at. The split brain studies indicated that the left brain likes to be boss, so to speak, and prefers not to relinquish tasks to its dumb partner unless it really dislikes the job—either because the job takes too much time, is too detailed or slow or because the left brain is simply unable to accomplish the task. That's exactly what we need—tasks that the dominant left brain will turn

down. The exercises that follow are designed to present the brain with a task which the left hemisphere either can't or won't do.

Handedness, Left or Right

It will be helpful to take up the question of the relationship of left-handedness to drawing and hemisphere function before we get into the instruction. Students ask many questions about handedness in my classes. I will try to cover the main questions, although the extensive research on handedness appears to be somewhat unresolved and contradictory.

Despite the difficulties, it does seem clear that in the Western World between 5 and 12 percent of the population are strongly or significantly left-handed. This seems to be true for most other cultures as well but there is some evidence that early historical and prehistorical humans were less predominantly right-handed.

Left-handed individuals were once thought to be the converse of right-handers in terms of brain organization: verbal functions (speech, writing, etc.) are in the left hemispheres of right-handers, and it was thought that verbal functions were in the right brain of left-handers. But recent research indicates that most left-handers, like right-handers, have verbal functions in the left hemispheres. An exception to this finding is that left-handers whose mothers were left handed may possibly have verbal functions in the right brain.

Whether being left-handed improves a person's ability to gain access to right-hemisphere functions such as drawing is still unclear. One point that does seem clear — and is a question often asked in my classes — is whether drawing with the left hand by a right-hander helps tap into right-brain processes. The answer seems to be no. The problems with seeing that prevent individuals from being able to draw do not disappear simply by changing hands; the drawing is just more awkward. And a person who is skilled in drawing can draw with the right hand, the left hand, or learn to draw with the pencil held in the teeth or between the toes if necessary, because that person has learned how to see.

In the chapters to follow, I will address the instruction to right-handers, and that instruction will be appropriate for all left-handers as well, except for the left-handers whose mothers were left-handed. For those few, the instructions dealing with hemisphere function should be reversed.

4

Crossing Over: Experiencing the Shift From Left to Right

"Our normal waking consciousness, rational consciousness, as we call it, is but one special type of consciousness, whilst all about it, parted from it by the filmiest of screens, there lie potential forms of consciousness entirely different. We may go through life without suspecting their existence; but apply the requisite stimulus, and at a touch they are there in all their completeness, definite types of mentality which probably somewhere have their field of application and adaptation."

—William James The Varieties of Religious Experience rawing a perceived form is largely a right-hemisphere function. This has now been empirically tested and documented. As I have explained, to draw a perceived form we want the left mode mainly "off" and the right mode "on," a combination that produces a slightly altered subjective state in which the right hemisphere "leads." The characteristics of this subjective state are those that artists speak of: a sense of close "connection" with the work, a sense of timelessness, difficulty in using words or understanding spoken words, a feeling of confidence and a lack of anxiety, a sense of close attention to shapes and spaces and forms that remain nameless.

It's important that you experience the shift from one mode to the other — the shift from the ordinary verbal, analytic state to the spatial, nonverbal state. By setting up the conditions for this mental shift and experiencing the slightly different feeling it produces, you will be able to recognize and foster this state in yourself — a state in which you will be able to draw.

VASES AND FACES: AN EXERCISE FOR THE DOUBLE BRAIN

The exercises that follow are specifically designed to help you shift from your dominant left-hemisphere mode to your subdominant R-mode. I could go on describing the process over and over in words, but only *you* can experience for yourself this cognitive shift, this slight change in subjective state. As Fats Waller once said, "If you gotta ask what jazz is, you ain't never gonna know." So it is with R-mode state: you must experience the L- to R-mode shift, observe the R-mode state, and in this way come to know it.

VASE-FACES DRAWING #1

You have probably seen the perceptual-illusion drawing of the vase and faces. Looked at one way, the drawing appears to be two faces seen in profile. Then, as you are looking at it, the drawing seems to change and become a vase. One version of the drawing is shown in Figure 4-1.

Before you begin: First, read all the directions for the exercise.

1. Draw a profile of a person's head on the left side of the

Fig. 4-1.

paper, facing toward the center. (If you are left-handed, draw the profile on the right side, facing toward the center.) Examples are shown of both the right-handed and left-handed drawings (Figures 4-2 and 4-3). Make up your own version of the profile if you wish. It seems to help if this profile comes from your own memorized, stored *symbols* for a human profile.

- 2. Next, draw horizontal lines at the top and bottom of your profile, forming top and bottom of the vase (Figures 4-2 and 4-3).
- 3. Now go back over your drawing of the first profile with your pencil. As the pencil moves over the features, *name them to yourself:* forehead, nose, upper lip, lower lip, chin, neck. Repeat this step at least once. This is an L-mode task: naming symbolic shapes.
- 4. Next, starting at the top, draw the profile in *reverse*. By doing this, you will *complete the vase*. The second profile should be a reversal of the first in order for the vase to be symmetrical. (Look once more at the example in Figure 4-1.) Watch for the faint signals from your brain that you are shifting modes of information processing. You may experience a sense of mental conflict at some point in the drawing of the *second* profile. Observe this. And observe *how you solve the problem*. You will find that you are doing the second profile *differently*. This is right-hemisphere-mode drawing.

Before you read further, do the drawing.

After you finish: Now that you have completed the Vase-Faces drawing, think back on how you did it. The first profile was

Fig. 4-3. For right-handers.

Fig. 4-2. For left-handers.

Thomas Gladwin, an anthropologist, contrasted the ways that a European and a native Trukese sailor navigated small boats between tiny islands in the vast Pacific Ocean.

Before setting sail, the European begins with a plan that can be written in terms of directions, degrees of longitude and latitude, estimated time of arrival at separate points on the journey. Once the plan is conceived and completed, the sailor has only to carry out each step consecutively, one after another, to be assured of arriving on time at the planned destination. The sailor uses all available tools, such as a compass, a sextant, a map, etc., and if asked, can describe exactly how he got where he was going.

The European navigator uses the lefthemisphere mode.

In contrast, the native Trukese sailor starts his voyage by imaging the position of his destination relative to the position of other islands. As he sails along, he constantly adjusts his direction according to his awareness of his position thus far. His decisions are improvised continually by checking relative positions of landmarks, sun, wind direction, etc. He navigates with reference to where he started, where he is going, and the space between his destination and the point where he is at the moment. If asked how he navigates so well without instruments or a written plan, he cannot possibly put it into words. This is not because the Trukese are unaccustomed to describing things in words, but rather because the process is too complex and fluid to be put into words.

The Trukese navigator uses the righthemisphere mode.

 J. A. Paredes and M.J. Hepburn "The Split-Brain and the Culture-Cognition Paradox" probably rather rapidly drawn and then, as you were instructed, redrawn while verbalizing the names of the parts as you went back over the features.

This is a left-hemisphere mode of processing: drawing symbolic shapes from memory and naming them.

In drawing the second profile (that is, the profile that completes the vase), you may have experienced some confusion or conflict, as I mentioned. To continue the drawing, you had to find a different way, some different process. You probably lost the sense of drawing a profile and found yourself scanning back and forth in the space between the profiles, estimating angles, curves, inward-curving and outward-curving shapes, and lengths of line in relation to the opposite shapes, which now become unnamed and unnamable. Putting it another way, you made constant adjustments in the line you were drawing by checking where you were and where you were going, by scanning the space between the first profile and your copy in reverse.

NAVIGATING A DRAWING IN RIGHT-HEMISPHERE MODE

When you did your drawing of the Vase-Faces, you drew the first profile in the left-hemisphere mode, like the European navigator, taking one part at a time and naming the parts one by one. The second profile was drawn in the right-hemisphere mode. Like the navigator from the South Sea island of Truk, you constantly scanned to adjust the direction of the line. You probably found that *naming* the parts such as forehead, nose, or mouth seemed to confuse you. It was better not to think of the drawing as a face. It was easier to use the *shape of the space between* the two profiles as your guide. Stated differently, it was easiest *not* to think at all — that is, in words. In right-hemisphere-mode drawing, the mode of the artist, if you do use words to think, ask yourself only such things as:

"Where does that curve start?"

"How deep is that curve?"

"What is that angle relative to the edge of the paper?"

"How long is that line relative to the one I've just drawn?"

"Where is that point as I scan across to the other side — where is that point relative to the distance from the top (or bottom) edge of the paper?"

These are R-mode questions: spatial, relational, and compara-

tive. Notice that *no parts are named*. No statements are made, no conclusions drawn, such as, "The chin must come out as far as the nose," or, "Noses are curved."

In the next exercise, keep your mind on nonverbal, relative factors. If your left brain intrudes with verbal phrases about the separate things (faces and vases) try to quiet it down. Your hidden Observer might say, "Just stay out of this, please. The other side can handle this job. It won't take long and then we'll get back to you."

(This may sound a bit odd, but it is necessary because the left hemisphere is not used to being shut out, and you must, in a sense, reassure it.)

VASE-FACES DRAWING #2: THE BAROQUE VASE AND MONSTER FACE

Draw the second Vase-Faces drawing, following the directions below. Again, read all of the directions before you begin.

- 1. On the left side of the paper if you are right-handed, or the right side if you are left-handed, draw a profile. This time draw the profile of the oddest face you can conjure up a witch, a ghoul, a monster. Again, name the parts of the face as you go down the profile, naming also whatever embellishments you add, such as wrinkles, moles, double chins, etc. Figures 4-4 and 4-5 provide examples, but make up your own profile if you wish.
- 2. After you finish this first profile, add the horizontal lines at the top and bottom for the vase.

Fig. 4-4. For left-handers.

Fig. 4-5. For right-handers.

Charles Tart, professor of psychology at the University of California, Davis, states: "We begin with a concept of some kind of basic awareness, some kind of basic ability to 'know' or 'sense' or 'cognize' or 'recognize' that something is happening. This is a fundamental theoretical and experiential given. We do not know scientifically what the ultimate nature of awareness is, but it is our starting point."

—Charles T. Tart Alternative States of Consciousness

3. Now draw the profile in reverse, completing the vase, this time a *baroque* vase.

As in the previous exercise, the first monster profile is an *L-mode drawing* of symbolic forms that represent the features of the face. Especially in this complex Vase-Faces drawing, the second profile can best be done — even, perhaps, can only be done — by shifting to right-hemisphere mode. The complexity of the form forces the shift to right-hemisphere mode. The point of this exercise is not how perfectly you do the drawing but rather that you try to feel the shift from left-mode to right-mode. Try to be aware of the difference between the modes. As you begin to recognize when you have shifted cognitive modes, you will be taking a first step toward learning to control by conscious volition which side of your brain you use for a given task.

Trying to draw a perceived form by using the verbal left mode is like trying to use a foot to thread a needle. It doesn't work. What is needed is for you to be able to "turn down" the left hemisphere and activate the right. This requires unblocking the right, or, as Aldous Huxley phrased it, "opening the Door in the Wall." The next exercise is designed to produce a further, deeper shift into R-mode.

UPSIDE-DOWN DRAWING: MAKING THE SHIFT TO R-MODE

Familiar things do not look the same when they are upside down. We automatically assign a top, a bottom, and sides to the things we perceive, and we expect to see things oriented in the usual way — that is, right side up. For, in upright orientation, we can recognize familiar things, name them, and categorize them by matching what we see with our stored memories and concepts.

When an image is upside down, the visual clues don't match. The message is strange, and the brain becomes confused. We see the shapes and the areas of light and shadow. We don't particularly object to looking at upside-down pictures unless we are called on to *name* the image. Then the task becomes exasperating.

Seen upside down, even well-known faces are difficult to recognize and name. For example, the photograph in Figure 4-6 is of a famous American. Do you recognize who it is?

You may have had to turn the photograph right side up to see

Fig. 4-6.

that it is John F. Kennedy. Even after you know who the person is, the upside-down image probably continues to look strange.

Inverted orientation causes recognition problems with other images (see Figure 4-7). Your own handwriting, turned upside down, is probably difficult for you to figure out, although you've been reading it for years. To test this, find an old shopping list or letter in your handwriting, and try to read it upside down.

A complex drawing, such as the one shown upside down in the Tiepolo drawing, Figure 4-8, is almost indecipherable. The (left) mind just gives up on it.

Fig. 4-7. In copying signatures, forgers turn the originals upside down to see the exact shapes of the letters more clearly — to see, in fact, in the artist's mode.

Fig. 4-8. Giovanni Battista Tiepolo (1696-1770), *The Death of Seneca*. Courtesy of The Art Institute of Chicago, Joseph and Helen Regenstein Collection.

Fig. 4-9. Pablo Picasso (1881-1973), *Portrait of Igor Stravinsky*. Paris, May 21, 1920 (dated). Privately owned.

UPSIDE-DOWN DRAWING

We shall use this gap in the abilities of the left hemisphere to allow the R-mode to have a chance to take over for a while.

Figure 4-9 is a reproduction of a line drawing by Picasso of the composer Igor Stravinsky. The image is upside down. You will be copying the upside-down image. Your drawing, therefore, will be done also upside down. In other words, you will copy the Picasso drawing just as you see it.

Before you begin: Read all of the following instructions.

- 1. Find a quiet place to draw where no one will interrupt you. Play music if you like. As you shift into R-mode, you may find that the music fades out. Finish the drawing in one sitting, allowing yourself about thirty to forty minutes more if possible. Set an alarm clock or a timer, if you wish, so that you can forget about keeping time (an L-mode function). And more importantly: do not turn the drawing right side up until you have finished. Turning the drawing would cause a shift back to L-mode, which we want to avoid while you are learning to experience the R-mode.
- 2. Look at the upside-down drawing (Figure 4-9) for a minute. Regard the angles and shapes and lines. You can see that the lines all *fit* together. Where one line ends another starts. The lines lie at certain angles in relation to each other and in relation to the edges of the paper. Curved lines fit into certain spaces. The lines, in fact, form the edges of spaces, and you can look at the shapes of the spaces within the lines.
- 3. When you start your drawing, begin at the top (as in Figure 4-10) and copy each line, moving from line to adjacent line, putting it all together just like a jigsaw puzzle. Don't concern yourself with naming the parts; it's not necessary. In fact, if you come to parts that perhaps you *could name*, such as the h-a-n-d-s or the f-a-c-e (remember, we are *not naming* things!), just continue to think to yourself, "Well, this line curves that way; this line crosses over, making that little shape there; this line is at that angle, compared to the edge of the paper," and so on. Again, try not to think about what the forms are and avoid any attempt to recognize or name the various parts.
- 4. Begin your upside-down drawing now, working your way through the drawing by moving from line to line, part to adjacent part.
- 5. Once you've started drawing, you'll find yourself becoming very interested in how the lines go together. By the time you are well into the drawing, your L-mode will have turned off (this is not the kind of task the left hemisphere readily takes to: it's too slow and it's too hard to recognize anything), and your R-mode will have turned on.

Remember that everything you need to know in order to draw the image is *right in front of your eyes*. All of the information is right there, making it easy for you. Don't make it complicated. It really is as simple as that.

Fig. 4-10. Inverted drawing. Forcing the cognitive shift from the dominant left-hemisphere mode to the subdominant right-hemisphere mode.

1.

2:

Look at the drawings on the right-hand side of Figure 4-11. Students 1 and 2 copied Picasso's drawing right side up. As you can see, their drawings did not improve, and they used the same stereotypic, symbolic forms in their copies of the Picasso Stravinsky as they used in their Draw-a-Person drawings. In the drawings done by Student 2, you can see the confusion caused by the foreshortened chair and Stravinsky's crossed legs.

In contrast, the second two students, starting out at about the same level of skill, copied the Picasso upside down, just as you did. The Student 3 and Student 4 drawings show the results. Surprisingly, the drawings done upside down reflect much greater accuracy of perception and appear to be much more skillfully drawn.

How can we explain this? The results run counter to common sense. You simply would not expect that a figure observed and drawn upside down could possibly be easier to draw, with superior results, than one viewed and drawn in the normal right-side-up way. The lines, after all, are the same lines. Turning the Picasso drawing upside down doesn't in any way rearrrange the lines or make them easier to draw. And the students did not suddenly acquire "talent."

3. Student 1. Drawn right side up. Student 2. Drawn right side up. Student 3. Drawn upside down. Student 4. Drawn upside down. Fig. 4-11. Draw-a-Person Stravinsky After you finish: Once you've finished and turned your drawing right side up, you'll probably be quite surprised at how well the drawing came out. In Figure 4-11, look at some examples of similar drawings from a controlled experiment with randomly selected college students. The drawings on the left show the students' level of skill prior to the experiment. (They were simply asked to draw a person from memory.) As you see, all of the students were drawing at about the ten- to twelve-year-old level, which is typical of adults in our culture who have not studied drawing.

A Logical Box for the Left Brain

This puzzle puts the logical left brain into a logical box: how to account for this sudden ability to draw well, when it (the knowit-all left hemisphere) has been eased out of the task. The left brain, which admires a job well done, must now consider the possibility that the disdained right brain is *good at drawing*.

More seriously speaking, a plausible explanation of the illogical result is that the left brain refused the task of processing the upside-down image. Presumably, the left hemisphere, confused and blocked by the unfamiliar image and unable to name or symbolize as usual, turned off, and the job passed over to the right hemisphere. Perfect! *The right brain is the hemisphere appropriate for the task of drawing*. Because it is specialized for the task, the right brain finds drawing easy and enjoyable.

GETTING TO KNOW THE L-R SHIFT

Two important points of progress emerge from the upside-down exercise. The first is your conscious recall of how you felt after you made the L-R cognitive shift. The quality of the R-mode state of consciousness is different from the L-mode. One can detect those differences and begin to recognize when the cognitive shift has occurred. Oddly, the moment of shifting between one state of consciousness always remains out of awareness. For example, one can be aware of being alert and then of being in a daydream, but the moment of shifting between the two states remains elusive. Similarly, the moment of the cognitive shift from L-R remains out of awareness, but once you have made the shift, the difference in the two states is accessible to knowing.

"I have supposed a Human Being to be capable of various physical states, and varying degrees of consciousness, as follows:

"(a) the ordinary state, with no consciousness of the presence of Fairies;

"(b) the 'eerie' state, in which, while conscious of actual surrroundings, he is *also* conscious of the presence of Fairies;

"(c) a form of trance, in which, while *unconscious* of actual surrounding, and apparently asleep, he (i.e., his immaterial essence) migrates to other scenes, in the actual world, or in Fairyland, and is conscious of the presence of Fairies."

—Lewis Carroll Preface to Sylvie and Bruno

Lewis Carroll

This knowing will help to bring the shift under conscious control — a main goal of these lessons.

The second insight gained from the exercise is your awareness that shifting to the R-mode enables you to see in the way a trained artist sees, and therefore to draw what you perceive.

Now, it's obvious that we can't always be turning things upside down. Your models are not going to stand on their heads for you, nor is the landscape going to turn itself upside down or inside out. Our goal, then, is to teach you how to make the

cognitive shift when perceiving things in their normal rightside-up positions. You will learn the artist's mode of seeing: the key is to direct your attention toward visual information that the left brain cannot or will not process. In other words, you will always try to present your brain with a task the left brain will refuse, thus allowing your right brain to use its capability for drawing. Exercises in the coming chapters will show you some ways to do this.

A REVIEW OF THE R-MODE

It might be helpful to review what the R-mode feels like. Think back. You have made the shift several times now — while doing the Vase-Faces drawings, and just now while drawing the "Stravinsky."

In the R-mode state, did you notice that you were somewhat unaware of the passage of time — that the time you spent drawing may have been long or short, but you couldn't have known until you checked it afterward? If there were people near, did you notice that you couldn't listen to what they said — in fact, that you didn't want to hear? You may have heard sounds, but you probably didn't care about figuring out the meaning of what was being said. And were you aware of feeling alert, but relaxed — confident, interested, absorbed in the drawing and clear in your mind?

Most of my students have characterized the R-mode state of consciousness in these terms, and the terms coincide with my own experience and accounts related to me of artists' experiences. One artist told me, "When I'm really working well, it's like nothing else I've ever experienced. I feel at *one* with the work: the painter, the painting, it's all *one*. I feel excited, but calm — exhilarated, but in full control. It's not exactly happiness; it's more like bliss. I think it's what keeps me coming back and back to painting and drawing."

The R-mode is indeed pleasurable, and in that mode you can draw well. But there is an additional advantage: shifting to R-mode releases you for a time from the verbal, symbolic domination of the L-mode, and that's a welcome relief. The pleasure may come from *resting* the left hemisphere, stopping its chatter, keeping it quiet for a change. This yearning to quiet the L-mode may partially explain centuries-old practices such as meditation and self-induced altered states of consciousness achieved through

"I know perfectly well that only in happy instants am I lucky enough to lose myself in my work. The painter-poet feels that his true immutable essence comes from that invisible realm that offers him an image of eternal reality. . . . I feel that I do not exist in time, but that time exists in me. I can also realize that it is not given to me to solve the mystery of art in an absolute fashion. Nonetheless, I am almost brought to believe that I am about to get my hands on the divine."

—Carlo Carra
"The Quadrant of the Spirit"

Fig. 4-12. *A Court Dwarf* (c. 1535). Courtesy of the Fogg Art Museum, Harvard University, Mr. E. Schroeder and Coburn Fund.

fasting, drugs, chanting, and alcohol. Drawing in R-mode induces a changed state of consciousness that can last for hours, bringing significant satisfaction.

Before you read further, do at least two more drawings upside down. Use either the reproduction in Figure 4-12, or find other line drawings to copy. Each time you draw, try consciously to experience the R-mode shift, so that you become familiar with how it feels to be in that mode.

"To empty one's mind of all thought and refill the void with a spirit greater than oneself is to extend the mind into a realm not accessible by conventional processes of reason."

> —Edward Hill The Language of Drawing

RECALLING THE ART OF YOUR CHILDHOOD

In the next chapter we'll review your childhood development as an artist. The developmental sequence of children's art is linked to development changes in the brain. In the early stages, infants' brain hemispheres are not specialized for separate functions. Lateralization — the consolidation of specific functions into one hemisphere or the other — progresses gradually through the childhood years, paralleling the acquisition of language skills and the symbols of childhood art.

Lateralization is usually complete by around age ten, and this coincides with the period of conflict in children's art, when the symbol system seems to override perceptions and to interfere with accurate drawing of those perceptions. One could speculate that conflict arises because children may be using the "wrong" brain half — the left brain — to accomplish a task best suited for the right brain. Perhaps they simply cannot work out a way on their own to gain access to the right hemisphere which is specialized for drawing by age ten or so. Also, by age ten the verbal left hemisphere is dominant, adding further complication as names and symbols overpower spatial, holistic perception.

Reviewing your childhood art is important for several reasons: to look back as an adult at how your set of drawing symbols developed from infancy onward; to reexperience the increasing complexity of your drawing as you approached adolescence; to recall the discrepancy between your perceptions and your drawing skills; to view your childhood drawings with a less critical eye than you were able to manage at the time; and finally, to set your childhood symbol system aside and move on to an adult level of visual expression by using the appropriate brain mode — the right mode — for the task of drawing.

Drawing on Memories: Your History as an Artist

"When I was a child, I spake as a child, I thought as a child: but when I became a man, I put away childish things."

-1 Cor. XIII:11

he majority of adults in the Western World do not progress in art skills much beyond the level of development they reached at age nine or ten. In most mental and physical activities, individuals' skills change and develop as they grow to adulthood: speech is one example, handwriting another. The development of drawing skills, however, seems to halt unaccountably at an early age for most people. In our culture, children, of course, draw like children, but most adults also *draw like children*, no matter what level they may have achieved in other areas of life. For example, Figures 5-1 and 5-2 illustrate the persistence of childlike forms in drawings that were done recently by a brilliant young professional man who was just completing a doctoral degree at a major university.

Fig. 5-1.

Fig. 5-2.

I watched the man as he did the drawings, watched him as he regarded the models, drew a bit, erased and drew again, for about twenty minutes. During this time, he became restless and seemed tense and frustrated. Later he told me that he hated his drawings and that he hated *drawing*, period.

If we were to attach a label to this disability in the way that educators have attached the label *dyslexia* to reading problems, we might call the problem *dyspictoria* or *dysartistica* or some such term. But no one has done so because drawing is not a vital skill for survival in our culture, whereas speech and reading are. Therefore, hardly anyone seems to notice that many adults draw childlike drawings and many children give up drawing at age

nine or ten. These children grow up to become the adults who say that they never could draw and can't even draw a straight line. The same adults, however, if questioned, often say that they would have liked to learn to draw well, just for their own satisfaction at solving the drawing problems that plagued them as children. But they feel that they *bad* to stop drawing because they simply couldn't learn how to draw.

A consequence of this early cutting off of artistic development is that fully competent and self-confident adults often become suddenly self-conscious, embarrassed, and anxious if they are asked to draw a picture of a human face or figure. In this situation, individuals often say such things as "No, I can't! Whatever I draw is always terrible. It looks like a kid's drawing." Or, "I don't like to draw. It makes me feel so stupid." You yourself may have felt a twinge or two of those feelings when you did the first four preinstruction drawings.

THE CRISIS PERIOD

The beginning of adolescence seems to mark the abrupt end of artistic development in terms of drawing skills for many adults. As children, they confronted an artistic crisis, a conflict between their increasingly complex perceptions of the world around them and their current level of art skills.

Most children between the ages of about nine and eleven have a passion for realistic drawing. They become sharply critical of their childhood drawings and begin to draw certain favorite subjects over and over again, attempting to perfect the image. Anything short of perfect realism may be regarded as failure.

Perhaps you can remember your own attempts at that age to make things "look right" in your drawings, and your feeling of disappointment with the results. Drawings you might have been proud of at an earlier age probably seemed hopelessly wrong and embarassing. Looking at your drawings, you may have said, as many adolescents say, "This is terrible! I have no talent for art. I never liked it anyway, so I'm not doing it anymore."

Children often abandon art as an expressive activity for another unfortunately frequent reason. Unthinking people sometimes make sarcastic or derogatory remarks about children's art. The thoughtless person may be a teacher, a parent, another child, or perhaps an admired older brother or sister. Many adults have related to me their painfully clear memories of someone's An expert on children's art, Miriam Lindstrom of the San Francisco Art Museum, described the adolescent art student:

"Discontented with his own accomplishments and extremely anxious to please others with his art, he tends to give up original creation and personal expression. . . . Further development of his visualizing powers and even his capacity for original thought and for relating himself through personal feelings to his environment may be blocked at this point. It is a crucial stage beyond which many adults have not advanced."

-Miriam Lindstrom Children's Art ridiculing their attempts at drawing. Sadly, children often blame the *drawing* for causing the hurt, rather than blaming the careless critic. Therefore, to protect the ego from further damage, children react defensively, and understandably so: they seldom ever attempt to draw again.

ART IN SCHOOL

Even sympathetic art teachers, who may feel dismayed by unfair criticism of children's art and who want to help, become discouraged by the style of drawing that young adolescents prefer — complex, detailed scenes, labored attempts at realistic drawing, endless repetitions of favorite themes such as racing cars, and so on. Teachers recall the beguiling freedom and charm of younger children's work and wonder what happened. They deplore what they see as "tightness" and "lack of creativity" in students' drawings. The children themselves often become their own most unrelenting critics. Consequently, teachers frequently resort to crafts projects because they seem safer and cause less anguish — projects such as paper mosaics, string-painting, drip-painting, and other manipulations of materials.

As a result, most students do not learn how to draw in the early and middle grades. Their self-criticism becomes permanent, and they very rarely try to learn how to draw later in life. Like the doctoral candidate mentioned earlier, they may grow up to be highly skilled in a number of areas, but if asked to draw a human being, they will produce the same childlike image they were drawing at age ten.

FROM INFANCY TO ADOLESCENCE

For most of my students, it has proved beneficial to go back in time to try to understand how their visual imagery in drawing developed from infancy to adolescence. With a firm grasp on how the symbol system of childhood drawing has developed, students seem to "unstick" their artistic development more easily in order to move on to adult skills.

The Scribbling Stage

Making marks on paper begins at about age one and a half, when you as an infant were given a pencil or crayon, and you, by

yourself, made a mark. It's hard for us to imagine the sense of wonder a child experiences on seeing a black line emerge from the end of a stick, a line the child controls. You and I, all of us, had that experience.

After a tentative start, you probably scribbled with delight on every available surface, perhaps including your parents' best books and the walls of a bedroom or two. Your scribbles were seemingly quite random at first, like the example in Figure 5-3, but very quickly began to take on definite shapes. One of the basic scribbling movements is a circular one, probably arising simply from the way the shoulder, arm, wrist, hand, and fingers work together. A circular movement is a natural movement — more so, for instance, than the arm movements required to draw a square. (Try both on a piece of paper, and you'll see what I mean.)

The Stage of Symbols

After some days or weeks of scribbling, infants — and apparently all human children — make the basic discovery of art: a drawn symbol can stand for something out there in the environment. The child makes a circular mark, looks at it, adds two marks for eyes, points to the drawing, and says, "Mommy," or "Daddy," or "That's me," or "My dog," or whatever. Thus, we all made the uniquely human leap of insight which is the foundation for art, from the prehistoric cave paintings all the way up through the centuries to the art of Leonardo, Rembrandt, and Picasso.

With great delight, infants draw circles with eyes, mouth, and lines sticking out to represent arms and legs, as in Figure 5-4. This form, a symmetrical, circular form, is a basic form universally drawn by infants. The circular form can be used for almost anything: with slight variations, the basic pattern can stand for a human being, a cat, a sun, a jellyfish, an elephant, a crocodile, a flower, or a germ. For you as a child, the picture was whatever you said it was, although you probably made subtle and charming adjustments of the basic form to get the idea across.

By around age three and a half, the imagery of children's art becomes more complex, reflecting a child's growing awareness and perceptions of the world. A body is attached to the head, though it may be smaller than the head. Arms may still grow out of the head, but more often they emerge from the body — sometimes from below the waist. Legs are attached to the body.

"The scribblings of any . . . child clearly indicate how thoroughly immersed he is in the sensation of moving his hand and crayon aimlessly over a surface, depositing a line in his path. There must be some quantity of magic in this alone."

—Edward Hill The Language of Drawing

Fig. 5-3. Scribble drawing by a two-and-a-half-year-old.

Fig. 5-4. Figure-image drawing by a three-and-a-half-year-old.

By age four, children are keenly aware of details of clothing — buttons and zippers, for example, appear as details of the drawings. Fingers appear at the ends of arms and hands, and toes at the ends of legs and feet. Numbers of fingers and toes vary imaginatively. I have counted as many as thirty-one fingers on one hand and as few as one toe per foot (Figure 5-4).

Although children's drawings of figures resemble each other in many ways, each child works out through trial and error a favorite image, which becomes refined through repetition. Children draw their special images over and over, memorizing them and adding details as time goes on. These favorite ways to draw various parts of the image eventually become embedded in the memory and are remarkably stable over time (Figure 5-5).

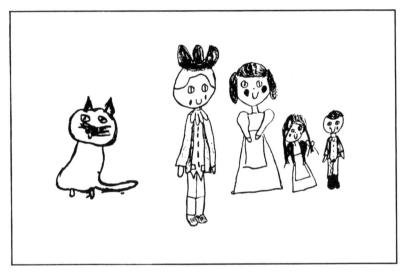

Fig. 5-5. Notice that the *features* are the same in each figure — including the cat — and that the little *band* symbol is also used for the cat's paws.

Pictures That Tell Stories

Around age four or five, children begin to use drawings to tell stories and to work out problems, using small or gross adjustments of the basic forms to express their intended meaning. For example, in Figure 5-6, the young artist has made the arm that holds the umbrella huge in relation to the other arm, because the arm that holds the umbrella is the important point of the drawing.

Another instance of using drawing to portray feelings is a family portrait, drawn by a shy five-year-old whose every waking moment apparently was dominated by his older sister.

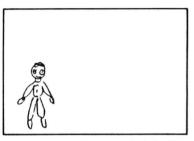

Using his basic figure symbol, he first drew himself.

He then added his mother, using the same basic figure configuration with adjustments — long hair, a dress.

He then added his father, who was bald and wore glasses.

Even Picasso could hardly have expressed a feeling with greater power than that. Once the feeling was drawn, giving *form* to formless emotions, the child who drew the family portrait may have been better able to cope with his overwhelming sister.

Drawing can be a potent problem-solving aid for both children and adults. A drawing can let you see how you feel. Putting that another way, the right brain, by means of a drawing, can show the left brain what the trouble is. The left brain, in turn, can use its own powerful skills — language and logical thought — to solve the problem.

He then added his sister, with teeth.

Fig. 5-7.

The Landscape

By around age five or six, children have developed a set of symbols to create a landscape. Again, by a process of trial and error, children usually settle on a single version of a symbolic landscape which is endlessly repeated. Perhaps you can remember the landscape you drew around age five or six.

What were the components of that landscape? First, the ground and sky. Thinking symbolically, a child knows that the ground is at the bottom and the sky is at the top. Therefore, the ground is the bottom edge of the paper, and the sky is the top edge, as in Figure 5-7. Children emphasize this point, if they are working with color, by painting a green stripe across the bottom, blue across the top.

Most children's landscapes contain some version of a house. Try to call up in your mind's eye an image of the house you drew. Did it have windows? With curtains? And what else? A door? What was on the door? A doorknob, of course, because that's how you get in. I have never seen an authentic, child-drawn house with a missing doorknob.

You may begin to remember the rest of your landscape: the sun (did you use a corner sun or a circle with radiating rays?), the clouds, the chimney, the flowers, the trees (did yours have a convenient limb sticking out for a swing?), the mountains (were yours like upside-down ice cream cones?). And what else? A road going back? A fence? Birds?

At this point, before you read any further, please take a sheet of paper and draw the landscape that you drew as a child. Label your drawing "Recalled Childhood Landscape." You may remember this image with surprising clarity as a *whole* image, complete in all its parts; or it may come back to you more gradually as you begin to draw.

While you are drawing the landscape, try also to recall the pleasure drawing gave you as a child, the satisfaction with which each symbol was drawn, and the sense of rightness about the placement of each symbol within the drawing. Recall the sense that nothing must be left out and, when all the symbols were in place, your sense that the drawing was *complete*.

If you can't recall the drawing at this point, don't be concerned. You may recall it later. If not, it may simply indicate that you've blocked it out for some reason. Usually about ten percent of my adult students are unable to recall their childhood drawings.

Fig. 5-8.

Fig. 5-9.

Before we go on, let's take a minute to look at some recalled childhood landscapes drawn by adults. First, you will observe that the landscapes are personalized images, each different from the other. Observe also that in every case the *composition* — the way the elements of each drawing are composed or distributed within the four edges — seems exactly right, in the sense that not a single element could be added or removed without disturbing the rightness of the whole (Figure 5-8). Let me demonstrate that by showing you what happens in Figure 5-9 when one form (the tree) is removed. Test this concept in your own recalled landscape by covering one form at a time. You will find that removing any single form throws off the balance of the whole picture. Figures 5-10 to 5-12 show examples of some of the other characteristics of childhood landscape drawings.

After you have looked at the examples, observe your own drawing. Observe the composition (the way the forms are arranged and balanced within the four edges). Observe distance as a factor in the composition. Try to characterize the expression of the house, at first wordlessly and then in words. Cover one element and see what effect that has on the composition. Think back on how you did the drawing. Did you do it with a sense of sureness, knowing where each part was to go? For each part, did you find that you had an exact symbol that was perfect in itself and fit perfectly with the other symbols? You may have, been aware of feeling the same sense of satisfaction that you felt as a child when the forms were in place and the image completed.

Children seem to start out with a nearly perfect sense of composition, which they often lose during adolescence and regain only through laborious study. I believe that the reason may be that older children concentrate their perceptions on separate objects existing in an undifferentiated space, whereas young children construct a self-contained conceptual world bounded by the paper's edges. For older children, however, the edges of the paper seem almost nonexistent, just as edges are nonexistent in open, real space.

Fig. 5-10. Landscape drawing by a six-year-old. This house is very close to the viewer. The bottom edge of the paper functions as the ground. To a child it seems that every part of the drawing surface has symbolic meaning, the empty spaces of this surface functioning as *air* through which smoke rises, the sun's rays shine, and birds fly.

Fig. 5-11. Landscape drawing by a six-year-old. This house is farther away from the viewer and has a wonderfully self-satisfied expression, enclosed as it is under the arc of a rainbow.

Fig. 5-12. Landscape drawing by a seven-year-old. This drawing is more difficult to read. To me, the house seems enclosed; almost dozing. The boy seems to be warding off intruders. Perhaps you have a different response.

This way of reading drawings, by sensing the visual meaning and responding on a feeling level, is the skill that sensitive viewers of art constantly attempt to use when looking at works of art — for example, in museums or galleries. The question is: what is the work communicating in the nonverbal language of art? In fact, one of the qualities of masterpieces is that they evoke a myriad of many-layered responses, while at the same time they may elicit a general consensus about the underlying meaning.

Skill in reading works of art can be gained through practice. The best way is to *sense* them without words then later find words to fit your response. I used this R-mode process to arrive at my statement of response to this childhood landscape. This method is similar to the way we respond to the changing expression of a friend's face and is a good example of holistic, relational R-mode processing.

The Stage of Complexity

Now, like the ghosts in Dickens's *A Christmas Carol*, we'll move you on to observe yourself at a slightly later age, at nine or ten. Possibly you may remember some of the drawings you did at that age — in the fifth, sixth, or seventh grade.

During this period, children try for more detail in their art work, hoping by this means to achieve greater realism, which is a prized goal. Concern for composition diminishes, the forms often being placed almost at random on the page. Seemingly, children's concern for *where things are* in the drawing is replaced with concern for *how things look*, particularly the details of forms.

Fig. 5-13.

Overall, drawings by older children show greater complexity and, at the same time, less assurance than do the landscapes of early childhood.

Also around this time, children's drawings become differentiated by sex, probably because of cultural factors. Boys begin to draw automobiles — hot rods and racing cars; war scenes with dive bombers, submarines, tanks, and rockets; legendary figures and heroes — bearded pirates, Viking crewmen and their ships, television stars, mountain climbers, and deep-sea divers; block letters, especially monograms; and some odd images such as (my favorite) an eyeball complete with piercing dagger and pools of blood.

Meanwhile, girls are drawing tamer things — flowers in vases, waterfalls, mountains reflected in still lakes, pretty girls running or sitting on the grass, fashion models with incredible eyelashes, elaborate hairstyles, tiny waists and feet, and hands held behind the back because hands are "hard to draw."

Figures 5-13 through 5-16 are some examples of these early adolescent drawings. I've included a cartoon drawing: cartoons are drawn by both boys and girls and are much admired. I believe that cartooning appeals to children at this age because cartoons employ familiar symbolic forms, but are used in a more sophisticated way, thus enabling adolescents to avoid feeling that their drawing is "babyish."

The Stage of Realism

By around age ten or eleven, children's passion for realism is in full bloom (Figures 5-17 and 5-18). When their drawings don't come out "right" — meaning that they don't look realistic — children often become discouraged and ask their teachers for help. The teacher may say, "You must look more carefully," but this doesn't help, because the child doesn't know what to look more carefully *for*. Let me illustrate that with an example.

Say that a ten-year-old wants to draw a picture of a cube, perhaps a three-dimensional block of wood. Wanting the drawing to look "real," the child tries to draw the cube from an angle that shows two or three planes — not just a straight-on side view that would show only a single plane, and thus would not reveal the true shape of the cube.

To do this, the child must draw the oddly angled shapes just as they appear — that is, just like the image that falls on the

Fig. 5-14. Complex drawing by a ten-year-old. This is an example of the kind of drawing by adolescents that teachers often deplore as "tight" and uncreative. Young artists work very hard to perfect images like this one, however, trying different symbols and configurations. Note the symbol for *face in the crowd*, patiently repeated. The child will soon reject this image, however, as hopelessly inadequate.

Fig. 5-15. Complex drawing by a nine-year-old. *Transparency* is a recurrent theme in the drawings of children at this stage. Things seen under water, through glass windows, or in transparent vases — as in this drawing — are all favorite themes. Though one could guess at a psychological meaning, it is quite likely that young artists are simply trying this idea to see if they can make the drawings "look right."

Fig. 5-16. Complex drawing by a ten-year-old. Cartooning is a favorite form of art in the middle adolescent years. As art educator Miriam Lindstrom notes in *Children's Art*, the level of taste at this age is at an all-time low.

Fig. 5-17. Realistic drawing by a twelve-year-old. Children aged ten to twelve are searching for ways to make things "look real." Figure drawing in particular fascinates adolescents. In this drawing, symbols from an earlier stage are fitted into new perceptions: note the front-view eye in this profile drawing. Note also that the child's knowledge of the chair back has been substituted for the purely visual appearance of the back of the chair seen from the side.

Fig. 5-18. Realistic drawing by a twelve-year-old. At this stage, children's main effort is toward achieving realism; and awareness of the edges of the drawing surface fades. Attention is concentrated on individual, unrelated forms randomly distributed about the page. Each segment functions as an individual element without regard for unified composition.

retina of the perceiving eye. Those shapes are not square. In fact, the child must suppress knowing that the cube is square and draw shapes that are "funny." The drawn cube will look like a cube only if it is comprised of oddly angled shapes. Put another way, the child must draw unsquare shapes to draw a square cube. The child must accept this paradox, this illogical process, which conflicts with verbal, conceptual knowledge. (Perhaps this is one meaning of Picasso's statement that "Painting is a lie that tells the truth.")

If verbal knowledge of the cube's real shape overwhelms the student's purely visual perception, "incorrect" drawing results — drawing with the kinds of problems that make adolescents despair (see Figure 5-19). Knowing that cubes have square cor-

"I must begin, not with hypothesis, but with specific instances, no matter how minute."

-Paul Klee

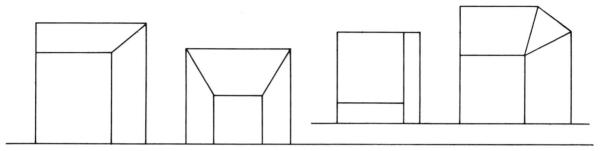

Fig. 5-19. "Incorrect" drawings of a cube (from student drawings).

ners, students usually start a drawing of a cube with a square corner. Knowing that a cube rests on a flat surface, students draw straight lines across the bottom. Their errors compound themselves as the drawing proceeds, and the students become more and more confused.

Though a sophisticated viewer, familiar with the art of cubism and abstraction, might find the "incorrect" drawings in Figure 5-19 more interesting than the "correct" drawings in Figure 5-20, young students find praise of their wrong forms incomprehensible. In this case, the child's intent was to make the cube look "real." Therefore, to the child, the drawing is a failure. To say otherwise seems as absurd to students as telling them that "two plus two equals five" is a creative and praiseworthy solution.

On the basis of "incorrect" drawings such as the cube drawings, students may decide that they "can't draw." But they can draw; that is, the forms indicate that manually they are perfectly able to draw. The dilemma is that previously stored knowledge — which is useful in other contexts — prevents their seeing the thing-as-it-is, right there in front of their eyes.

"The painter who strives to represent reality must transcend his *own* perception. He must ignore or override the very mechanisms in his mind that create objects out of images. . . . The artist, like the eye, must provide true images and the clues of distance to tell his magic lies."

—Colin Blakemore Mechanics of the Mind

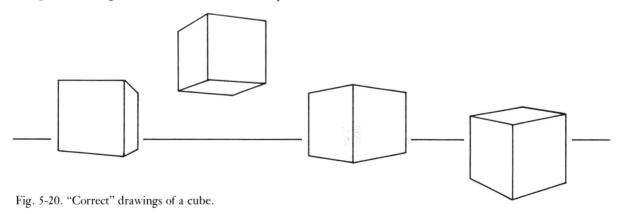

Sometimes the teacher solves the problem by showing the students how — that is, by demonstrating the process of drawing. Learning by demonstration is a time-honored method of teaching art, and it works if the teacher can draw well and has confidence enough to demonstrate realistic drawing in front of a class. Unfortunately, most teachers at the crucial elementary level are themselves not trained in perceptual skills in drawing. Therefore, teachers often have the same feelings of inadequacy concerning their own ability to draw realistically as the children they wish to teach.

Many teachers wish children at this age would be freer, less concerned about realism in their art work. But however much some teachers may deplore their students' insistence on realism, the children themselves are relentless. They will have realism, or they will give up art forever. They want their drawings to match what they see, and they want to know how to do that.

I believe that children at this age love realism because they are trying to learn how to see. They are willing to put great energy and effort into the task if the results are encouraging. A few children are lucky enough to accidentally discover the secret: how to see things in a different (R-mode) way. As I mentioned in the preface, I believe that I was one of those children who stumbled on the process. But the majority of children need to be taught how to make that cognitive shift. Fortunately, we are now developing new instructional methods, based on recent brain research, which will enable teachers to help satisfy children's yearning for seeing and drawing skills.

HOW THE SYMBOL SYSTEM, DEVELOPED IN CHILDHOOD, INFLUENCES SEEING

Now we are coming closer to the problem and its solution. First, what prevents a person from *seeing* things clearly enough to draw them?

A part of the answer is that, from childhood onward, we have learned to see things in terms of words: we name things, and we know facts about them. The dominant left verbal hemisphere doesn't want too much information about things it perceives — just enough to recognize and to categorize. The left brain, in this sense, learns to take a quick look and says, "Right, that's a chair (or an umbrella, bird, tree, dog, etc)." Because the brain is overloaded most of the time with incoming information, it seems that

one of its functions is to screen out a large proportion of incoming perceptions. This is a necessary process to enable us to focus our thinking and one that works very well for us most of the time. But *drawing* requires that you look at something for a long time, perceiving lots of details, registering as much information as possible — ideally, *everything*, as Albrecht Dürer tried to do in Figure 5-21.

The left hemisphere has no patience with this detailed perception, and says, in effect, "It's a chair, I tell you. That's enough to know. In fact, don't bother to look at it, because I've got a ready-made symbol for you. Here it is; add a few details if you want, but don't bother me with this *looking* business."

Fig. 5-21. Albrecht Dürer, Study for the Saint Jerome (1521).

"By the time the child can draw more than a scribble, by age three or four years, an already well-formed body of conceptual knowledge formulated in language dominates his memory and controls his graphic work. . . . Drawings are graphic accounts of essentially verbal processes. As an essentially verbal education gains control, the child abandons his graphic efforts and relies almost entirely on words. Language has first spoilt drawing and then swallowed it up completely."

-Written in 1930 by psychologist Karl Buhler And where do the symbols come from? From the years of childhood drawing during which every person develops a system of symbols. The symbol system becomes embedded in the memory, and the symbols are ready to be called out, just as you called them out to draw your childhood landscape.

The symbols are also ready to be called out when you draw a face, for example. The efficient left brain says, "Oh yes, eyes. Here's a symbol for eyes, the one you've always used. And a nose? Yes, here's the way to do it." Mouth? Hair? Eyelashes? There's a symbol for each. There are also symbols for chairs, tables, and hands.

To sum up, adult students beginning in art generally do not really see what is in front of their eyes — that is, they do not perceive in the special way required for drawing. They take note of what's there, and quickly translate the perception into words and symbols mainly based on the symbol system developed throughout childhood and on what they know about the perceived object.

What is the solution to this dilemma? Psychologist Robert Ornstein suggests that in order to draw, the artist must "mirror" things or perceive them exactly as they are. Thus, you must "turn off" your dominant L-mode of verbal categorizing and "turn on" the R-mode processing part of your brain, so that you can see the way an artist sees.

Again, the key question is how to accomplish that cognitive L

R shift. As I said in Chapter Four, the most efficient way seems to be to present the brain with a task the left brain either can't or won't handle. You have already experienced a few of those tasks: the Vase-Faces drawings; the upside-down drawing. And to some extent, you have already begun to experience and recognize the alternate state of right-hemisphere mode. You are beginning to know that while you are in that slightly different subjective state you can see more clearly and you are able to draw better.

As you think back over experiences with drawing since you started this book and over experiences of alternative states of consciousness you may have had in connection with other activities (freeway driving, reading, etc., mentioned in Chapter One), think again about the characteristics of that slightly altered state. It is important that you continue to develop your hidden Observer and become able to recognize the state.

Let's review the characteristics of the R-mode one more time. First, there is a seeming suspension of time. You are not aware of time in the sense of *marking* time. Second, you pay no attention to spoken words. You may hear the sounds of speech, but you do not decode the sounds into meaningful words. If someone speaks to you, it seems as though it would take a great effort to cross back, think again *in words*, and answer. Furthermore, whatever you are doing seems immensely interesting. You are attentive and concentrated and feel "at one" with the thing you are concentrating on. You feel energized but calm, active without anxiety. You feel self-confident and capable of doing the task at hand. Your thinking is not in words but in images and, particularly while drawing, your thinking is "locked on" to the object you are perceiving. The state is very pleasurable. On leaving it, you do not feel tired, but refreshed.

Our job now is to bring this state into clearer focus and under greater conscious control, in order to take advantage of the right hemisphere's superior ability to process visual information and to increase your ability to make the cognitive shift to R-mode at will.

The exercise in the next chapter is designed to carry you more deeply into the alternative state than you have been before. The purpose is to strengthen your Observer and increase your control over the cognitive shift so that you can place yourself *by conscious choice* into the condition in which the shift will occur. Once the shift occurs and the L-mode subsides, you will see more clearly in the artist's mode of seeing.

"Art is a form of supremely delicate awareness . . . meaning at-oneness, the state of being at one with the object. . . . The picture must all come out of the artist's inside. . . . It is the image that lives in the consciousness, alive like a vision, but unknown."

—D. H. Lawrence, the English writer, speaking about his paintings

"The development of an Observer can allow a person considerable access to observing different identity states, and an outside observer may often clearly infer different identity states, but a person himself who has not developed the Observer function very well may never notice the many transitions from one identity state to another."

—Charles T. Tart Alternative States of Consciousness

Lewis Carroll described an analogous shift in Alice's adventures in *Through the Looking-Glass:*

"Oh, Kitty, how nice it would be if we could only get through into Looking Glass House! I'm sure it's got, oh! such beautiful things in it! Let's pretend there's a way of getting through into it, somehow, Kitty. Let's pretend the glass has got all soft like gauze, so that we can get through. Why, it's turning to a mist now, I declare! It'll be easy enough to get through. . . ."

Getting Around Your Symbol System: Meeting Edges and Contours

e have reviewed your childhood art and the development of the set of symbols that formed your childhood language of drawing. This process paralleled the development of other symbol systems: speech, reading, writing, and arithmetic. Whereas these other symbol systems formed useful foundations for later development of verbal and computational skills, childhood drawing symbols seem to *interfere* with later stages of art.

Thus, the central problem of teaching realistic drawing to individuals from age ten or so onward is that the left brain seems to insist on using its memorized, stored drawing symbols when they are no longer appropriate to the task. In a sense, the left brain unfortunately continues to "think" it can draw long after the ability to process spatial, relational information has been lateralized, or shifted, to the right brain. When confronted with a drawing task, the left hemisphere comes rushing in with its verbally linked symbols; afterward, ironically, the left brain is all too ready to supply derogatory words of judgment if the drawing looks childlike or naive.

In the last chapter I said that an effective way to "turn off" your dominant left hemisphere, with its verbal, symbolic style of working, and to "turn on" your nondominant right brain, with its spatial relational style, is to present your brain with a task that the left brain either can't or won't work at. We have used the Vase-Faces drawings and upside-down drawings to gain access to your R-mode. Now we'll try another, more drastic strategy that will force a stronger cognitive shift and suppress your L-mode more completely.

The technique is called "pure contour drawing," and your left hemisphere is probably not going to like it. Introduced by a respected art teacher, Kimon Nicolaides, in his 1941 book, *The Natural Way to Draw*, the method has been widely used by art teachers. I believe that our new knowledge about how the brain divides its work load provides a conceptual basis for understanding *why* pure contour drawing is effective as a teaching method. At the time of writing his book, Nicolaides apparently felt that the reason the pure contour method improved students' drawing was that it caused students to use both senses of sight *and* touch: Nicolaides recommended that students imagine that they were *touching* the form as they drew. It seems more likely now that the method works because the left brain rejects the slow, meticulous,

complex perceptions of spatial, relational information, thus allowing access to R-mode processing. In short, pure contour drawing doesn't suit the left brain's style; it suits the style of the right brain — again, just what we want.

Before describing the method, I'll define some terms.

In drawing, a *contour* is defined as an *edge as you perceive it*. As a method, pure contour drawing (which is sometimes termed "blind contour drawing") entails close, intense observation as you draw the edges of a form *without looking at the drawing* while it is in progress.

An edge, as the term is used in drawing, is the place where two things meet. In drawing your hand, for example, the places where the air (which in drawing is thought of as background or negative space) meets the surface of your hand, the place where a fingernail meets the surrounding skin, the place where two folds of skin meet to form a wrinkle, and so on, are shared edges. The shared edge (called a contour) can be described — that is, drawn — as a single line, which is called a contour line. (We'll be working with edges again in the next chapter on negative space.)

This concept of edges is a fundamental concept in art, having to do with *unity*, perhaps the most important principle in art. Unity is achieved when everything in a composition fits together as a coherent whole, each part contributing to the wholeness of the total image.

AN EXERCISE IN EDGES

To firmly set in your mind the concept of unified shapes and spaces that share edges, do the following exercise in imaging and seeing edges:

- 1. See in your mind's eye a disassembled child's jigsaw puzzle of six or eight painted pieces. The pieces will go together to form a picture of a sailboat on a lake. Imagine that the jigsaw pieces are shaped like the forms: a single white piece is the sail; a red piece, the boat, etc. Imagine the rest of the pieces in your own way land, dock, clouds, whatever.
- 2. Now assemble the pieces in your imagination. See that the two edges come together to form a *single line* (imagine this as a precision-cut puzzle). These shared edges form *contour lines*. All of the pieces spaces (sky and water) and shapes (boat, sail, land, etc.) fit together to form the whole puzzle.
- 3. Next regard your own hand, one eye closed to flatten the image (closing one eye removes binocular depth perception).

"Merely to see, therefore, is not enough. It is necessary to have a fresh, vivid, physical contact with the object you draw through as many of the senses as possible — and especially through the sense of touch."

—Kimon Nicolaides The Natural Way to Draw Think of your hand and the air around it as a jigsaw puzzle, the spaces (negative spaces) between the fingers sharing edges with the fingers; the shape of the flesh *around* each fingernail sharing an edge with the fingernail; two areas of skin sharing an edge to form a wrinkle. The whole image, made up of shapes and spaces, fits together like a jigsaw puzzle.

4. Now direct your eyes at one specific edge anywhere on your hand. Imagine in your mind's eye that you are drawing that edge as a single, slow, exact line on a piece of paper. As your eyes move slowly along the edge, imagine that you can *simultaneously* see the line being drawn, as though by some magical recording device.

USING PURE CONTOUR DRAWING TO BYPASS YOUR SYMBOL SYSTEM

In my classes, I demonstrate pure contour drawing, describing how to use the method as I draw — if I can manage to keep talking (an L-mode function) while I'm trying to use my right brain for drawing. Usually, I start out all right but begin trailing off in mid-sentence after five minutes or so. By that time, however, my students will have the idea.

Following the demonstration, I show examples of previous students' pure contour drawings.

Before you begin: To best achieve an approximation of the class-room procedure, be sure to read all of the instructions and examine all of the student drawings in the Student Showing before beginning your drawing.

- 1. Find a place where you can be alone and uninterrupted for at least twenty minutes.
- 2. Set an alarm clock or timer, if you wish, for twenty minutes just before you start your drawing. (This is to remove the necessity of keeping track of time an L-mode function.) Or, if you have plenty of time and don't care about how long you might be drawing, omit the timer.
- 3. Place a piece of paper on a table and tape it down in any position that seems comfortable. Taping is necessary so that the paper won't shift about while you are drawing.
- 4. You are going to draw a picture of your own hand your left hand if you are right-handed, your right hand if you are left-handed. Arrange yourself so that your drawing hand, hold-

ing the pencil, is ready to draw on the taped-down paper.

5. Face all the way around to the opposite direction, gazing at the hand you will draw. Be sure to rest the hand on some support, because you will be holding the same position for quite a long time. You are going to draw your hand without being able to see what you are drawing (see the position in Figure 6-1). Facing away from your drawing is necessary to achieve the purpose of the method: first, to focus your entire attention on the visual information out there in front; and second, to remove all attention from the drawing, which might trigger off your old symbolic patterns memorized from childhood as the "way to draw hands." You want to draw only what you see (in spatial R-mode) and not what you know (in symbolic L-mode). Turning all the way around is necessary also because the impulse to look at the drawing is almost overwhelming at first. If you draw in the normal position

Fig. 6-1. The turned-around drawing position for pure contour drawing.

"In oneself lies the whole world and if you know how to look and learn, then the door is there and the key is in your hand. Nobody on earth can give you either the key or the door to open, except yourself."

—J. Krishnamurti You Are the World and say to yourself, "I just won't look," you will very likely find yourself stealing peeks out of the corner of your eye. This will reactivate the L-mode and defeat the purpose of the exercise.

6. In the turned-around position, focus your eyes on some part of your hand and perceive an *edge*. At the same time, place the point of your pencil on the paper (at any place well within the outside borders of the paper).

7. Very slowly, creeping a millimeter at a time, move your eyes along the edge of your hand, observing every minute variation and undulation of the edge. As your eyes move, also move your pencil point at the same slow pace on the paper, recording each slight change or variation in the edge that you observe with your eyes. Become convinced in your mind that the information originating in the observed object (your hand) is minutely and precisely perceived by your eyes and is simultaneously recorded by the pencil, which registers everything you are seeing at the moment of seeing.

8. Do not turn around to look at the paper. Observing your hand, draw the edges you see one bit at a time. Your eyes will see and your pencil will record bit by bit the changing configuration of the contour. At the same time you will be aware of the relationship of that contour to the whole configuration of complex contours that is the whole hand. You may draw outside or inside contours or move from one to the other and back again. Don't be concerned about whether the drawing will look like your hand. It probably won't, since you can't monitor proportions, etc. By confining your perceptions to small bits at a time, you can learn to see things *exactly as they are*, in the artist's mode of seeing.

9. Match the movement of the pencil exactly with your eye movement. One or the other may attempt to speed up, but don't let that happen. You must record everything at the very instant that you see each point on the contour. Do not pause in the drawing, but continue at a slow, even pace. At first you may feel uneasy or uncomfortable: some students report sudden headaches or a sense of panic. I believe this happens when the left brain senses that pure contour drawing is presenting a serious challenge to its dominance. It realizes, I think, that if you record the intricate, complex tangle of edges in your hand at the slow pace you are drawing, the right brain will have control for a long, long time. Therefore, the left brain says, in effect, "Stop this stupid stuff right now! We don't need to look at things that closely. I've already named everything for you, even some small

things like wrinkles. Now be reasonable and let's get on with something that's not so boring — if you don't, I'll give you a headache."

Ignore this complaining. Simply persist. As you continue to draw, the protests from the left will fade out and your mind will become quiet. You will find yourself becoming fascinated with the wondrous complexity of the thing you are seeing, and you will feel that you could go deeper and deeper into the complexity. Allow this to happen. You have nothing to fear or be uneasy about. Your drawing will be a beautiful record of your deep perception. We are not concerned about whether the drawing looks like a hand. We want the record of your perceptions.

After you finish: Think back now on how you felt at the beginning of the pure contour drawing compared to how you felt later, when you were deeply into the drawing. What did that later state feel like? Did you lose awareness of time passing? Like Max Ernst, did you become enamored of what you saw? When you return to the alternative state, will you recognize it?

For most students, pure contour drawing produces the deepest hift, the farthest journey into the R-mode subjective state, of any of the exercises. Cut off from the drawing — from visual input that would allow naming, symbolizing, categorizing — and forced to focus on what it considers too much information, the left mode is turned down and the right mode takes over the job. The slowness of the drawing seems to push the left mode deeper and deeper into neutral, or "off." Pure contour drawing is so effective at producing this strong shift that many artists routinely begin drawing with at least a short session of the method, in order to start the process of turning off the L-mode.

If perhaps you did not achieve a strong shift to R-mode in this first drawing, be patient with yourself. Some individuals' left hemispheres are very determined, or perhaps very fearful, of giving up control to the right. You must reassure the left. Talk to it. Tell it that you are not going to abandon it, that you just want to try something out.

Gradually, you'll find that the left will "allow" the shift. Make sure, however, that you don't permit your verbal left brain to ridicule your pure contour drawing, saying critical things and spoiling the gain you have made. That's not what we were after at this point. Soon, however, we'll be putting everything together, and your drawing will be better than ever before.

Krishnamurti: "So where does silence begin? Does it begin when thought ends? Have you ever tried to end thought?"

Questioner: "How do you do it?" Krishnamurti: "I don't know, but have you ever tried it? First of all, who is the entity who is trying to stop thought?"

Questioner: "The thinker."

Krishnamurti: "It's another thought, isn't it? Thought is trying to stop itself, so there is a battle between the thinker and the thought.... Thought says, 'I must stop thinking because then I shall experience a marvelous state.'... One thought is trying to suppress another thought, so there is conflict. When I see this as a fact, see it totally, understand it completely, have an insight into it... then the mind is quiet. This comes about naturally and easily when the mind is quiet to watch, to look, to see."

-J. Krishnamurti
You Are the World

"Blind swimmer, I have made myself see. *I have seen*. And I was surprised and enamored of what I saw, wishing to identify myself with it...."

-Max Ernst

In *The Doors of Perception*, Aldous Huxley described the effects of mescalin on his perception of ordinary things — in this instance, the folds of his gray flannel trousers. He saw the folds as "living hieroglyphs that stand in some peculiarly expressive way for the unfathomable mystery of pure being.... The folds of my gray flannel trousers were charged with 'isness.'"

Huxley continued: "What the rest of us see only under the influence of mescalin, the artist is congenitally equipped to see all the time."

STUDENT SHOWING:

A Record of an Alternative State

Following is a Student Showing of some pure contour drawings. What strange and marvelous markings are these! Never mind that some of the drawings don't resemble greatly the overall configuration of a hand — that's to be expected. We will attend to the overall configuration in the next exercise, "modified contour drawing."

In pure contour drawing, it is the quality of the marks and their character that we care about. The marks, these living hieroglyphs, are *records of perceptions*. To be found nowhere in the drawings are the thin, glib, stereotypic marks of casual, rapid L-mode symbolic processing. Instead, we see rich, deep, intuitive marks made in response to the thing-as-it-is, the thing as it exists out there, marks that delineate the *is-ness* of the object.

Cami Berg

Blind swimmers have seen! And seeing, they have drawn.

I believe that these drawings are visual records of the R-mode state of consciousness. As a friend of mine, writer Judi Marks, remarked on viewing a pure contour drawing for the first time, "No one in their left mind would do a drawing like that!"

Begin now to draw, using the Pure Contour Drawing method. Continue to draw until the timer goes off. While you may of course stop whenever you feel like it, try to draw for about 30 minutes without stopping and without looking at your drawing. If you make a significant shift to R-mode, you may draw on and on for even an hour or so.

MODIFIED CONTOUR DRAWING

Now that you have learned how to gain access to the right half of your brain — how to open doors of perception and to enter the slightly altered subjective state of right-hemisphere processing

Student Showing: Pure Contour Drawing

Supplementary Exercises

6a. Following precisely the directions for pure contour drawing, observe and draw a complex flower such as an iris, a chrysanthemum, a rose, a geranium. Draw for thirty minutes.

6b. Again following the directions for pure contour drawing, draw a natural inanimate object such as a shell, a rock, or a piece of driftwood. Again, choose a complex object. Draw for thirty minutes.

6c. Crumple a piece of paper and draw it, using pure contour drawing. If possible, take a full hour to do this drawing.

— you are beginning to *see* in the way artists see, and you are almost ready to draw a realistic image using the next method, "modified contour drawing."

But before we go into that, do exercises 6a, b, and c. Do not skip these drawings. They are necessary for you to fully experience the cognitive shift so that the R-mode state becomes familiar and pleasurable. After that, the transition to modified contour drawing will be easier to make.

Modified contour drawing is exactly like pure contour drawing, *except* that you allow yourself to glance at the drawing at intervals for the sole purpose of noting relationships of sizes, lengths, and angles. You will be able to glance briefly at your drawing to monitor line direction, proportion, etc., and at the same time to use the slow, intense observation that causes the cognitive shift to R-mode.

Before you begin: Read all of the directions.

- 1. Arrange for at least a half-hour of uninterrupted time.
- 2. Sit comfortably at a table, this time in the usual position, shown in Figure 6-2. Again, tape your paper to the table so that it won't slip around. You are going to draw your own hand again. Arrange your hand in a complex position fingers entwined, clenched, crossed, whatever. A complicated position is better for our purposes than a flat, open, simple position because the right hemisphere seems to prefer complexity.
- 3. Be sure not to move either the position of your hand, once you've started the drawing, or your head that is, don't tilt your head to see part of your hand that may be hidden from view. Take a single position and stay there. We want one view only, not a multiple view that would distort your drawing.
- 4. Gaze at your hand in preparation to draw. This will start the cognitive shift to R-mode processing. *Image* a vertical line and a horizontal line next to your hand. Observe the relationship of a single angle to either vertical or horizontal. Now look at your paper and *image* the angle as though it were drawn on the paper. Find a space, perhaps between the fingers. Gaze at that space until you see the edge of the space where it meets the edge of the finger. Try to feel your mind making the cognitive shift to R-mode.
- 5. Fasten your eyes at any point on a contour. Check the angle in relation to vertical or horizontal. As your eyes move slowly along the contour, your pencil draws the contour on the paper at the same slow

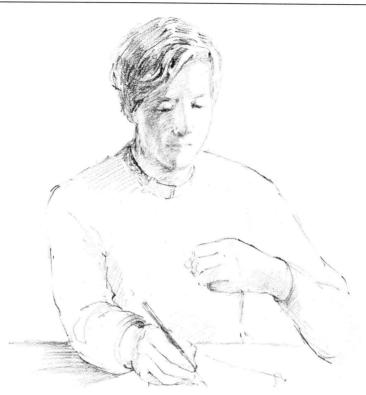

Fig. 6-2. The position for modified contour drawing is the usual drawing position.

speed. Move from contour to adjacent contour. Do not draw a complete outline and then try to draw the interior forms. It's much easier to move from form to adjacent form. As in pure contour drawing, your pencil will record all of the edges, noting every slight change of direction and undulation of each contour. This is a wordless process. Do not talk to yourself. Do not name the parts as you draw. You are working with visual information only; words do not help. It's not necessary to try to figure anything out logically, because all of the visual information is right there in front of your eyes. Concentrate on what you see, wordlessly sensing to yourself how long one part is in relation to another; how wide one part is in relation to the one you have just drawn; how steep one angle is compared to another; and where one contour appears to emerge from one you have just drawn.

6. Glance at your paper only to locate a point or to check on a relationship. About ninety percent of your drawing time should be spent with your eyes focused on the hand you are drawing, just as in the pure contour method.

Professor Elliot Elgart of the University of California at Los Angeles Art Department told me in conversation that he has often observed beginning drawing students, presented for the first time with a reclining model, tilt their heads far to one side while drawing the model. Why? To see the model in the position they are used to, which is standing up!

- 7. When you come to the f-i-n-g-e-r-n-a-i-l-s (we are not naming things, remember), draw the shapes around the nails, not the nails themselves. This way you will avoid any dredged-up symbols from childhood. The left brain has no names for the shapes around fingernails. In fact, if you have trouble with any part, shift to the next adjacent shape or to the space that *shares* the contour you need.
- 8. Finally, remember that everything you need to know about your hand in order to do your drawing all of the required perceptual information you need is right there in front of your eyes. Your job is simply to set down the perceptions just as you see them in marks that are records of perceptions. You don't need to think in order to do this. Since you need only sense and observe and record what you see, the drawing will seem easy and you will feel confident and relaxed and engaged, fascinated with how the parts all fit together like a perfectly fitted jigsaw puzzle.

Begin now to draw. Within a few minutes you will have shifted to the alternative state of R-mode, but you needn't think about that. You have consciously set the conditions for the shift to occur, and it will soon occur without any effort on your part. Modified contour drawing, like the other exercises, is a task that the left brain will turn down, opening access to the right-hemisphere mode.

After you finish: Review in your mind the drawing strategies you used, what the R-mode state of consciousness felt like, how you slipped into that state by consciously setting up conditions to facilitate the shift.

This first drawing may reveal some misperceptions of proportion or of relative angles. Exercises in the next chapters will help correct problems with proportions.

Drawing at this stage is rather like learning to drive a car. You first learned the separate operations — acceleration, braking, signaling; watching cars ahead, behind, at the sides. In driving that first time, you had to put everything together, coordinating separate skills into an integrated whole. The first time was harder than the second, the second harder than the third. Soon the skills and strategies were integrated.

And so it is with drawing. Drawing is a holistic skill, requiring the coordination of a number of strategies. In a short time, these strategies will become as automatic as braking, accelerating, and signaling have become for you when driving. To give yourself more practice and to build confidence, carefully do exercises 6d to 6g on page 95. Before you start each drawing, set up the conditions that will facilitate the cognitive shift to the R-mode state of consciousness. Especially important: make sure you have a block of uninterrupted time. Later, you may be able to accomplish the shift in spite of interruptions, but most artists seek solitude for drawing.

STUDENT SHOWING: Modified Contour Drawing

In the following student drawings, the hands seem to have been drawn by individuals who were experienced at drawing. The hands are three-dimensional, believable, authentic. They seem to be made of flesh, muscles, skin, and bones. Even very subtle qualities are described, such as the pressure of one finger on another, the tension of certain muscles, or the precise texture of the skin.

THE NEXT STEP: TRICKING THE L-MODE WITH EMPTY SPACE

So far, we have located some gaps in the abilities of the left hemisphere: it has problems with mirror images (as in the Vase-Faces drawing); it can't deal with upside-down perceptual information (as in the upside-down Stravinsky drawing); it refuses to process slow, complex perceptions (as in the pure and modified contour drawings). We used those disabilities to give your right hemisphere a chance to process visual information without interference from the domineering left brain.

The next chapter is designed to reestablish your grasp of the unity of spaces and forms in composition, which you had as a child. The emphasis of that chapter is on negative space.

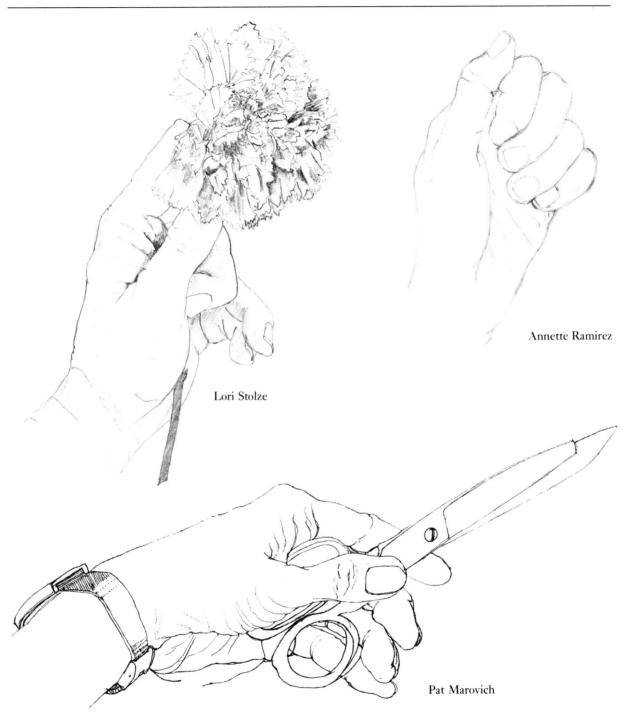

Student Showing: Modified Contour Drawing

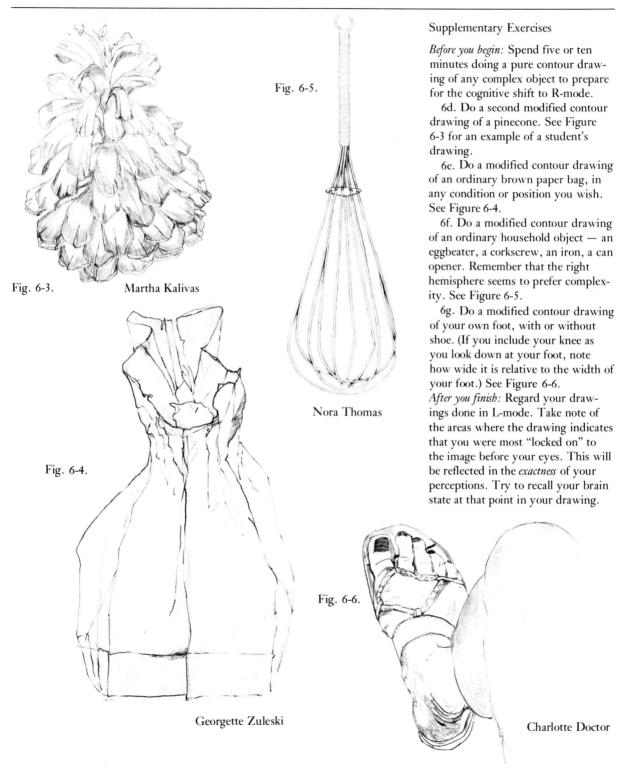

Perceiving the Shape of a Space: The Positive Aspects of Negative Space

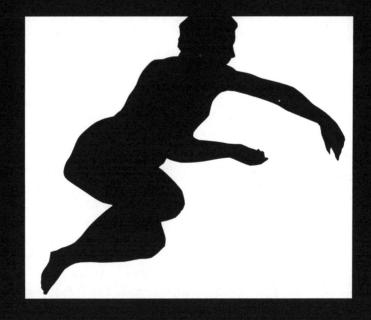

Fig. 7-1. A variety of formats.

In drawing, the term *composition* means the way the components of a drawing are arranged by the artist. Some key components of a composition are *positive shapes* (the objects or persons), *negative spaces* (the empty areas), and the *format* (the relative length and width of the bounding edges of a surface). To compose a drawing, therefore, the artist places and fits together the positive shapes and the negative spaces *within the format*.

The format controls composition. Put another way, the shape of the drawing surface (usually rectangular paper) will greatly influence how an artist distributes the shapes and spaces within the bounding edges of that surface. To clarify this, use your R-mode ability to image a tree, perhaps an elm or a pine. Now fit the same tree into each of the formats in Figure 7-1. You will find that you have to change the shape of the tree and the spaces around the tree for each format. Test that by imaging exactly the same tree in all of the formats. You will find that a shape that fits one format is all wrong for another.

Experienced artists fully comprehend the importance of the shape of the format. Beginning students in drawing, however, are curiously oblivious to the bounds of the paper. Because their attention is directed almost exclusively toward the objects or persons they are drawing, they seem to regard the edges of the paper almost as nonexistent, almost like the real space that surrounds objects and has no bounds.

This obliviousness to the edges of the paper, which bound both the negative spaces and positive shapes, causes problems with composition for nearly all beginning art students. The most serious problem is the failure to unify two basic components — the spaces and the shapes.

YOUNG CHILDREN COMPOSE WITHIN THE FORMAT

In Chapter Five, we saw that young children have a strong grasp of the importance of the format. Children's consciousness of the bounding edges of the format controls the way they distribute the forms and spaces, and young children often produce nearly flawless compositions. The composition by a six-year-old in Figure 7-3 compares favorably with the Spanish artist Miro's composition in Figure 7-2.

Fig. 7-2. Joan Miró, *Personages with Star* (1933). Courtesy, Art Institute of Chicago.

Unfortunately, as you have seen, this ability lapses as children approach adolescence, perhaps due to increasing domination of their left hemisphere, with that hemisphere's penchant for recognizing, naming, and categorizing objects. Concentration on things seems to supersede the young child's more holistic view of the world, where everything is important, including the negative spaces of sky, ground, and air. Usually it takes years of training to convince students, in the way experienced artists are convinced, that the negative spaces, bounded by the format, require the same degree of attention and care that the positive forms require. Beginning students generally lavish all their attention on the objects, persons, or forms in their drawings, and then sort of "fill in the background." It may seem hard to believe at this moment, but if care and attention are lavished on the negative spaces, the forms will take care of themselves. I'll be showing you specific examples of that.

The quotations by the playwright Samuel Beckett and the Zen philosopher Alan Watts state this concept concisely. In art, as Beckett says, *nothing* (in the sense of empty space) is real. And as Alan Watts says, *the inside and outside are one*. You saw in the last chapter that in drawing, the objects and the spaces around them

Fig. 7-3.

James Lord described artist Alberto Giacometti's reaction to an empty space:

"He began to paint once more, but after a few minutes he turned round to where the bust had been, as though to reexamine it, and exclaimed, 'Oh, it's gone!' Although I reminded him that Diego had taken it away, he said, 'Yes, but I thought it was there. I looked and suddenly I saw emptiness. I saw emptiness. It's the first time in my life that that's happened to me."

—James Lord A Giacometti Portrait

"Nothing is more real than nothing."
—Samuel Beckett

"You can never have the use of the inside of a cup without the *outside*. The inside and the outside go together. They're one."

-Alan Watts

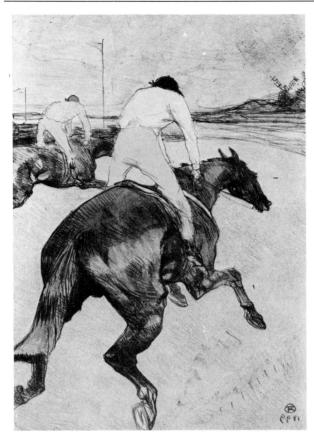

Fig. 7-4. Henri de Toulouse-Lautrec (1864-1901), *Le Jockey*. Courtesy, The Cleveland Museum of Art, Mr. and Mrs. Charles G. Prasse Collection.

"Expression to my way of thinking does not consist of the passion mirrored upon a human face or betrayed by a violent gesture. The whole arrangement of my picture is expressive. The place occupied by the figures or objects, the empty spaces around them, the proportions, everything plays a part."

—Henri Matisse "Notes d'un peintre" fit together like the pieces of a puzzle. Every piece is important, and together they fill up all of the area within the four edges — that is, within the format.

Look at the example of this *fitting together* of the spaces and shapes in the jockey drawing by Toulouse-Lautrec (Figure 7-4), the still-life painting by Paul Cézanne (Figure 7-5), and the figure drawing by Dürer (Figure 7-6).

NEGATIVE-SPACE DRAWING: WHEN SPACES TAKE SHAPE

Now, we shall take advantage of another gap in the L-mode. The left hemisphere is not well equipped to deal with empty spaces. It can't name them, recognize them, match them with stored categories, or produce ready-made symbols for them. In fact, the left brain seems to be bored with spaces and refuses to deal with

Fig. 7-5. Paul Cézanne (1839-1936), *The Vase of Tulips*. Courtesy of The Art Institute of Chicago. By making the positive forms touch the edge of the format in several places, Cézanne enclosed and separated the negative shapes, which contribute as much to the interest and balance of the composition as do the positive forms.

Fig. 7-6. Albrecht Dürer (1471-1528), *Nude Woman with a Staff* (1508). Courtesy of The National Gallery of Canada, Ottawa. The negative shapes surrounding the figure are beautifully varied in size and configuration.

them. Therefore, they are passed over to the right hemisphere — just what we want!

The right brain doesn't seem to mind spaces, being more eclectic, more pliable, more democratic (metaphorically speaking). To the right brain, spaces, objects, the known and unknown, the nameable or unnameable, are all the same. It's all interesting — and should the visual information falling on the retina of the eye be strange and complex, all the better.

Let's try it out. We'll start with some objects, just to keep your L-mode happy.

1. On a sheet of paper draw some large forms: two starfish, three pipes, musical instruments, some abstract shapes, or any other forms you wish. *These are positive forms*. Look at the starfish example in Figure 7-7. Be sure that the positive forms *touch the edges of the format* in at least two places, as in the example. The

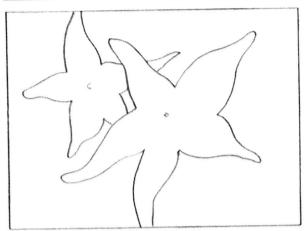

Fig. 7-7.

The poet John Keats wrote that understanding poetry required that we must be willing to put ourselves in a special state of mind, which Keats called "negative capability." He described this state as one in which a person "is capable of being in uncertainties, mysteries, doubts; without any irritable reaching after facts and reason."

Fig. 7-8.

spaces around the starfish are the negative spaces.

2. To reinforce the idea that, in drawing, the *spaces* are regarded as *shapes*, go over the drawing with your pencil, consciously and deliberately, heavily outlining the shapes of the spaces, *including the edges of the paper as part of the negative space/shape*. Go over the outline several times, as shown in Figure 7-8.

- 3. Now, direct your gaze at one of these outlined areas, until you can see it as a shape. This takes a little time. The left brain, confronted with a shape that has no name, takes a moment to scan for recognition. Unable to match the space up with any known thing, the left brain says, in effect, "I don't know what that is. That kind of thing isn't useful to me and if you are going to continue to look at it, *you* (the right hemisphere) will have to deal with it. I'm not interested." Good! That's just what we want. Keep gazing at one of the shapes, and it will come into focus as a shape.
- 4. Darken the negative spaces with pencil or pen, as in Figure 7-9, to further strengthen the concept of the *space as a shape*. Again, gaze at the shapes, one at a time, until you can perceive them.
- 5. Next, using scissors, *cut out* the negative spaces. Pick them up. Perceive them as shapes. Turn them various ways. Then, using paste or tape, put them back together with the *positive forms* on a new sheet of paper, perhaps of a different color. Since the negative spaces share edges with the positive forms, when pasted back in place the negative-space cutout pieces (Figure 7-10), reconstruct the positive form (the starfish) as well.

The point of this exercise is important. As you learned in

Fig. 7-9. Fig. 7-10.

contour drawing, the positive forms and the negative spaces share the same edges. If you draw one, you have inadvertently drawn the other. Test that concept again in your mind. Look at some object — the scissors, for example, that you just used. If you draw the shapes of the spaces in the handles, the edges of those negative spaces are also the inner edges of the handles themselves.

An Analogy

Let me say it another way. You probably have seen cartoons in the movies or on TV where one of the characters — Bugs Bunny, for example — runs down a hallway and smashes through a closed door, leaving a Bugs Bunny-shaped hole in the door. Image this seeming paradox in your mind: what's left of the door is the negative space, and the inner edge of that *shape* is the edge of the negative space and *also* is the outline of the positive form (Bugs Bunny). In other words, the empty hole and the solid door share edges, and if you draw one you will have also drawn the other.

Now, turn your gaze to some piece of furniture that has open spaces — a stool, a rocking chair, a school desk, a dining chair with a slatted back and rungs. Imagine to yourself that — poof! the chair is gone, leaving the negative spaces intact and solid.

Holding that image in your mind, gaze now at one of the enclosed spaces that the arrows point to in the chair in Figures 7-11 and 7-12. Hold your gaze there, and wait until you can see the space as a shape. It's important to remember that this will take a little time, a moment or two. The left hemisphere, perhaps,

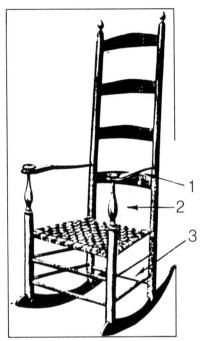

Fig. 7-11.

Fig. 7-12.

regards the space but finds the information unsuited to its style and passes the job over to the right hemisphere.

Practice this perception of negative spaces several times at least, shifting from space to space, waiting until the *shape of the space* comes into focus — that is, until you perceive the space as a *shape*. Try exercise 7a before continuing.

USING A VIEWFINDER TO FORM EDGES

Now we are going to *bound* the perception of the whole thing — positive form and negative spaces within a format — by using an aid to perception called a viewfinder.

Construct a viewfinder as follows:

- 1. Take a sheet of paper, or use thin cardboard of the same size as the paper you use for drawing. The viewfinder must be the same format, that is, the same proportional shape, as the paper you are using to draw on.
- 2. Draw diagonal lines from opposite corners, crossing in the center. In the center of the paper, draw a small rectangle by connecting horizontal and vertical lines at points on the diagonals. The rectangle should be about $1'' \times 1\frac{1}{4}''$. (See Figure 7-13.) Constructed this way, the inner rectangle has the same proportion of length to width as the outer edges of the paper.
- 3. Next, cut the small rectangle out of the center with scissors. Hold the paper up and *compare* the shape of the small opening with the shape of the whole format. You can see that the two *shapes* are the same, and only the size is different. This perceptual aid is called a viewfinder. It will help you to perceive negative

Supplementary Exercise

7a. Practice seeing negative spaces by cutting apart a magazine photograph or a photocopy of a drawing by a master artist, such as the Boucher nude in Figure 7-14. Reassemble the *negative-space pieces* only, gluing them to a sheet of black paper. As you see, the negative spaces form the figure because they *share edges* with the figure.

Fig. 7-14. François Boucher (1703-1770), *Seated Nude*. Courtesy of the Rijksmuseum, Amsterdam.

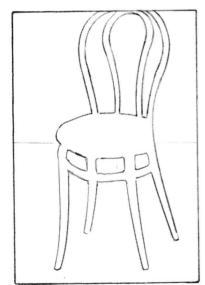

Fig. 7-16.

- spaces by establishing an edge to the space around forms.
- 4. Hold up your viewfinder, close one eye (or hold a hand over one eye), and look through the opening at a chair. You may have to move the viewfinder closer to, or farther from, your eyes in order to frame the chair so that you can see most of it. Move the viewfinder so that the *chair touches the edges* at at least two points (Figure 7-15).
- 5. Now direct your gaze at one of the negative spaces surrounding the chair and *wait* until you can see it as a shape, just as you did with the starfish negative spaces.
- 6. Now imagine that the chair vanishes, and, like the door that Bugs Bunny smashed through, only the negative spaces remain as shapes. *These are what you are going to draw: the negative spaces*. Let me first show you some examples, and then I'll explain why this technique works so well and is valuable to artists.

A Paradox: Drawing Something by Drawing Nothing

You'll notice that no descriptive interior lines of the chairs themselves are included in Figures 7-16 and 7-19. Yet the chairs seem to be nearly fully described, because the negative spaces around them share edges with the chairs themselves. If the shapes of the spaces are drawn, the object is *inadvertently* drawn also, *but with ease*. And by raising the spaces to the same level of importance as the shapes, the drawing also becomes somehow pleasing to look at. That is, the compositional problem is solved: *the spaces and shapes are unified* by giving equal importance to every "puzzle piece" within the bounding edges of the format.

Why is drawing easier when you draw the shapes of the spaces? I believe that the left brain, having no equivalent name or category for a negative space, stops intruding what it knows about chairs, and lets the right brain take over. The problem with drawing chairs and tables, as with many other things we might want to draw, is that we know too much about them. We know that table tops are flat and have square corners (or are round or oval); the legs are all the same length; chair seats are flat; a chair back is at right angles to the seat; the chair seat is wide enough and long enough to be comfortable to sit on; the chair legs are all the same length, etc.

When a beginning drawing student starts to draw a chair or table, this previously stored, verbal, analytic, L-mode knowledge contradicts the visual information coming into the brain. Chairs and tables seen from an oblique angle *visually* may have none of the attributes we associate with them: square corners appear to be angles, circles appear to be ovals or straight lines, legs may appear to be three or four different lengths, as you see in Figure 7-16.

Therefore, the drawing student tries to solve the problem of chairs and tables two different ways, using two contradictory sets of information, and a struggle ensues. Look back, now, at the preliminary drawing you did of a chair. Perhaps you can see in your drawing the evidence of your struggle to reconcile what you know about chairs with what you saw.

THE COGNITIVE BATTLE OF PERCEPTION

Figures 7-17 and 7-18 show an interesting graphic record of the struggle and its resolution in two drawings by a student of a cart and slide projector. In Figure 7-17, the first drawing, the student had great difficulty reconciling his stored knowledge of what the objects were "supposed to look like" with what he saw. Notice in the drawing that the legs of the cart are all the same length, and a symbol is used for the wheels. When he switched to R-mode drawing, using a viewfinder and drawing only the shapes of the negative spaces, he was far more successful (Figure 7-18). The visual information apparently came through clearly; the drawing looks confident and as though it were done with ease. And, in fact, it was done with ease, because the left hemisphere had been tricked into keeping quiet.

It's not that the visual information gathered by regarding spaces rather than objects is really less complex or is in any way easier to draw. The spaces, after all, share edges with the form. But by looking at the spaces, we *free the R-mode from the domination of the L-mode*. Put another way, by focusing on information that does not suit the style of the left brain, we cause the dominant L-mode to turn off and the job is passed over to the hemisphere that is appropriate for drawing, the right hemisphere. Thus, the conflict ends, and in R-mode, the brain processes spatial, relational information with ease.

DRAW UP A CHAIR — YOU ARE READY TO START

You are ready now to do your own negative-space drawing of a chair.

Before you begin: Read the following specific instructions.

Fig. 7-17.

Fig. 7-18. Robert Dominguez

In a conversation with his friend, André Marchand, the French artist Henri Matisse described the process of passing perceptions from one way of looking to another:

"Do you know that a man has only one eye which sees and registers everything; this eye, like a superb camera which takes minute pictures, very sharp, tiny — and with that picture man tells himself: 'This time I know the reality of things,' and he is calm for a moment. Then, slowly superimposing itself on the picture another eye makes its appearance, invisibly, which makes an entirely different picture for him.

"Then our man no longer sees clearly, a struggle begins between the first and second eye, the fight is fierce, finally the second eye has the upper hand, takes over and that's the end of it. Now it has command of the situation, the second eye can then continue its work alone and elaborate its own picture according to the laws of interior vision. This very special eye is found here," says Matisse, pointing to his brain.

Marchand didn't mention which side of his brain Matisse pointed to.

—J. Flam, Matisse on Art

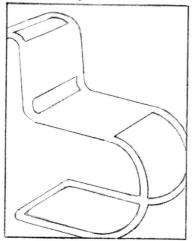

Fig. 7-19.

- 1. Select a chair to draw. Use a real chair, not a photograph.
- 2. Hold up your viewfinder (refer back to Figure 7-15) and look through it at the chair with one eye closed or one eye covered. (Closing one eye *flattens* the image by limiting vision to a *monocular image*, meaning a single image. *Binocular* vision with both eyes open produces a double image, enabling us to perceive a three-dimensional form.) If you feel uncomfortable viewing the image with one eye closed, don't worry about it. You'll do quite well with both eyes open. It simply is a little easier to transfer a *flat*, one-eyed image to the flat paper. Most artists use this technique at least occasionally.
- 3. Frame the chair in the viewfinder so that parts of the chair touch the edges of the opening at a minimum of two points.
- 4. Gaze at the whole image as though you were memorizing it, fixing the image in your mind.
- 5. Next, look down at the paper you will draw on. *Image* the positive form of the chair on paper just as you saw it in the viewfinder.
- 6. Now look through the viewfinder. Gaze at the negative space on one side of the chair. Wait until you can see it as a shape. Now look down at your paper, and image the shape on the paper, keeping in mind that the edges of the viewfinder represent the edges of your paper.
- 7. Your job now is to draw only the spaces, one after another. You can draw all of the outside spaces, and then draw the inside spaces, or vice versa. It doesn't really matter where you start, because all the shapes will fit together like a jigsaw puzzle. You don't have to figure out anything about the chair. In fact, you don't have to think about the chair at all. And don't question why the edge of a space goes this way or that. Just draw it as you see it.
- 8. If an edge is at an angle, say to yourself, "What is the direction of that angle compared to the side of the viewfinder that represents vertical?" Then, using the edge of the paper you're drawing on as the same vertical, draw the edge at the angle you see it.

Let me demonstrate that, because it's an important point: say that you see through the viewfinder that a negative space has an angled edge, as in Figure 7-20. On your drawing paper, you will draw the edge of the space at the same angle compared to the edge of your paper (Figures 7-21, 7-22). In other words, the edges of your viewfinder and the edges of your paper represent

vertical and borizontal as you see them in the real world.

9. Further on in the drawing, gauge horizontals in the same way: what is the angle, compared to horizontal (that is, the top or bottom edges of the viewer *and* of your drawing paper)?

10. Again, as you draw, try to take mental note of what that mode feels like — the loss of the sense of time, the feeling of "locking on" to the image, and the wonderful sense of amazement at the beauty of the perceptions. During the process you will find that the negative spaces will begin to seem interesting in their strangeness and complexity. If you have a problem with any part of the drawing, say to yourself, "What is the shape (or angle, or length of line)?" and wait until it comes into R-mode focus. Again, remind yourself that everything you need to know in order to do this drawing is right there, perfectly available to you.

After you finish: To reinforce your ability to use negative space, go on to exercises 7b-f on page 112.

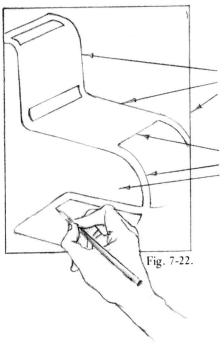

STUDENT SHOWING: All Manner of Chairs

Negative-space drawings are intriguingly pleasurable to look at, even when the positive forms are as mundane as schoolroom chairs. One could speculate that the reason is that the method of drawing raises to a conscious level the *unity* of positive and negative shapes and spaces. Another reason may be that the technique results in particularly interesting divisions of the total area within the format. The drawings in the Student Showing have these interesting space/shape divisions.

Learning to see clearly through drawing can surely enhance your capacity to take a clear look at problems and to be better able to see things in perspective. In the next chapter we shall use the artist's mode of seeing perspective relationships, a skill you can put to use in as many directions as your mind can take you.

Wendy Pickerell

Supplementary Exercises

7b. Using your viewfinder to frame the image, draw the negative spaces of a plant, preferably one with a complex shape. (See Figure 7-23.)

7c. Using your viewfinder to bound the form, draw the negative spaces of an ordinary household object: an eggbeater, an ironing board, a can opener. (See Figure 7-24.)

7d. Draw the negative spaces of a human figure *from a photograph*. Try to find a complex action pose: a football player, a ballet dancer, a construction worker, someone digging, etc. In this drawing, *combine* two methods: Turn the photograph upside down *and* draw the negative space. The outside edges of the photo are the bounding edges of the spaces and shapes. Make sure that in your drawing you use the same *format*, — the same proportional shape as the photograph. (See Figure 7-25.)

7e. Observe how Winslow Homer used negative space in his drawing of a child in a chair. Try copying this drawing. (See Figure 7-26.)

7f. Copy the drawing by Peter Paul Rubens, *Study of Arms and Legs* (Figure 7-27). Turn the original upside down and draw the negative spaces. Then turn the drawing right side up and complete the details *inside* the forms. These "difficult" *fore-shortened* forms become easy to draw if attention is focused on the *spaces around* the forms.

Fig. 7-26. Winslow Homer (1836-1910), *Child Seated in a Wicker Chair* (1874). Courtesy of the Sterling and Francine Clark Art Institute.

Fig. 7-27. Peter Paul Rubens (1577-1640). *Studies of Arms and Legs*. Courtesy of Museum Boymans-Van Beuningen, Rotterdam.

Branching Out in All Directions: Perspective in a New Mode

ne of the first steps in solving problems is to scan the relevant factors and to put things "into perspective." This process requires the capacity to see the various parts of a problem in their true relationship, their actual relative importance.

Learning to draw in perspective requires the same skill we've been learning: to see things as they are out there in the external world. In both instances, we must put aside our prejudgments, our stored and memorized stereotypes and habits of thinking. We must overcome false interpretations, which are often based on what we think must be out there even though we may never have taken a really clear look at what is right in front of our eyes.

For many centuries artists have sought ways to represent the three-dimensional world on the two-dimensional surface of a drawing or painting. Various cultures have developed different conventions or perspective systems. The term "perspective" comes from the Latin word *prospectus*, meaning "to look forward." The system most familiar to us, *linear perspective*, was perfected by European artists during the Renaissance. Linear perspective enabled artists to reproduce visual changes of lines and forms as they appear in three-dimensional space.

Artists of other cultures — Egyptian and Oriental, for example — developed a kind of stair-step or tiered perspective, in which placement from bottom to top of the format indicated

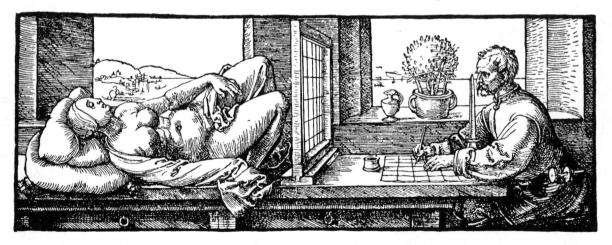

Fig. 8-1. Albrecht Dürer, *Draughtsman Making a Perspective Drawing of a Woman* (1525). Courtesy of the Metropolitan Museum of Art, New York. Gift of Felix M. Warburg, 1918.

position in space. In this system, which is often used by children, the forms at the very top of the page — regardless of size — are considered to be the farthest away. More recently, artists have rebelled against rigid conventions of perspective and have invented new systems employing abstract spatial qualities of colors, textures, lines, and shapes.

Traditional Renaissance perspective, however, conforms most closely to the way people in our Western culture perceive objects in space. In our perceptions, parallel lines appear to converge at vanishing points on a horizon line (the viewer's eye level) and forms appear to become smaller as distance from the viewer increases. For this reason, realistic drawing depends heavily on these principles. The Dürer etching (Figure 8-1) illustrates this perceptual system.

DÜRER'S DEVICE

In Dürer's depiction, the artist, holding his head in a stationary position (note the vertical marker for his *viewpoint*), looks through an upright wire grid. The artist peers at his model from a viewpoint that *foreshortens* his visual image of the model — that

Fig. 8-2. What Dürer saw; an approximation.

is, a viewpoint in which the main axis of the woman's figure from head to foot coincides with the artist's line of sight. This view causes the more distant parts of the figure (the head and shoulders) to appear to be smaller than they actually are, and the nearby parts (the knees and lower legs) to appear to be larger.

In front of Dürer's draughtsman on his drawing table is a paper the same size as the wire grid, marked off with an identical grid of lines. The artist draws on the paper what he perceives through the grid, matching in his drawing the exact angles and curves and lengths of lines compared to the verticals and horizontals of the grid. If he draws just what he sees he will produce on the paper a *foreshortened view* of the model. The proportions, shapes, and sizes will be *contrary* to what the artist knows about the actual proportions, shapes, and sizes of the human body; but only if he draws the untrue proportions he perceives will the drawing look true to life.

What did Dürer see through his grid? I've sketched an approximation (Figure 8-2). If you look at the drawn figure part by part, most of the shapes do not match with what we know about the configuration of a human figure. But taken as a whole form, we interpret the drawn lines as a three-dimensional figure seen in space from a particular point of view. We don't notice the distortions because we mentally adjust the image so that it fits with what we know.

The problem with foreshortening in drawing is that our mental adjustments of the visual image somehow intrude into the drawing, and we draw what we know rather than what we see. That was the purpose of Dürer's device: using the grid and the fixed viewpoint, he forced himself to draw the form *exactly as he saw it*, with all of its "wrong" proportions.

The achievement, therefore, of Renaissance perspective was to codify and systematize a method of bypassing artists' knowledge about shapes and forms and to provide a means by which they could draw forms just as they appeared to the eye — including distortions created optically by a form's position in space relative to the viewer's eye.

The system worked beautifully and solved the problem of how to create an illusion of deep space on a flat surface — of recreating the visible world. Dürer's simple device evolved into a complicated mathematical system, enabling artists from the Renaissance onward to overcome their mental resistance to optical distortions of the true shapes of things and to draw realistically.

But the system is not without problems. Followed to the let-

ter, linear perspective requires a fixed viewpoint, and artists do not work with their heads rigidly held in one position. Also, strictly applied perspective rules can result in rather dry and rigid drawings.

But the most serious problem with the linear perspective system is that it is so left-brained. It employs the style of left-hemisphere processing: analysis, counting, logical cogitation, propositional thinking, mental calculations. There are vanishing points, horizon lines (see Figure 8-3), perspective of circles and ellipses, and so on. The system is detailed and cumbersome, the antithesis of the artist's R-mode style with its antic/serious, trancelike quality.

Fortunately, once perspective is understood in its broad terms, it can be set aside. In fact, if you can *see* in the mode emphasized in these lessons, you don't need perspective at all.

SIGHTING: USING THE EDGES OF THE PAPER TO DETERMINE ANGLES

Most artists today do not make extensive use of perspective systems even for realistic drawing. Distortions of forms caused by position in space are *perceived visually* and most artists draw "by eye" — that is, by a method rather than a system. The method of drawing by eye is called *sighting*.

Sighting is a process of comparing the relationships of angles, points, shapes, and spaces. Sighting is *visual perspective*, with the optical information perceived directly by the eye and drawn by the artist without revision. Sighting requires no T-squares, triangles, protractors, rulers. All you need is pencil and paper. The only other requirement is a quiet L-mode that will stay out of the act and not protest when you draw things according to the way they really look and not according to what we know about them.

In Chapter Five, I mentioned that most beginning students of drawing tend to ignore the edges of the paper, almost as though they were nonexistent. But the edges of the paper are an important key to drawing in perspective and will help you to put down on a flat surface the three-dimensional forms you see in front of your eyes.

The edges of the paper represent horizontal and vertical. As you saw in Chapter Five, young children intuitively understand this concept. In a child's drawing, the ground is the bottom edge of the paper and the sky is the top edge. If something goes up in the air,

Professor of Art Graham Collier states that in the early days of the inception and development of Renaissance perspective it was used creatively and imaginatively to impart what must have been a thrilling sense of space to art. "Effective as perspective is, however," Collier says, "it becomes a deadening influence on an artist's natural way of seeing things once it is accepted as a system — as a mechanical formula."

-Graham Collier Form, Space, and Vision

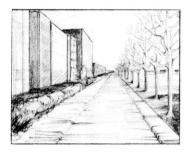

Fig. 8-3. The classic perspective illustration. Note that vertical lines remain vertical; horizontal edges converge at a vanishing point (or points) on the horizon line (which is always at the artist's eye level). That's onepoint perspective in a nutshell. Twopoint and three-point perspective are complex systems, involving multiple vanishing points that often extend far beyond the edges of the drawing paper and requiring a large drawing table, T-squares, straight-edges, etc., to draw. Sighting in R-mode is much easier and is sufficiently accurate for most drawing.

"To paraphrase Eugène Delacroix's observation on the study of anatomy, perspective should be learned — and then forgotten. The residue — a sensitivity to perspective — helps perception, varying with each individual and determined by his responsive needs."

—Nathan Goldstein The Art of Responsive Drawing

An adult artist uses the edges in a different way, not as actual top, bottom, and sides, but instead as a boundary for the image and as a gauge of horizontal and vertical, a gauge against which to estimate perspective angles and line directions. The technique is to use the R-mode to observe angles or line directions in relation to horizontal and vertical, and then to draw the same angles and line directions on your paper in relation to the edges, which represent horizontal and vertical.

Practice that now for a moment. Hold your pencil perfectly vertically. Close one eye and observe the angle of an object such as a chair, as compared to the vertical of your pencil (see Figure 8-4). Then draw the same angle on a piece of paper using the vertical edge of the paper to gauge the angle (Figure 8-5).

Now hold your pencil perfectly horizontally on a plane parallel to your eyes. (Extend the pencil horizontally with both hands to keep the pencil parallel to your eyes.) Close one eye and observe the relation of another part of the chair as compared to the horizontal of your pencil (see Figure 8-6). The part may in fact be horizontal, as in the illustration, or, depending on your view of the chair, it may be at some angle *in relation to horizontal* (see Figure 8-7). Whatever it is, you can now draw the same angle in relation to the top or bottom edges of the paper. To fix the concept in your mind, do exercises 8a and b.

The Use of Sighting in Figure Drawing

This technique of using the edges as a constant vertical and horizontal against which to gauge angles is an important basic skill in drawing figures as well as objects. Many artists' sketches still show traces of sight lines drawn in by the artist, as in the Edgar Degas drawing, *Dancer Adjusting Her Slipper* (Figure 8-8). Degas was probably sighting such points as the location of the left toe in relation to the ear and the angle of the arm compared to vertical.

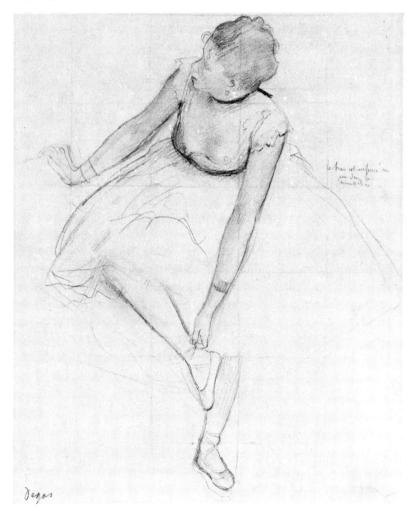

Fig. 8-8. Edgar Degas (1834-1917), *Dancer Adjusting Slipper* (1873). Courtesy of The Metropolitan Museum of Art, bequest of Mrs. H. O. Havemeyer, 1929. The H. O. Havemeyer Collection.

Supplementary Exercises

- 8a. In talking with a person, *note* the angle of the tilt of the head compared to vertical.
- 8b. Copy a photograph of a room interior or a landscape with a street and buildings. Look for the *angles relative to the edges of the photo*. Draw the same angles on your paper.

Fig. 8-7.

A MODERN VERSION OF DÜRER'S DEVICE

Next, try out the sighting technique by setting up a modern version of Dürer's experiment.

1. Tear off a sheet of clear plastic of the type used for wrapping food. Smooth it onto a window that looks out on a street scene. Using a felt-tip marker, draw a grid on the plastic with lines about two inches apart.

2. Standing at arm's length from the window, close one eye and regard the scene from a single point of view — do not move your head. Now, with the marker, trace the outlines of the street, buildings, automobiles, trees — the whole scene — on the plastic sheet.

3. Your completed drawing is a *perspective drawing*. Carefully remove the plastic from the window and lay it down on a light surface so that you can see the lines clearly. Take a sheet of drawing paper and very lightly draw a second grid exactly the same size as the first. Now copy the drawing from the plastic onto the drawing paper.

4. Take this drawing back to the same window. Now you are going to *sight* angles using your pencil as a sighting tool, and your drawing can function as a check on the accuracy of your sighting.

5. Stand again at arm's length from the window, in the same spot you stood to do the grid drawing. Now, holding your pencil up perfectly vertically and *parallel to the window*, line your pencil up with the vertical edge of a building. You will see that the edge is vertical. Check that on your drawing: the vertical edge will be parallel to the edge of your paper. In fact, *all* lines that are perpendicular to the earth always remain perfectly vertical.

6. Take a sight on one of the angled forms you drew — perhaps the edge of the street or the top of a building. Let your horizontal pencil touch the form at some point.

7. Observe the angle between the pencil and the form; note the direction in relation to horizontal. Now look on your drawing at the same angle and see how you drew it using Dürer's method. Compare your observation and the drawing. The drawing should *match* your observation.

8. Now check other angles and line directions, in each case looking at your drawing to see how the observation is translated in the drawing.

Summing up, then, this is how most artists do perspective drawing.

Knowing that vertical lines always remain vertical (except in rare and extreme bird's-eye or ant's-eye views) and that the horizontal edges of forms converge at vanishing points on a horizon line (the viewer's eye level), the artist simply finds out (by sighting) what the angles are relative to the constants, horizontal or vertical, and then draws those angles in the same relationship on the paper. This is possible because the edges of the paper represent horizontal and vertical. The key point is that the artist simply uses the pencil, held at arm's length either perfectly horizontally or perfectly vertically, to determine the specific angles. Any angle can be checked, and any angle can be drawn correctly on the paper without relying on complicated perspective systems. You need only to see relationally — in R-mode — what is right there in front of your eyes.

ANOTHER KIND OF SIGHTING: COMPARING RELATIVE LENGTHS AND WIDTHS

Sighting can be used to determine the relationship of lengths and widths of forms. When drawing a table viewed from an oblique angle, for example, an artist first determines angles of the edges relative to horizontal and vertical by sighting, as in Figure 8-9. The next perception required is how wide the table is (from this viewpoint) in relation to its length. This apparent width relative to length will vary from viewpoint to viewpoint, depending on where the viewer's eye level happens to be. (See Figure 8-10 for several views of a table.)

The technique of sighting relative sizes follows.

Fig. 8-9. Sighting angles relative to a horizontal edge.

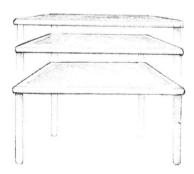

Fig. 8-10.

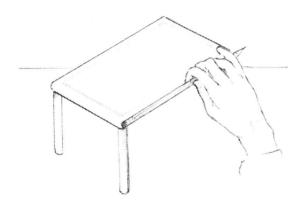

Fig. 8-13.

Fig. 8-12.

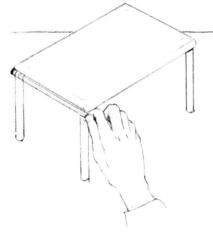

Fig. 8-11.

- 1. Holding the pencil on a plane parallel to your eyes and at arm's length, with the elbow locked to keep the scale constant, measure the width of the table: place the eraser of the pencil so it coincides with one corner of the table and place your thumb at the other corner (Figure 8-11).
- 2. Still keeping your elbow locked and with the pencil still parallel to your eyes, carry that measurement to the long side of the table (Figure 8-12). How long is the table, relative to its width? Let's say it is one-and-a-quarter widths.
- 3. On the angled lines you have drawn, make a mark for the width (this is an arbitrary width you decide how wide you want to draw the table). The length, however, is *relative* to the width. Make a mark on the angled line and draw the table top.
- 4. Next, you will take a sight on the table legs by holding your pencil vertically (Figure 8-13), taking note of the angle of one leg relative to vertical. Are the table legs perfectly vertical or are they at an angle? Draw the legs closest to you. You can take a sight on the length of the legs relatively (again) to the width. By holding your pencil horizontally so that it coincides with the tip of the leg closest to you, you can place the tips of the other legs, again by sighting angles (Figure 8-14).

Practice sighting relative sizes at odd moments of the day. The key to the technique is shutting off your verbal, L-mode knowl-

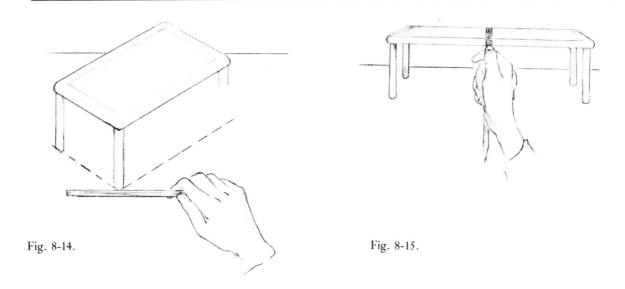

edge of *actual* size relationships. For example, from certain viewpoints you may sight a width-length relationship for a table that you feel positive can't be right: perhaps you sight a relationship of one to ten (Figure 8-15). Your verbal knowledge informs you that the table is certainly not that long and narrow. But one to ten is the *perceptual* relationship, and that's how you must draw it. You must believe what you see, and draw your perceptions without changing or revising them to fit your verbal knowledge. Then, paradoxically, the table will appear to be the width you know it to be.

PERSPECTIVE SKILLS IN R-MODE: CORNERS

In this exercise, you'll use your new ability to gauge angles relationally to draw a corner of a room, perhaps a room at home, at work, or at school.

Before you begin: Read all of the directions and look at the drawings in the Student Showing before you start your perspective drawing. Be sure that you have ample time, about half an hour, to complete the drawing. Since this kind of relational drawing is suited to the style of the right hemisphere, you will find yourself again shifting into the slightly altered state. The perceptions will become interesting in their complexity, and you will find yourself taking pleasure in the way all of the parts fit together.

Fig. 8-16.

Fig. 8-17

- 1. Position yourself so that you are facing a corner of a room.
- 2. Use your viewfinder to frame the corner, adjusting the viewfinder backward or forward to include whatever you wish to include in your drawing.
- 3. *Image* your perception of the corner of your paper, seeing the view almost as though it were already drawn on paper. Remind yourself that the *edges* of your paper represent the constants *vertical and borizontal*.
- 4. Take a sight first on the upper corner of the room: holding your pencil by the fingertips of both hands, extend both arms out full length. You are using both hands as shown in Figure 8-16 to make sure that the pencil stays on a plane parallel to the plane of your eyes. The most frequent mistake students make in sighting is to extend the pencil outward parallel to the angle they are sighting, pointing away from the plane parallel to the eyes. If it helps, image a window pane at arm's length, just like the one you drew the street scene on, and keep your pencil parallel to that plane. With the pencil extended at a perfect horizontal, move it up or down slightly until it seems to touch the upper corner, where the ceiling meets the walls, as in Figure 8-16. You should now be able to see the angles in relation to horizontal of the upper edges of the two walls.
- 5. Draw those two angles and the vertical line of the corner as in Figure 8-17. (The corner, of course, is vertical because it is a line *perpendicular* to the earth's surface and these lines always remain perfectly vertical. Only the horizontal lines that is, lines *parallel* to the earth's surface change angles in perspective.

- 6. Working your way down the walls, check every angle relative to vertical and horizontal of moldings, pictures on walls, doorways, etc.
- 7. Using the technique of sighting relative widths and lengths in addition to sighting angles, draw the forms of shelves, cabinets, chairs, or other furniture that may be in the corner. Use negative space wherever possible, always shifting to the next adjacent form or space. Try not to think in words or names of objects. In fact, try not to think in words at all in order to insure a strong cognitive shift to R-mode. Begin your drawing now.

After you finish: You may feel surprised that the drawing went so easily; my students often express the feeling before they start their corner drawings that the perceptions seem "too complicated" or "too hard." But drawing in R-mode always seems easy and pleasurable, and the drawings in the Student Showing reflect the R-mode state. If parts of your drawing reflect any L-mode conflicts, try a second one to shut down the L-mode chatter more completely.

This skill of sighting — drawing by eye or, as some artists say, "eyeballing" — is a tremendously useful technique. You will proceed with your drawing at a rapid pace once you have accustomed yourself to using the technique. The skill is essential in still-life drawing (to see the angles, placement, and relative sizes of forms), in landscape drawing, and in figure drawing.

STUDENT SHOWING: All Kinds of Corners

Students chose to draw corners with varying degrees of complexity; some with just a few objects, some filled with forms and details. Don't hesitate to choose a complex corner — kitchens are very interesting as you can see in several of the drawings. You'll notice that several students used negative spaces as well as perspective sighting. Students started drawing the corners, then worked from shape to adjacent shape, line to adjacent line, putting the forms together like jigsaw puzzles.

Supplementary Exercises

Before you begin: Practice perceiving foreshortened forms by extending the fingers of one hand straight toward your eyes. Focus on one fingernail and wait until you can see it as a shape (close one eye to flatten the image).

8c. Draw the fingernail, then the finger. Then draw the adjacent fingers, thumb, hand. Use negative space and sight the angles of the parts of your hand *relative* to vertical and horizontal. (See Figure 8-18 for an example of student drawing.)

8d. Put three objects of the same size on the table — for example, three apples. Place one apple on the near edge of the table, one in the middle, and one at the far edge. Sight the relative sizes, then draw the objects. (See Figure 8-19 for an example.)

8e. Figure 8-20 is a reproduction of a drawing by Charles White which demonstrates a foreshortened view. Study it. Copy it, turning the drawing upside down if necessary. Each time you experience the fact that drawing just what you see works the wonder of creating the illusion of space and volume on the flat surface of the paper, the methods will become more securely integrated as your way of seeing — the artist's way of seeing.

REVIEW OF SIGHTING TECHNIQUES

- 1. Imaginary *vertical* and *horizontal* lines are the constants by which you estimate everything in drawing. And remember that the edges of your paper *represent* vertical and horizontal as you see them *out there* in the visible world.
- 2. The easiest way to check the exact angle of a form is to hold up your pencil either horizontally or vertically (whichever is closer to the angle). Be sure to keep the pencil parallel to the plane of your eyes. Extending the pencil with both hands at arm's length is the best way to insure this. Then, on your paper, draw the same angle you have just observed.
- 3. In sighting relative widths and lengths, remember that you are always measuring *relative* sizes, never inches or feet that would be L-mode processing. In R-mode, choose a *unit one*, any part of a form. In a figure drawing, *unit one* might be the head. All other parts of the form are in some *ratio* or relative size compared to that unit. For example, the length of an upper arm might be one-and-a-quarter head-lengths. On your paper, then, you can draw the head whatever size you decide that is up to you. But all of the other parts are then *relative* to the size of the head. This is how you get things "in proportion," which means maintaining the *relative size* of the parts, one to another, by always referring back to a basic unit.

Returning to Dürer's experiment, perspective drawing generally involves the very problem that Dürer found a way to solve: the problem of foreshortening. A classic example of foreshortening is the old World War I poster of *Uncle Sam Wants You*, with the outstretched arm and finger pointing directly at you.

To strengthen your understanding of perspective, do exercises 8c, d, and e before proceeding.

The visible world is replete with foreshortened views of people, streets, trees, flowers. Beginning students sometimes avoid these "difficult" views and search instead for "easy" views. With the skills you now have, this limiting of subject matter for your drawing is unnecessary. As I have said before in other chapters, drawing is always the same task: to see clearly what is before your eyes. Sighting is an aptly named skill. You take a sight; you see the thing-as-it-is, bringing to the task all of your R-mode skills and your awakened eye.

Fig. 8-18.

Fig. 8-19.

Fig. 8-20. Charles White, Preacher (1952). Courtesy of the Whitney Museum.

9

Fitting It All Together: The Place of Proportion

ne of the important skills in seeing, thinking, learning, and problem solving is the skill of correctly perceiving relationships — the relationship of one part to another and the relationships of parts to the whole. In drawing, these relationships are called *proportion*. Perception of proportional relationships, particularly spatial relationships, is a special function of the right hemisphere of the human brain. Individuals whose jobs require close estimations of size relationships — carpenters, dentists, dressmakers, carpet-layers, surgeons — develop great facility in perceiving proportion. Creative thinkers in all fields benefit from enhanced awareness of part-to-whole relationships — from seeing both the trees *and* the forest.

All drawing involves proportion, whether the subject is still life, landscape, figure drawing, or portrait drawing, and whether the style is realistic, abstract, or completely nonobjective (that is, without recognizable forms from the external world). Realistic drawing in particular depends heavily on proportional correctness; therefore, realistic drawing is especially effective in training the eye (through gaining access to the right brain) to see the thing-as-it-is in its relational proportions.

SEEING WHAT YOU BELIEVE

Most beginning drawing students have problems with proportion: parts of forms are drawn too large or too small in relation to other parts or to the whole form. The reason seems to be that most of us tend to see parts of a form hierarchically. The parts that are *important* (that is, provide a lot of information), or the parts that we decide are larger, or the parts that we think should be larger, we see as larger than they actually are. Conversely, parts that are unimportant, or that we decide are smaller, or that we think should be smaller, we see as being smaller than they actually are.

Let me give you a couple of examples of this perceptual error. Figure 9-1 shows a diagrammatic landscape with four trees. The tree at the far right appears to be the largest of the four. But that tree is *exactly* the same size as the tree at the far left. Lay a pencil alongside the two trees to measure and test the validity of that statement. Even after measuring and proving to yourself that the two trees are the same size, however, you will probably find that

Fig. 9-1.

the tree on the right will still look larger.

The reason for this misperception of proportionate size probably derives from our past knowledge and experience of the effect of distance on the apparent size of forms: given two objects of the same size, one nearby and one at a distance away, the distant object will appear to be smaller. This makes sense, and we don't quarrel with the concept. But coming back to the drawing, even after we have measured the two trees and have determined with irrefutable evidence that they are the same size, we still wrongly see the right-hand tree as being larger than the left. This is overdoing it! And this is precisely the kind of overdoing — of overlaying memorized verbal concepts onto visual perceptions — that causes problems with proportion for beginning drawing students.

On the other hand, if you turn this book upside down and view the landscape drawing in the inverted orientation that the left brain rejects, thus activating your R-mode, you will find that you can more easily see that the two trees are the same size. The same visual information triggers a different response. The right brain,

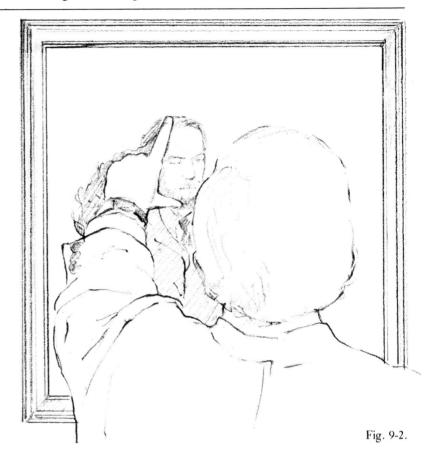

apparently less influenced by the verbal concept of diminishing size in distant forms, sees proportion correctly.

Not Believing What You See

A second example: stand in front of a mirror at about arm's distance away. How large would you say is the image of your head in the mirror? About the same size as your head? Using a felt-tip pen or a crayon, extend your arm and make two marks on the mirror — one at the top of the reflected image (the outside contour of your head) and one at the bottom contour of your chin (Figure 9-2). How long is the image in inches? About four-and-a-half to five inches, or *one-half* the true size of your head. Yet, when you remove the marks and look again, it seems that the image *must* be life size! Again, you are seeing what you believe, not believing what you see.

DRAWING CLOSER TO REALITY

We are going to try to talk the left brain out of some similar misperceptions in terms of the proportions of the head. To accomplish that, we will let the left back in a little and use its analytic abilities to help correct its own perceptions. We shall try to prove in a logical way that certain proportions *are* what they are.

Before we start, gather some photographs of heads — ordinary photographs of ordinary people — from newspapers, magazines, etc. Five or six will be enough. If you have some books with drawings by master artists, that would be helpful. Find some drawings of heads — front view, side view, or three-quarter view. Or use the photo of George Orwell, Figure 9-3. We will be using these images after you have worked through the following exercise.

For the exercises in perceiving proportion — and also for a number of the drawing exercises in the following chapters — we'll use the human head as a subject, but the methods of seeing proportional relationships apply to all drawing. The proportion exercises will concentrate on two critical relationships that are persistently difficult for beginning drawing students to correctly perceive: the *location of eye level* in relation to the length of the whole head; and the *location of the ear* in the profile and three-quarter views of the head. We will also review other proportions of the head.

But first, let me explain more fully the reasons why many of the lessons in this book will pertain to drawing the human head.

Seeing Face to Face

As mentioned in Chapter One, human faces have always fascinated artists. To catch a likeness, to show the exterior in such a way that the person behind the mask is revealed to view, has seemed a worthwhile goal to many artists. Like any drawing of a closely observed subject, a portrait reveals not so much the appearance and personality of the sitter as it does the *soul* of the artist. Paradoxically, the more clearly the artist sees the sitter, the more clearly we see *through* the likeness and see the artist.

Therefore, because we are searching for you through the images you draw, you will be drawing human faces in the next set of exercises. The more clearly you see, the better you will draw,

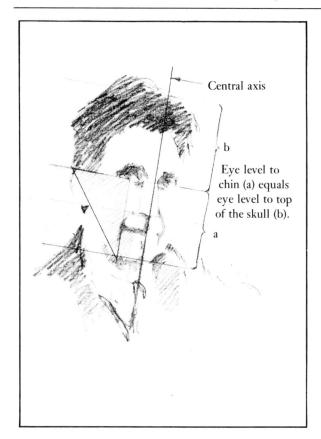

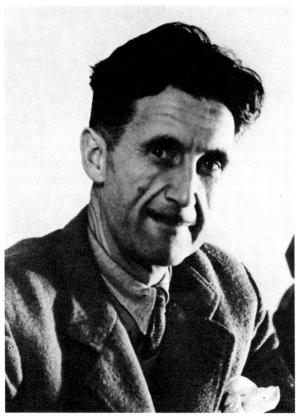

Fig. 9-3. The late George Orwell, the well-known writer, who died in January 1950. Courtesy of BBC.

and the more you will express yourself to yourself and to others.

Since portrait drawing requires very fine perceptions in order to produce a likeness, faces are effective for training beginners in seeing and drawing. The feedback on the correctness of perception is immediate and certain, because we all know when a drawing of a human head is correct in its general proportions. And if the sitter is known to us, we can make even more precise judgments about the accuracy of the perceptions.

But perhaps more important for our purposes, drawing the human head has a special advantage to us in our quest for ways to gain access to our right-hemisphere functions. The right hemisphere of the human brain is specialized for the recognition of faces. People with right-hemisphere damage caused by strokes or accidents often have difficulty recognizing their friends or even recognizing their own faces in the mirror. Left-hemisphere-damaged patients do not have this problem.

Beginners often think that drawing people is the hardest of all kinds of drawing. It isn't, actually. The visual information is right there, ready and available. The problem is *seeing*. To restate a major premise of this book, drawing is always the same task—that is, to *see clearly* and to draw your clear perceptions. One subject is not harder or easier than another. However, certain things often *seem* harder than others, probably because embedded symbol systems, which interfere with clear perceptions, are stronger for some subjects than for others.

The human head, of course, is a good example of a subject for which most people have a very strong, persistent symbol system. Your own unique set of symbols, as we discussed in Chapter Five, was developed and memorized during childhood and is remarkably stable and resistant to change. These symbols actually seem to *prevent seeing*, and therefore few people can draw a realistic human head, and even fewer can draw recognizable portraits.

Summing up, then, portrait drawing is useful to our goals for these reasons: First, it will tap into your right hemisphere, which is specialized for recognition of human faces — that is, for making the fine discriminations necessary to achieve a likeness in drawing. Second, drawing faces will help you to strengthen your ability to perceive proportional relationships, since proportion is integral to portraiture. Third, drawing faces is excellent practice in bypassing embedded symbol systems. And fourth, ability to draw portraits with credible likenesses is a convincing demonstration to your ever-critical left hemisphere that you have — dare we say? — talent for drawing. And, as in all drawing, you'll find that drawing portraits is not hard now that you can shift to the artist's way of seeing.

In Chapter Ten, you will learn first to draw a profile of a model, then a three-quarter view, and then a full-face view. First, however, now that you have learned to make the shift to R-mode and, I hope, feel comfortable with your newly gained ability to shift to right-hemisphere mode, we are going to call on your left hemisphere to help us out a little with analysis of proportion.

LETTING THE LEFT BACK IN — A LITTLE

As you experienced in your upside-down and negative-space drawings, all proportions can be perceived merely by looking for

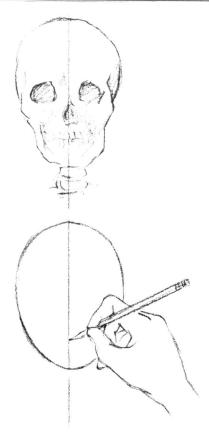

Fig. 9-4. Central axis.

Fig. 9-5.

size relationships. But I've found that students seem to progress faster and their perceptions seem to come through more easily if we *force* the left to recognize and *admit* certain facts (such as the size of the two trees in the landscape diagram or the face in the mirror) that it perceives wrongly. Now, in order to convince the logical left, we must put it in a logical box, i.e., show it irrefutable evidence, before it will admit that it could possibly be wrong.

HOW TO DRAW A BLANK AND SEE BETTER THAN EVER

- 1. Draw a "blank," an oval shape used by artists to represent the human skull in diagrams. The shape is shown in Figure 9-4. Draw in the center line of the blank, dividing the shape in half vertically. This is called the *central axis*.
- 2. Using your pencil, *measure on your own head* the distance from the inside corner of your eye to the bottom of your chin. Do this by placing the eraser end (to protect your eye) at the inside corner of your eye and marking with your thumb where your chin hits the pencil, as in Figure 9-5. Now, holding that measurement, raise the pencil as in Figure 9-6 and *compare* the first distance (eye level to chin) with the distance from your eye level to the *top of your head* (feel across from the end of the pencil to the topmost part of your head). You will find that those two distances are approximately the same.

Fig. 9-6.

- 3. Repeat the measurement *in front of a mirror*. Regard the reflection of your head. Without measuring, visually compare the bottom half with the top half of your head. Then use your pencil to repeat the measurement of eye level one more time.
- 4. Bring out the photos and drawings you have collected (or use the photo of George Orwell, Figure 9-3) and estimate the eye levels. In each head, is the eye level at about the middle, dividing the whole shape of the head about in half? Do you perceive the proportion clearly? If not, *measure* on the photos themselves, as in Figure 9-7, by placing your pencil flat on the drawing, measuring first eye level to chin, then eye level to the top edge of the head. Now, take the pencil away and look again. Can you see the proportion clearly now?

When you finally believe what you see, you will find that on nearly every head you observe, the eye level is at about the halfway mark. The *eye level is almost never less than half*—that is, almost never nearer to the top of the skull than to the bottom of the chin. And if the hair is thick, the top half of the head—the forehead-skull-hair half—is *bigger* than the bottom half. (See Figure 9-8.)

THE MYSTERY OF THE CUT-OFF SKULL

Most people find it quite difficult to perceive the relative proportions of the features and the skull. The eye level to most people appears to be about a third of the way down from the top of the head. I think this is because most people are not interested in foreheads and tops of heads, areas that perhaps seem boring to the left and difficult to characterize with a symbol. The top half of the head apparently is considered less important than the features, and therefore is perceived as smaller. This error in perception results in the cut-off-skull error, my term for the most common problem for beginning students. The cut-off skull creates the masklike effect so often seen in children's drawings and in primitive art. This masklike effect of enlarging the features relative to the skull size, of course, can have tremendous expressive power, as seen, for example, in works by Picasso, Matisse, and Modigliani. The point is that master artists use the device by choice and not by mistake. Let me demonstrate the effect of the misperception.

Fig. 9-7

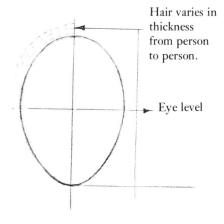

Fig. 9-8.

Fig. 9-9.

Setting Up a Logical Box for the Left-Brain: Irrefutable Evidence That the Top of the Head Is Important After All

I once said to a group of students who were having problems perceiving proportions of the skull correctly, "If anyone can suggest a way to explain eye-level proportions more clearly, please let me know." A student responded, "We'll see it when we can believe it." Later I accidentally hit on a way to help students "believe" which seems to be more effective than other methods. It has helped students avoid this most serious and stubborn problem in drawing the head. The demonstration follows.

First, I have drawn the lower part of the faces of two models, one in profile and one in three-quarter view (see Figure 9-9). I'll be showing you in detail how to draw this part of the head in the next chapter. Most students have few serious problems in learning to see and draw the features. The problem is not the features, it's in perceiving the *skull* that things go wrong. What I want to demonstrate now to you and your left hemisphere is how important it is to provide the full skull for the features—*not* to cut off the top of the head just because that part doesn't seem as interesting as the lower half with the features.

In Figure 9-10 are two sets of three drawings: first, the features only, without the rest of the skull; second, the identical features with the cut-off-skull error; and third, the identical features, this time with the *full skull*, which complements and supports the features.

Using your logical left brain, you can see that it's not the features that cause the problem of wrong proportion; it's the skull. (Turn back to Figure 1-5 in Chapter One and see that Van Gogh in his 1880 drawing of the carpenter apparently made the error of the cut-off skull in the carpenter's head. Also, see the Dürer etching in Figure 9-11 in which the artist demonstrates the effort of diminishing the relative proportion of the skull to the features.)

Now return to the photographs and drawings you gathered earlier. *Measure* (by laying your pencil down on the photo with the point at eye level and marking off the chin with your thumb) by comparing the size relationship of the bottom half of the head to the top. Are you convinced? Is your logical left hemisphere convinced? Good. You will save yourself innumerable hours of wrong drawing.

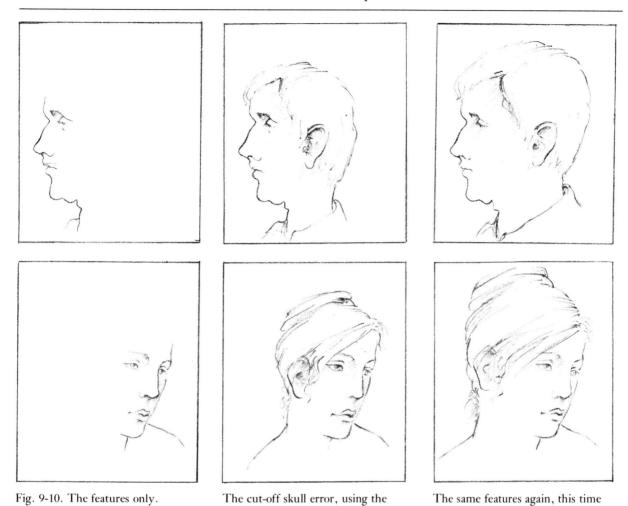

The cut-off skull error, using the

same features

FILLING IN THE BLANKS

Fig. 9-10. The features only.

Turn to Figures 9-12 and 9-13, the ovals representing the skull shape. Sit in front of a mirror with the blank and a pencil. You are going to observe and diagram the relationships of various parts of your own head, as you go step by step through the exercise. The numbers that appear within the figures correspond to the numbered directions in the exercise and illustrate these relationships.

- 1. First, diagram the eye level. Observe again, and on the blank draw in an eye-level line.
 - 2. We have already drawn in the central axis. Looking at your

with the full skull.

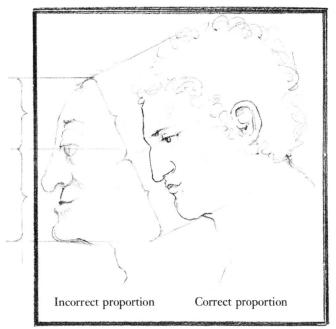

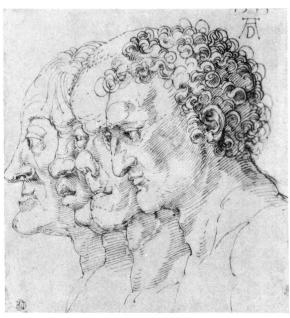

Fig. 9-11. Albrecht Dürer, Four Heads (1513 or 1515). Courtesy of The Nelson Gallery-Atkins Museum, Kansas City, Missouri (Nelson Fund).

own face, visualize a central axis that divides your face, and an eye-level line at a *right angle* to the central axis (see Figure 9-12). Tip your head to one side, as in Figure 9-13. Notice that the central axis and the eye-level line *remain at a right angle* no matter what direction you tip your head. (This is only logical, I know, but many beginners ignore this fact and skew the features as in the example in Figure 9-14). (See also Figures 9-16, 9-17, and 9-18.)

- 3. Observe your face: between eye level and chin, where is the end of the nose? About less than half, and more than a third. Make a mark on the blank.
- 4. Where is the level of the *center line* of the mouth? About a third between the nose and chin. Make a mark on the blank.
- 5. What is the width of the distance *between your* eyes, compared to the width of one eye? Yes, it's the width of one eye. Divide the eye level in fifths. Mark the centers of the eyes.
- 6. If you drop a straight line down from the inside corners of your eyes, what do you come to? The edges of your nostrils. *Noses are wider than you think.* Mark the blank.
- 7. If you drop a line straight down from the center of the pupils of your eyes, what do you come to? The outside corners of your mouth. *Mouths are wider than you think*. Mark the blank.

- 8. If you move your pencil along a horizontal line on the level of your eyes, what do you come to? The tops of your ears. Mark the blank.
- 9. Coming back from the *bottoms* of your ears, in a horizontal line, what do you come to? In most faces, the space between your nose and mouth. *Ears are bigger than you think*. Mark the blank.
- 10. Feel on your own face and neck: how wide is your neck compared to the width of your jaw just in front of your ears? You'll see that your neck is almost as wide—in some men, it's as wide or wider. Mark the blank. Note that necks are wider than you think.
- 11. Now test each of your perceptions on people, photographs of people, images of people on the television screen. Practice often, observing—first without measuring, then if necessary corroborating by measuring—perceiving relationships between this feature and that, perceiving the unique, minute differences between faces; seeing, seeing, seeing. Don't analyze in the left-hemisphere mode as we have been doing, but perceive people's faces as they really are in their totality, not piecemeal or hierarchically, but with every part contributing its full importance to the whole. See Figure 9-15 for an example.

Fig. 9-15.

Fig. 9-12. General proportions of the human head.

Fig. 9-13.

Fig. 9-14. I believe that skewing of the features happens because the student sees that the head is tipped but then fits the features into the most familiar pattern: upright and parallel to the edges of the paper.

Fig. 9-16. Vincent Van Gogh, *Dr. Gachet* (etching, 1890), B-10, 283. Courtesy of the National Gallery of Art, Washington, D.C., Rosenwald Collection. An interesting example of the expressive effect of skewed features.

Fig. 9-17. Sketch after Lovis Corinth (1858-1925), *Self-portrait*, drawn before his illness in 1911.

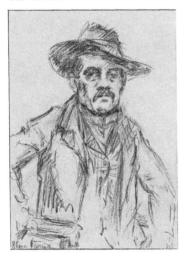

Fig. 9-18. Lovis Corinth, *Self-portrait* (1921). Courtesy of the Fogg Art Museum, Harvard University, gift of Meta and Paul J. Sachs.

The German artist Lovis Corinth sustained severe right-hemisphere brain damage from a stroke in December 1911. The first self-portrait (Fig. 9-17) was drawn before the stroke occurred. The second self-portrait, drawn some ten years later, shows the skewed features that appeared in most of Corinth's portraits after his illness.

Note that skewing the features produces a strong expressive effect, which you might choose to use for certain drawings. Again, the point is to use the device *by choice*, not *by mistake*.

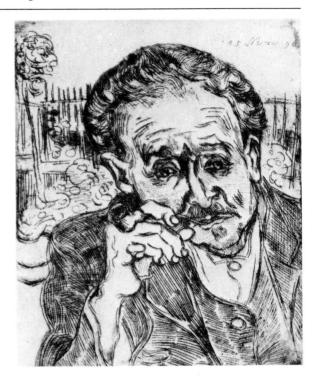

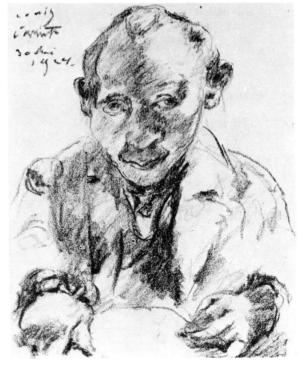

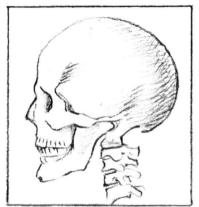

Fig. 9-20. The side-view blank. Note that (a) eye level to chin equals (b) eye level to highest part of the skull.

DRAWING ANOTHER BLANK AND GETTING A LINE ON THE PROFILE

Draw another blank now, this time for a profile. The profile blank is a somewhat different shape—an odd-ball egg. This is because the human skull (Figure 9-19), seen from the side, is a different shape than the skull seen from the front. It's easier to draw the blank if you look at the shapes of the *negative spaces* around the blank in Figure 9-20. Notice that the negative spaces are different in each corner.

If it helps you to see, draw in some symbolic shapes for nose, eye, mouth, and chin, making *sure* that you have first drawn the eye-level line at the halfway point on the blank.

The next measurement is extremely important in helping you perceive correctly the placement of the ear, which in turn will help you perceive correctly the *width* of the head in profile.

On your own face, use your pencil again to measure the length from the inside corner of your eye to the bottom of your chin (Figure 9-21). Now, holding that measurement, lay the pencil horizontally along your eye-level line (Figure 9-22) with the eraser end at the *outside corner* of your eye. That measurement coincides with *the back of your ear*. Putting that another way, the length from eye level to chin *equals* the distance from the back of the eye to the back of the ear. Make a mark for the ear placement

Fig. 9-21.

Fig. 9-22.

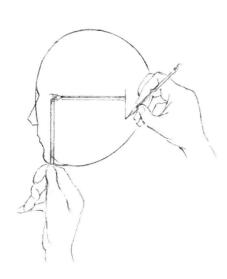

Fig. 9-23.

on the eye-level line of the blank, as in Figure 9-23. This proportion may seem a little complex, but if you will learn the measurement it will save you from another stubborn problem in drawing the human head: most beginning students draw the ear too close to the features when drawing a profile. When the ear is placed too close to the features, the skull is once more chopped off, this time at the back. Again, the reason for the problem may be that the expanse of cheek and jaw is uninteresting and boring, and therefore beginning students fail to perceive the *width* of the space correctly.

Figure 9-24 shows an example of a student drawing that contains this misconception, and in Figure 9-25, the Austrian artist Koskoschka uses this distortion, probably by design. As you can see, enlarging of the features_and diminishing of the skull produce strong, expressive, symbolic effects, a device you can always use later if you wish. Right now, we want you to be able to see things as they really are in their correct proportion.

I recently hit upon another useful technique for teaching the correct placement of the ear. Since you now know that two

Fig. 9-24. Student drawing.

Fig. 9-25. Oskar Kokoschka (1886-), *Portrait of Norbert Wein* (1920). Courtesy of the Worcester Art Museum, Worcester, Massachusetts.

measurements are equal—from eye level to chin, and from the back of the eye to the back of the ear—you can visualize an equal-sided right-angle triangle connecting these three points, as shown in the drawing in Figure 9-26. This is an easy way to place the ear correctly.

Practice seeing proportional relationships now by looking at photographs or drawings of people in the profile view and visualizing the triangle, as in Figure 9-26. This technique will save you from a lot of problems and errors in your profile drawings.

We still need to make two more measurements on the profile blank. First, holding your pencil horizontally, just under your ear, slide the pencil forward as in Figure 9-27. You come to the

Fig. 9-26.

space between your nose and mouth. This is the level of the bottom of your ear. Make a mark on the blank.

Again, holding your pencil horizontally just under your ear, slide the pencil this time backward. You will come to the place where your skull and neck connect—the place that bends. Mark this point on the blank. The point is *higher* than you think. In symbolic drawing, the neck is usually placed *below* the circle of the head, with the point that bends on the level of the chin. This will cause problems in your drawing: the neck will be too narrow, as in Figure 9-28. Make sure that you *perceive* on your model the correct place where the neck begins at the back of the skull.

Now you will need to practice these perceptions. Look at people. Practice perceiving faces, observing relationships, seeing the unique forms of each individual face.

You are ready now to draw a profile portrait. You will be using all of the skills you have learned so far:

Drawing just what you see without trying to identify or attach

verbal labels to forms (you learned the value of this in the upside-down drawing).

Drawing just what you see without relying on old storedand-memorized symbols from your childhood drawing.

Focusing on negative spaces and complex areas until you feel the shift to an alternative state of consciousness, one in which your right hemisphere leads and your left hemisphere is quiet. Remember that this process requires an uninterrupted block of time.

Estimating angles in relation to the vertical and horizontal edges of the paper.

Estimating relationships of sizes — how long is this form compared to that one?

And finally:

Perceiving proportions as they really are, without changing or revising to fit preconceptions about what parts are important. They are *all* important, and each part must be given its full proportion in relation to the other parts.

If you feel that you need to review any of the techniques at this point, turn to the previous chapters to refresh your memory. Reviewing some of the exercises, in fact, will help to strengthen your new skills. Pure contour drawing is particularly useful in strengthening your newfound method of gaining access to your right hemisphere and quieting the left.

Fig. 9-27.

Correct point in relation to the facial features.

A common error: misplacement of the point where the neck joins the skull.

Fig. 9-28.

10

Facing Forward:
Portrait Drawing
With Ease

"The process of drawing is before all else, the process of putting the visual intelligence into action, the very mechanics of taking visual thought. Unlike painting and sculpture it is the process by which the artist makes clear to *himself*, and not to the spectator, what he is doing. It is a soliloquy before it becomes communication."

— Michael Ayerton Golden Sections

"The material thing which is before you, that is It."

-The 16th-century Zen master, Huang Po Learning any new skill generally involves learning first the separate components that make up the skill, then putting the parts together as an integrated whole. After learning the subskills of bicycle riding or automobile driving, for example, you finally got on the bicycle and rode away or climbed into the car and drove off. In doing so, you made it clear to yourself and to others that you had attained the skill. Similarly, with the exercises of this chapter we shall put together the separate components you have acquired of the skill of seeing. Thus, in your drawings you will make it clear to yourself and subsequently to others that you have truly seen.

We shall now draw faces, first setting up the conditions that will cause your left brain to take a little nap. And your right brain will have a field day: seeing contours in their wondrous complexity; watching your drawing evolve from the line that is your unique, creative invention; observing yourself integrating your skills into a dancelike drawing process; seeing, in the artist's mode, the astounding thing-as-it-is, not a pale, symbolized, categorized, analyzed, memorized shell of itself; opening the door to see clearly that which is before you; and drawing the image through which you make yourself known to us.

FACING THREE WAYS

This chapter is divided into three parts: first, instructions for drawing the profile view of a model; second, the three-quarter view, with the model turned slightly to one side; and third, the frontal view with the face seen straight on. The reason the frontal view is saved for the last is not that frontal views are harder. As I have said, in drawing it's all the same task — to see clearly — and no position or subject is harder to draw than another. But the embedded symbol system for the front-view head, practiced and memorized since early childhood, is particularly strong and persistent. Once you have drawn the head several times in profile and three-quarter view and know that seeing clearly in R-mode is the key, I feel sure that you will be better able to suppress the symbols and guard against their creeping back into a form that is so familiar — the front-view face.

FIRST, THE PROFILE

Before you begin: Find a model — a friend, a neighbor, or someone in your family who will pose informally for a portrait drawing. Your model can be drawn while reading, sleeping, watching television. You will need about a half-hour to forty minutes for the drawing, with one or two rest periods for the model.

If I were personally demonstrating the process of drawing a portrait profile, I would not be naming parts. I would point to the various areas and refer to features, for example, as "this form, this contour, this angle, the curve of this form," and so on. For the sake of clarity in writing, unfortunately, I'll have to name the parts. In *your* drawing, however, the process that may seem cumbersome and detailed when written out as verbal instructions will become like a wordless, antic dance, an exhilarating investigation, with each new perception miraculously linked to the last and to the next.

Read through all of the directions and look at the drawings in the Student Showing before you start drawing.

- 1. Tape or tack your paper to a drawing board or some smooth, rigid surface. A bread board is fine, though you may need a pad of paper under your drawing paper to smooth the surface.
- 2. Seat yourself before your model so that you see the model in profile view. You should be about four feet from the model if possible. Five or six feet away from the model is about the outer limit for drawing a portrait head. Further away you cannot see the details clearly enough and you might tend to substitute symbols.
- 3. To begin drawing, first *bound* the form, either with your viewfinder or with your hand and pencil, as shown in Figure 10-1. Direct your gaze first at the negative space around the head and *wait* until you can see that space as a shape. *See the overall shape* of the head as an empty shape surrounded by *solid* negative space like the Bugs Bunny-shaped hole in the door.
- 4. Turn your gaze to your empty drawing paper and image the shape of your model's head on the paper itself the overall outside contour of the head (which is also the inside contour of the negative space). It helps to set that image if you do a little "phantom drawing," that is, move your pencil around the projected image of the head as though drawing, but not touching the

Fig. 10-1.

Fig. 10-2.

paper. Now you know how big the head will be and where it will be located on the paper. You can even image the whole head, features and all, right onto the paper.

5. Start the actual drawing anywhere you like. I generally start at the forehead and work down the profile, but others use different sequences. All of the shapes and spaces will fit together like a jigsaw puzzle, each part in relation to the other parts; so where you start is immaterial.

6. Again, bound the form, gaze at the negative space beyond the forehead and nose, and wait until you can see it as a shape (that is, until the task has been passed from the left mode to the right). Then, using the method of modified contour drawing, draw the edge of the space. Estimate angles (of the nose, for example), as you did in Chapter Nine, by holding up your pencil vertically, closing one eye, and lining up the vertical pencil with the tip of the nose as in Figure 10-2. What is that angle in relation to vertical? As you come down the profile, estimate points and sizes: observe where one point is in relation to another, how long a contour is in relation to another, always referring back to something that you have already drawn.

7. Now for some specific instructions on seeing parts of the head. Of course you can perceive all of these relationships simply by looking, but my pointing out some specific details may help you to see them.

EYES:

Observe that the eyelids have thickness. The eyeball is behind the lids (Figure 10-3). To draw the iris (the colored part of the eye) — don't draw it. Draw the shape of the white (Figure 10-4). The white can be regarded as negative space, sharing edges with the iris. By drawing the (negative) shape of the white part, you'll get the iris right because you'll bypass your memorized symbol for iris. Note that this bypassing technique works for everything that you might find "hard to draw." The technique is to shift to the next adjacent shape or space and draw that instead. Observe that the upper lashes grow first downward and then (sometimes) curve upward. Observe that the whole shape of the eye slants back at an angle from the front of the profile (Figure 10-5). This is because of the way the eyeball is set in the surrounding bony structure. Observe this angle on your model's eye — this is an important detail.

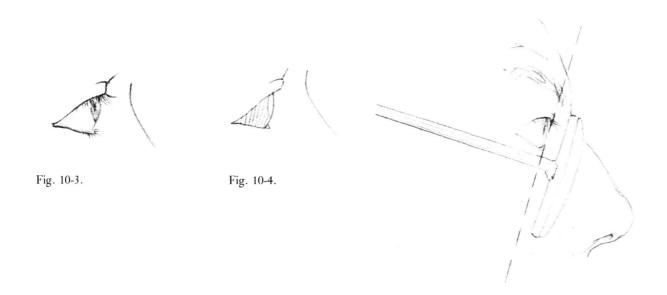

NOSE:

Nostrils, like irises, are often drawn symbolically. Again, using the bypassing technique described above, shift away from the symbolically memorized parts to the next adjacent part. In the case of nostrils, direct your gaze at the space *underneath the edge of the nostril* and draw that exact shape (Figure 10-6).

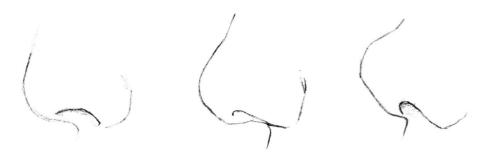

Fig. 10-6. Look for the shape of the space under the nostril. This shape will vary from model to model and should be specifically observed on each individual.

Fig. 10-5.

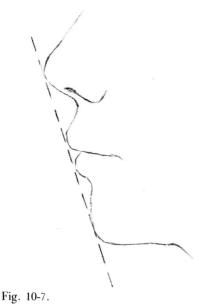

MOUTH:

In many faces seen in profile, the outer contour of the tip of the nose, the upper lip and lower lip, and the chin often fall on a slanted line as shown in Figure 10-7. Carefully observe these points on your model and note the exact angle. See first the overall relationships, then the specific relationships, then the specific relationships between parts. Negative space helps tremendously here, presenting fresh, unstereotyped shapes for you to draw. Next, observe that the contours of the edges of the lips are not real edges (that is, the meeting of two edges) but are merely a color change. You will observe that, for most models, the slight color change of the lips is best represented by a pale line, not a dark, heavy line. The center line of the lips, however, is a real contour (that is, represents the meeting of two edges), and as you regard your model, you can see that that contour is darker than the outer edges of the lips. The shape of the upper lip is important to the expression of the model. To draw the shape of the upper lip correctly, don't draw it — again, shift to the next adjacent space, the space between the nose and the upper lip, as in Figure 10-8. Check the length of the center line of the mouth. Where is the corner of the mouth relative to, for example, the front of the eye? (Always check positions against something that you have already drawn.)

ady (IIawii.)

Fig. 10-8. To draw the shape of the upper lip, observe and draw the shape of this space.

CHIN:

Check where the front contour of the chin is *in relation to* the forehead or the upper lip — something you have already drawn. Observe the length of the chin relative to, for example, the length of the nose.

GLASSES:

If your model is wearing glasses, don't draw the glasses themselves — they are strongly symbolic (Figure 10-9). Draw the negative shapes around the glasses, as in Figure 10-10. The key here, of course, is not to question your perceptions of the negative spaces. Draw what you see.

NECK:

Use the negative space in front of the neck in order to perceive the contour under the chin and the contour of the neck (Figure 10-11). Check the *angle* of the front of the neck in relation to vertical. Make sure to check the point where the back of the neck joins the skull. This is often at about the level of the nose or mouth (Figure 10-11).

Fig. 10-11. Be sure to check where this point is in relation to the nose/mouth. The front of the neck is usually slanted relative to vertical.

Fig. 10-9. The symbol for glasses is particularly persistent.

Fig. 10-10. To avoid the symbol, use the shapes of the face *around* the glasses as negative spaces.

Fig. 10-12. Use the bypassing technique for parts with strongly linked symbolic, conceptual, stereotypic shapes memorized during childhood drawing.

COLLAR:

Don't draw the collar. Collars, too, are strongly symbolic (Figure 10-12). Instead, use the neck as negative space to draw the top of the collar, and use negative spaces to draw collar points, open necks of shirts, and the contour of the back below the neck, as in Figure 10-12. (This bypassing technique works, of course, because shapes such as the spaces around collars cannot be easily named and have generated no preexisting symbols to distort perception.)

EAR:

At this point in the drawing, with the features more or less completed, measure *on your model* the size comparison of the lower half of the head (eye level to chin) with the upper half (eye level to top of head). Do this by actually holding your pencil up to your model's head and measuring (Figure 10-13). The distance from eye level to the top of the hair will be at least as long (possibly longer if the hair is thick) than that from eye level to chin.

Then transfer those measurements to your drawing. Lay your

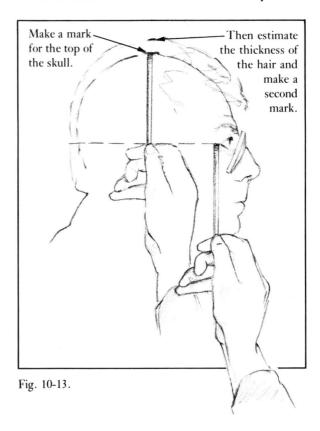

pencil down vertically on your drawing and *measure* from eye level to chin, placing the eraser end of your pencil at the eye level and marking with your thumb and forefinger where the chin comes. Holding that measurement, raise the pencil, slide it along the eye-level line to the center of the skull, and *make a mark on your drawing where the top of the skull will come*. Do not skip this step, thinking you will remember to make the skull big enough. Next, measure for the placement of the back of the ear: lay the pencil down again and measure from eye level to chin. Transfer the measurement from the *back of the eye to the back of the ear*. Or visualize the equal-sided right-angled triangle. Both methods are shown in Figures 10-14 and 10-15. Make a mark on your drawing where the back of the ear will come (Figure 10-15).

Draw the shape of the space behind the ear first. Then draw the interior shapes of the ear, always directing your gaze at the shape *next to* the one you want to draw, and use that adjacent shape as a negative space. Be sure to check the size of the ear *in relation to the features*; where is the top of the ear in relation to the eye and eyebrow? Where is the bottom of the ear in relation to the nose and mouth? Remember that ears are surprisingly big.

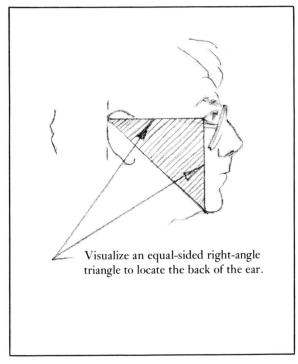

Fig. 10-14.

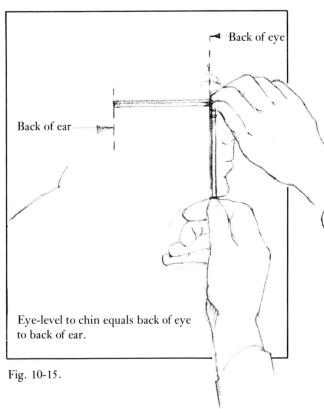

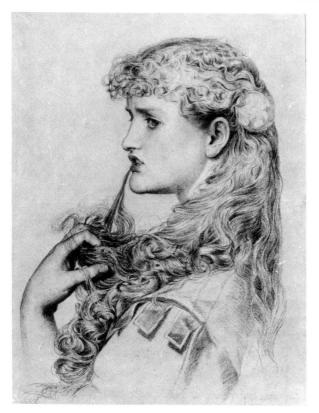

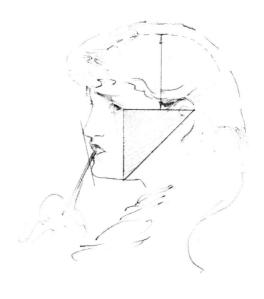

Fig. 10-16. Anthony Frederick Augustus Sandys (1832-1904), *Proud Maisie*. Courtesy of the Victoria and Albert Museum, London.

HAIR:

Students often ask me to show them "how to draw hair." I think that what most beginning students mean by that is, "Show me a way to draw hair that is quick, easy, and looks terrific." In other words, "Show me a better symbol for hair than the one I am using." There is, of course, no such thing. The way to draw hair is exactly like the way to draw anything: you must perceive the hair as it is, in all of its complexity, and draw what you see. This doesn't mean that you will draw every hair, but it does mean that you must take the time to describe in your drawing at least part of the hair — to show the exact movement of the strands, the exact texture of at least some section of the hair. Look for the dark areas where the hair separates and use those areas as negative spaces. Look for the major directional movements, the exact turn of a strand or wave. The right hemisphere, loving complexity, can become entranced with the perception of hair, and the record of your perceptions in this part of a portrait can have great impact, as in the portrait of Proud Maisie (Figure 10-16). To be

avoided are the thin, glib, symbolic marks that spell out *bair* on the same level as if you lettered the word across the skull of your portrait.

When you are ready to begin, remember that you will require thirty to forty minutes. You might set a timer to remind yourself to give your model a rest. Be sure to tell the model you won't be able to talk during the sitting.

Then seat your model. Position yourself. Bound the form. Image the form on your paper. Direct your gaze at the negative space around the form. You will feel yourself shifting into R-mode . . . attaining that state of being in which you can see clearly.

After you finish: Be proud of yourself — you've done it! I hope you are as pleased with your drawing as my students are when they complete this first portrait.

If you notice that any parts of the drawing seem not quite right, try the following procedures to check for errors. First, hold the drawing up to a mirror. Reversing the drawing can give you a fresh and more objective look at the relationships of parts and show you where corrections may be needed. Another very useful technique for finding errors is to *cover* any part you think may be wrong and then *image* what that part should look like. Hold the image in your mind while gazing at the drawing. Then quickly remove your hand, uncovering the part. If the drawn part is wrong — wrongly placed or too small or whatever — you will immediately see the error. A third technique is to hold the drawing up close to the model and check each negative space in turn, checking angles, lengths of parts, etc. — first on the model, then in your drawing. Wherever negative spaces do not match, that is where the error will be found.

In order to prevent yourself from being too critical, however, this is a good time to bring out the preinstruction drawings you did at the end of Chapter One. The comparison may be as striking as the *before* and *after* drawings at the end of that chapter. Also, if you compare your preinstruction drawing of the head with your preinstruction drawing of a memorized figure (your Draw-a-Person drawing) you may see repeats of your symbol system in the features of the faces. But the profile drawing you have just completed probably does not repeat the symbol system, and with this drawing, you are on your way to adult-level visual expression.

"The object, which is back of every true work of art, is the attainment of a state of being, a state of high functioning, a more than ordinary moment of existence. . . . We make our discoveries while in the state because then we are clear-sighted."

-Robert Henri The Art Spirit

STUDENT SHOWING: Profiles in Drawing

Now that you have read instructions about specific problems and how to handle them, look at the Student Showing of profile drawings. As you study the drawings, review the steps the students took to accomplish the portraits. Perform the major measurements by laying your pencil on each drawing, measuring eye level to chin, eye level to top of head, placement of the ear, and so on. Try to guess where the student-artist used negative space to draw "difficult" forms such as glasses, irises, ears, etc.

Rona Kramer

Janice Gallagher

Sheila Kalivas

Supplementary Exercises

Before you begin: In these exercises I am recommending that you copy master drawings — that is, portrait drawings by some master artist from the past. The purpose is to study how a great artist saw a particular individual's head in all of its relational complexity. Therefore, in your drawing, imagine that you are that great artist and retrace the master's steps.

10a., Copy a master drawing of a head in profile. Use negative space both outside the form and inside (the bypassing technique), shifting from "difficult" parts and drawing the *next adjacent part*. If you wish, do an upside-down drawing. (See Figure 10-17.)

10b. If your first copy of a master drawing was of a woman, draw another, using a master drawing of a man (or vice versa).

After you finish: Using the techniques outlined in the profile drawing exercise, check for possible errors in perception in the drawings you have done. Then, for the rest of the day, regard any individuals you encounter as though you were the master artist and the individuals were potential models. In your imagination, see what the portrait would look like drawn in the style of the master whose drawings you copied.

SETTING THE SKILL

Before going on to the next step, the three-quarter view, do exercises 10a and b.

As the first step for each drawing, arrange a situation for yourself in which the cognitive shift to the R-mode can occur. Be sure to arrange for at least a half-hour of drawing time. Begin by gazing at negative spaces. As time goes on, your brain will get used to this procedure, and the shift will occur more and more quickly. Once in R-mode, the only problem will be to remember to give your model a rest.

If, as occasionally happens, the left brain remains active, the best remedy is to do a short session of pure contour drawing, drawing either the model or any complex object. Pure contour drawing seems to force the shift to R-mode and therefore is a good warm-up exercise for drawing any subject.

TURNING TO THE THREE-QUARTER VIEW

Young children rarely draw people with heads turned partly to one side, the position called the three-quarter view. Children generally draw either profiles or faces seen straight on. Around age ten or so, children begin to attempt three-quarter view drawings, perhaps because this view can be particularly expressive of the personality of the model. The problems young artists encounter with this view are the same old problems: the three-quarter-view brings visual perceptions into conflict with the symbolic forms developed throughout childhood for profile and full-face views, which by age ten are embedded in the memory.

What are those conflicts? First, as you see in Figure 10-18, the nose is not the same as a nose seen in profile. Second, the two sides of the face are different widths — one side narrow, one side wide. Third, the eye on the turned side is narrower and shaped differently from the other eye. Fourth, the mouth from its center to the corner is shorter on the turned side and shaped differently from the mouth on the other side of the center line. These perceptions of nonmatching features conflict with the memorized symbols for matching features that are nearly always arranged symmetrically on each side of the face.

The solution to the conflict is of course to draw just what you see without questioning why it is thus or so and without changing the perceived forms to fit with a memorized-and-stored set of symbols for features. To see the thing-as-it-is in all of its unique

Fig. 10-17. Student drawing of one of Dürer's Four Heads.

Fig. 10-18. Sketch from a threequarter view portrait by the German artist Lucas Cranach (1472-1553), Head of a Youth with a Red Cap.

and marvelous complexity — that is the key that unlocks the door.

Before you begin: Let me again take you through the process step by step, giving you some methods for keeping your perceptions clear. Again note that if I were demonstrating the three-quarter view drawing, I would not be naming any of the parts, only pointing to each area. So when you are drawing, do not name the parts to yourself. In fact, try not to talk to yourself at all while drawing.

- 1. Position your model for this first drawing so that in your view of the model's head the tip of the nose nearly coincides with the outer contour of the turned cheek, as in Figure 10-19. You can see that this forms an *enclosed shape*.
- 2. Just as in drawing the profile, bound the form with a view-finder or with the hand and pencil. Gaze at the negative space around the head until you can see it as a shape. Then gaze at the whole shape of the head the whole outer contour and wait until you can see it as a shape.

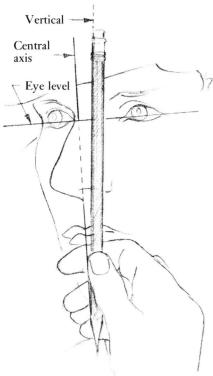

Fig. 10-19. Observe the tilt of the central axis compared to vertical (your pencil).

The eye-level line is at a right angle compared to the central axis.

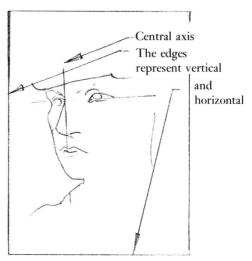

Fig. 10-20. The edges of the paper represent vertical and horizontal. The angle of the central axis is drawn on the paper in relation to vertical (the paper's edge).

- 3. Now direct your gaze at your empty drawing paper and *image* the whole shape of the head on the paper. "Phantom-draw" the shape that is, lightly sketch it in if it helps to set the image.
- 4. Observe your model. Perceive first the central axis that is, an imaginary line that passes through the very center of the face. In three-quarter view, the central axis passes through two points: a point at the *center of the bridge of the nose* and a point at the middle of the upper lip. Image this as a thin wire that passes right through the form of the nose (Figure 10-19). By holding your pencil vertically at arm's length toward your model's head, check the angle or tilt of the central axis of your model's head. Each model may have a different characteristic tilt to the head. Estimate this angle compared to vertical (your pencil). Image the whole head again on your paper, and then draw in the central axis of the head at the *correct angle* (Figure 10-20). This angle is very important for attaining a likeness. Then, very lightly, draw in the eye-level line at right angles to the central axis. This is to make sure you don't skew the features as I discussed in Chapter Nine. Measure on your model and then measure on your paper to make certain that the eye-level line is balf of the whole form.

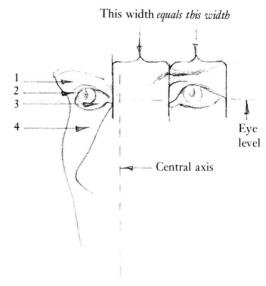

Fig. 10-21. First, see this whole area as a shape.

Fig. 10-22.

- 5. You will be using the method of modified contour drawing: drawing slowly, directing your gaze at *edges*, and perceiving *relational* sizes, angles, etc. Again, you can start anywhere you wish (I tend to start with that shape between the nose and the contour of the turned side of the cheek because that shape is easy to see, as in Figure 10-21). I'll describe a definite order for the drawing, but you may prefer a different order.
- 6. Direct your eyes at the shape and wait until you can see it clearly. Draw the outer contours of the shape. As you see, this will give you the contour of the nose. Inside the shape you have drawn is the eye with the odd configuration of the three-quarter eye. To draw the eye, don't draw the eye. Draw the shapes around the eye. You may want to use the order shown in Figure 10-22, but any order will work as well. First the shape over the eye (1), then the shape next to it (2), then the shape of the white part of the eye (3), then the shape under the eye (4). Try not to think about what you are drawing. Just draw each shape, always shifting to the next adjacent shape.
- 7. Next, locate the correct placement of the eye on the side of the head closest to you. Observe on your model that the inside corner lies on the eye-level line. Note especially how far away

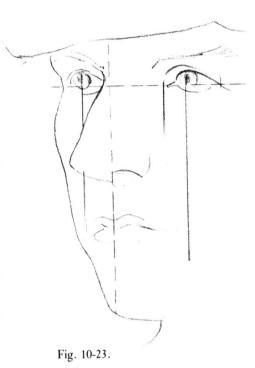

from the contour of the nose this eye is: this distance is *nearly* always a distance equal to the width of the eye itself (Figure 10-22). The most common error beginning students make in this view of the model is to place the eye too close to the nose. This error throws all of the remaining perceptions off and can spoil the drawing. Make sure that you see (by sighting) the width of that space and draw it as you see it.

8. Next, the nose. Check on your model where the edge of the nostril is *in relation to* the inside corner of the eye: drop a line straight down, following (that is, parallel to) the tilt of the central axis (Figure 10-23). Don't revise this perception. Remember, noses are bigger than you think. Then, draw the shape of the nostril by perceiving the shapes of the spaces *around* the nose.

9. The mouth. Estimate, in relation to, for instance, the length of the nose, how far down the center line (where the lips part) of the mouth is. Make a mark. Estimate where the corner of the mouth lies in relation to the eye (Figure 10-23). Then observe the center line of the mouth and draw the exact curve just as you perceive it. This curve is important in catching the expression of the model. Don't talk to yourself about this. Don't say to yourself such things as "She has such a pleasant expression" or "He has such a kindly look." The visual perceptions are there to be seen. By seeing clearly and drawing exactly what you see, the expression will be just what you are responding to. In R-mode, you do respond — but not in words.

To continue, draw first the center line of the mouth on the near side of the face. Complete the upper and lower edges of the lips on this side, remembering that the line is *light* because these

are not edges or strong contours.

When you draw the side of the mouth on the turned side of the face, use the same negative-space technique that you used for the eye on the turned side. Draw the *shapes of the spaces around the mouth*. Again, note the exact curve of the center line on this side.

- 10. The ear. Place the ear carefully by sighting or actually measuring on the model. Be sure to place the ear far enough back. The distance from eye level to chin will about equal the distance from the inside corner of the eye to the back of the ear. You can perceive this relationship by measuring it on the model if necessary. Then note where the top of the ear is, then the bottom, and draw the ear by using the negative spaces around the ear.
- 11. Hairline and hair. Draw the hairline by using the same method you used in the profile view: use the forehead as negative

space that has as its topmost contour the *bairline*. Then, observe and draw at least some of the hair, showing its main directions, some of its exact directions, texture, dark areas where the hair separates, etc.

12. The neck and collar. Observe on your model *where* the contour of the neck seems to emerge from the contour of the chin, which you have already drawn. Then, what is the exact angle of the neck compared to vertical? Draw those contours.

In drawing the collar or neckline of the clothing, shift to the next adjacent forms: the neck, the area *around* the collar or underneath the collar. As with any strongly symbolic form, you need to shift away from the form in order to see it clearly.

13. You may want to do a little work with shading in this drawing. Look for the *shapes of shadows*. You may find a shadowed shape *under* the lower lip, for example, or under the chin, or under the nose. You may see a shadow-shape on the side of the nose or under the lower lid. You can slightly tone the shadow-shape with your pencil, and if you wish, rub the tone in with your finger to smooth it. Be sure that you place and tone the shadow-shapes exactly as you see them. They are the shapes they are because of the bone structure and the particular light that falls on the shape. In the next chapter I will explain more fully the use of lights and shadows to increase the sense of three-dimensionality in your drawings.

Now that you have read all of the directions, you are ready to begin. Position your model and your paper. Bound the form. Image the form on your paper. Direct your gaze at the negative space. You will find yourself shifting into R-mode.

After you finish: When the drawing is finished, observe in yourself that you sit back and regard the drawing in a different way from the way you regarded the drawing while working on it. Afterward, you regard the drawing more critically, more analytically, perhaps noting slight errors, slight discrepancies between your drawing and the model. This is the artist's way. Shifting out of the working R-mode and back to L-mode, the artist assesses the next move, tests the drawing against the critical left brain's standards, plans the required corrections, notes where areas must be reworked. Then, by taking up the brush or pencil and starting in again, the artist shifts back into the working R-mode. This on-off procedure continues until the work is done — that is, until the

"If a certain activity, such as painting, becomes the habitual mode of expression, it may follow that taking up the painting materials and beginning work with them will act suggestively and so presently evoke a flight into the higher state."

—Robert Henri The Art Spirit

Supplementary Exercises

10c. Copy a master drawing of a person seen in three-quarter view. (See Figure 10-24.)

10d. If your three-quarter view was of a woman, draw another, using a man as a model.

10e. Arrange two mirrors and a lamp so that you can view your own face in three-quarter view, with the lamp creating strong light-shadow contrast on your face. Draw your self-portrait in this three-quarter view, shading in some of the shadow-shapes. See page 176.

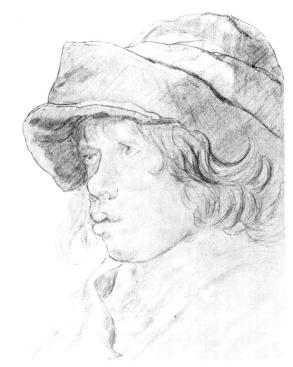

Fig. 10-24. Student copy of a master drawing.

Sara Clippinger

artist arrives at the decision that no further work should be done.

You may wish to go back into the drawing for a second sitting. Make sure, however, that you always work with the model before you. Once you begin "fixing up" a drawing without the model, the door of perception slams shut and the drawing can be spoiled. Especially in these early drawings, you need the material thing before you.

Before you go on to the next lesson, reread the directions for a three-quarter-view portrait, and do exercises 10c, d, and e.

GOING AT DRAWING HEAD-ON: THE FRONTAL VIEW

Before you begin: Again, read through all of the directions. Review the proportions of the blank in Chapter Nine. Look through the portraits in the Student Showing.

- 1. Tape or tack your paper to the board, position your model, set a timer, and so on. By now these preliminary moves are probably pretty well integrated as a procedure.
 - 2. Bound the form and wait until you can see the negative

space and the overall outside shape of the head. *Image* this shape on your empty paper to begin the cognitive shift to R-mode. Phantom draw, so that you know *where* the features, top of the head, etc., will be and what *size* they will be.

- 3. Using your pencil held out vertically at arm's length, check the tilt of the central axis. Draw (very lightly) the eye-level line Now begin the drawing. You will by now have shifted into R-mode.
- 4. You can start anywhere on the form. Again, to simplify the instructions, I'll put them in a specific order, which you may later want to change around.
- 5. Place the eyes (note that the space between the eyes is the width of one eye). See and draw the *exact* contours of each eye. They are often different from one another. To perceive the contours more clearly, direct your gaze at the shape *above the eye* (between the upper lid and the eyebrow) and use that shape as a negative space. Observe the exact shape of the lids, the exact directions of the eyelashes. Change nothing, revise nothing draw just what you see.
- 6. The nose. Gazing at the model, visualize a *triangle* with two points at the outer corners of the eyes and the third point at the tip of the nose. That triangle is a particular shape for each particular model. Next, image the particular triangle on your drawing and make a mark where the tip of the nose is. This is a very good R-mode way to correctly perceive the length of the nose often a problem for beginning students. Next, observe on your model how wide the nose is at the nostrils in relation to the inside corners of the eyes.

Observe the lights and shadows that run the length of the nose. In most cases, you will see a light on one side and a shadow on the other side of the nose. If you look carefully, you will see that those lights and shadows have specific shapes, caused by the light falling on the particular bone structure of this particular nose. If you draw the light *or* shadow (choose one or the other), you will have described the bony structure of the nose. Do that, drawing down one side of the nose, *not* both sides.

Most people have very strong, persistent symbols for drawing *nostrils*. Draw the shapes *under* the nostrils to bypass your symbolic shapes.

7. The mouth. Estimate the length of the upper lip in relation to, for example, the length of the nose. Draw the center line of the mouth first, making sure that the line is at right angles to the

"When drawing a face, any face, it is as if curtain after curtain, mask after mask, falls away . . . until a final mask remains, one that can no longer be removed, reduced. By the time the drawing is finished, I know a great deal about that face, for no face can hide itself for long. But although nothing escapes the eye, all is forgiven beforehand. The eye does not judge, moralize, criticize. It accepts the masks in gratitude as it does the long bamboos being long, the goldenrod being yellow."

-Frederick Franck The Zen of Seeing central axis. It is very easy to skew the mouth at a strange angle that will change the expression. Note with special care the position and shape of the outer corners of the mouth, where much of the subtle expression of a face is located. Then draw the contours of the outer edges of the lips. The lower lip may be only a shadowed area under the lip. Look at your model carefully. Hard lines around the edges of lips often reflect incorrect perception or substitution of a symbol. The edges of lips are usually not really sharp contours, only a color change.

8. The skull. Measure on your model the distance from eye level to the top of the hair as compared to eye level to chin. Make a mark on the paper where the outermost contour of the whole form will be. This will help you to get the shape of the face correct.

9. The face. Observe the distance from the features to the edge of the face as you perceive it. What is the relationship with some width you have already drawn, say that of the eye or the nose or the mouth? How long is the chin compared to the nose, which you have already drawn? Still using modified contour drawing, draw the shape of the face.

10. The hair. Again, observe the outside shape of the hair and the inside shape where it meets the face. Note the major directions in which the hair grows, the places where it parts and shows a darker tone underneath. Note and draw details of how the hair grows and what its texture is close to the face. Give your viewer enough information about the hair to know what it is like. Bypass your symbols for hair by drawing some complex sections of the hair. Make sure to use the same style of line in drawing the hair that you used in drawing the features — that is, make sure that the line you are using doesn't change greatly from the face to the hair. The line quality, depth of tone, and degree of detail should be consistent with your drawing of the features. For example, if you use a clear, dark line for the features, use the same clear, dark line for the contours of the hair. This unifies the face and hair. Using a clear, dark line for the features and a light, sketchy line for the hair will disunify your drawing.

11. The neck, collar, and shoulders. Make sure that the neck is wide enough by checking the width in relation to the width of the face. Use negative space for the collar (draw the spaces under and around the collar). *Make sure that the shoulders are wide enough*. Narrowed shoulders are a common error in beginning drawings. Double-check the negative space above the shoulder, and say to

yourself, "Where is the point of the shoulder in relation to the edge of the face?"

12. Complete the drawing with all of its beautiful complex contours, shading parts where you can perceive *shapes of shadows* if you wish.

After you finish: Now that you have, with great care, observed the faces of other human beings, surely you understand what artists mean when they say that every human face is beautiful.

STUDENT SHOWING: Full-Face Views

As you look at the student portraits on the following pages, try to mentally review how each artist proceeded. Go through the measurement process yourself. This will help to reinforce your skill and train your eye.

THE PORTRAIT AND BEYOND

Complete exercises 10f, g, and h before moving on to the next instructions on shading, by which we will expand the perceptions of your awakened eye.

Supplementary Exercises

See the Student Showing for examples of student portraits and copies of master drawings.

10f. Find a master drawing of a frontal-view portrait. Copy the drawing, using the master drawing to reinforce your knowledge of proportion, use of negative space, etc. As you copy the master drawing, notice that minute changes in lengths or directions of a line or form can alter the expression of a face. Check *all* of the proportions by laying your pencil along the parts of the drawing and *measuring*. Turn the drawing upside down if necessary to see the relationships better.

10g. If your frontal-view copy of a master drawing was of a woman, find a man who will model for you. Do a frontal-view drawing, this time with the model wearing a hat — of any kind. If your copy was a drawing of a man, find a woman to pose for you.

10h. Sitting in front of a mirror with a lamp to one side, draw a self-portrait, observing the shapes of shadows on your face.

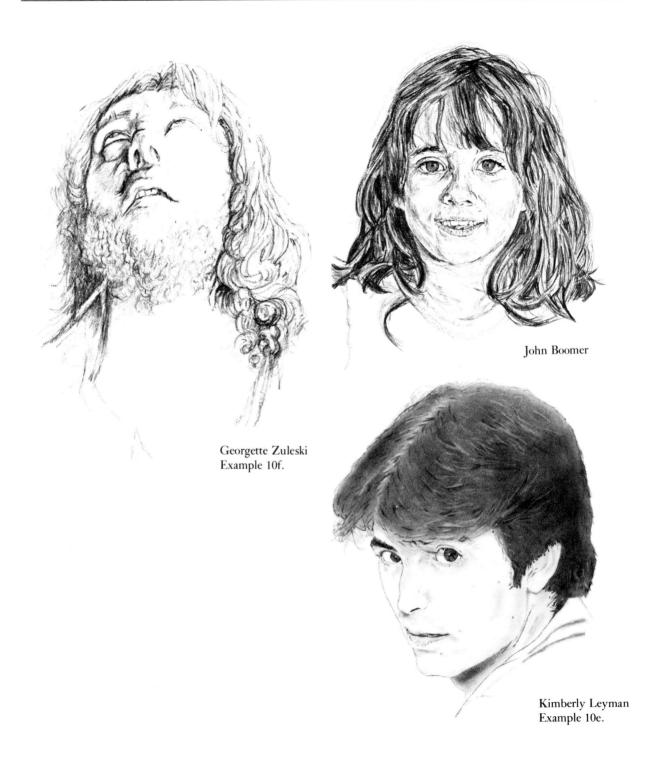

Portrait Drawing With Ease

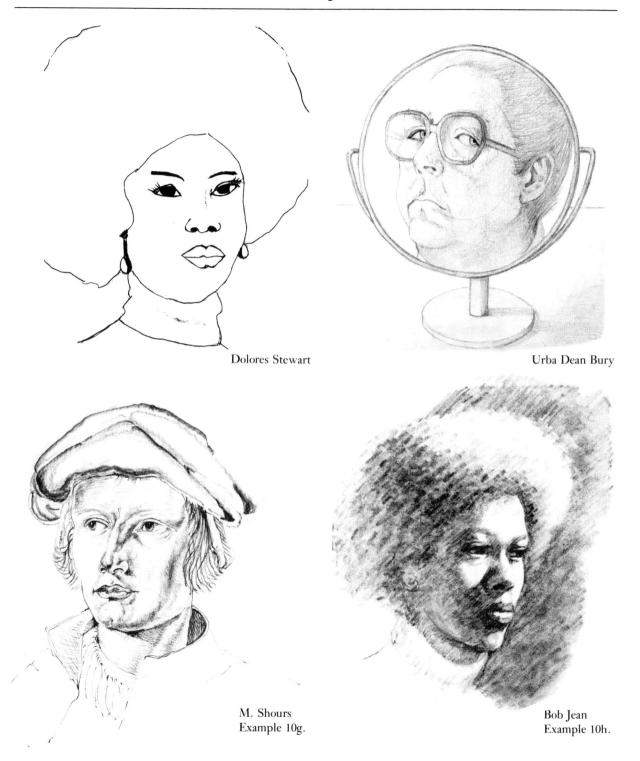

Moving Into the Third Dimension: Seeing Light, Drawing Shade

Fig. 11-1. Value scale.

ne of the skills most desired by drawing students is that of making things look three-dimensional through the use of what students often call "shading." Shading is based on perception of changes in *tones* of light and dark. These tonal changes are called *values*. A complete value scale goes from pure white to pure black, with literally thousands of minute gradations between the two ends of the scale. Figure 11-1 shows an abbreviated scale with just a few of the possible gradations.

In a pencil drawing, the lightest light is the white of the paper itself. The darkest dark is where the pencil lines are packed together in as dark a tone as the lead will allow. The tones in between are achieved by various methods of using the pencil: solid shading, crosshatching, etc. In this chapter, I shall first show you how to see shadows and then briefly describe some methods of shading.

THE ROLE OF THE RIGHT SIDE OF THE BRAIN IN PERCEIVING SHADOWS

Light falling on an object reveals to us the *shape* of the object: through tonal values of lights and shadows we perceive three-dimensional shapes. Curiously, though we *use* light/shadow to interpret and recognize objects, we pay almost no attention to the specific shapes of the lights and the shadows. They seem to be ignored or bypassed in the same way that upside-down images and negative spaces are ignored. The left brain, after all, has no use for shadows other than the information they provide about a namable three-dimensional object.

But shadows (and lighted areas), like negative space, can be seen as shapes in themselves by using the same procedure we used for negative space. First, focus your eyes on a shadow (for example, the shadow on the face of Henry Fuseli (Figure 11-2) and wait a moment while the left mode scans and fails to recognize the image, then passes the job over to the right mode — the shadow will then come into focus as a shape. That shape can then be drawn or painted on your paper, and it will work for the viewer in precisely the same way shadows work in the real world: it will reveal the exact shape of a three-dimensional form — in this example, the shape of Henry Fuseli's nose and left cheek. (If you turn the book upside down to look at the shadow

Fig. 11-2. Henry Fuseli (1741-1825), *Portrait of the Artist*. Courtesy of the Victoria and Albert Museum, London.

of Fuseli's face, it will be more easily seen as a shape.)

Let me emphasize the point by putting the idea another way: the shadow on Henry Fuseli's face is *shaped* the way it is *because of* the shape of Henry Fuseli's nose-cheek-face. Therefore, if you draw the shadow correctly, you will have correctly indicated the exact shape of Henry Fuseli's nose-cheek-face. In tonal drawing (shading), it's the shapes of the shadows that you must be able to

Fig. 11-3.

"One of life's most fulfilling moments occurs in that split second when the familiar is suddenly transformed into the dazzling aura of the profoundly new. . . . These breakthroughs are too infrequent, more uncommon than common; and we are mired most of the time in the mundane and the trivial. The shocker: what seems mundane and trivial is the very stuff that discovery is made of. The only difference is our perspective, our readiness to put the pieces together in an entirely new way and to see patterns where only shadows appeared just a moment before."

—Edward B. Lindaman
Thinking in Future Tense

see and draw. And within the shadowed shapes, you can detect the *relationships of values*: which shadow-shapes are the darkest, which are the middle tones, and which are the lightest.

These special perceptions, like all drawing skills, are easy to attain once you have made the cognitive shift to the artist's mode of seeing. Recent research indicates that the right hemisphere, as well as being able to perceive the shapes of particular shadows, is also specialized for processing *patterns* of shadows. Patients with right-hemisphere injuries often have great difficulty making sense of complex, fragmentary shadow patterns like those you see in Figure 11-3.

How does the right brain accomplish the leap of insight required to know what those patterns of light and dark areas *mean?* Apparently by comprehending the *relationships* of shapes that fit together to form a whole. The right brain is not deterred by missing parts and seems to delight in "getting" the picture in spite of its incompleteness.

LIGHTING UP THE SHADOW-SHAPES

Let's try it. If you can find someone to pose informally for you, set up a lamp so that a very strong, bright light shines on one side of your model's face, producing sharply edged, dark shadows on the unlighted half of the face. If you have no model, you can draw yourself by using a mirror, or use a photograph of a strongly lighted head.

For this exercise you will need a brush (a #7 watercolor brush is a good size, or you may use a Japanese paintbrush, available in most craft stores). And you will need a bottle of black India ink, available at most stationery stores.

Before you begin: Read through all of the directions for your light/shadow, ink-and-brush drawing. Be sure to allow plenty of time without interruption.

In these written directions I'll be naming forms. But when you are painting the first shadowed shape and all of those that follow, try not to think about the features in terms of their names (nose, lips, etc.).

- 1. The lighted side of the head will be the white of the paper. You will paint the shapes of the shadows in the black ink. You will use only the two values of white and black no middle tones. The purpose of the exercise is to enable you to see the shapes of shadows.
- 2. Direct your eyes at a shadow, perhaps the shadow on the side of the nose. Wait until you can *see it as a shape*. When you can see the shape clearly, paint the shape with your brush and ink. (See Figure 11-4 for an example of what the shape might look like.)
- 3. Direct your eyes to the next shape, perhaps the shadow under the upper lip. Paint that shadow.
- 4. Direct your eyes to the next shadow, perhaps under the lower lip. Note the relationship to the shapes you have already painted. Paint that shadow. (Figure 11-5.)
- 5. Since one entire half of the face is in shadow, paint in that large shape just as you perceive it. (Figure 11-6.)
- 6. Direct your eyes toward the small shadows on the lighted side of the face and wait until you can see them as shapes. Paint in those shapes, noting the relationships of sizes to the previously perceived shapes.
- 7. Look for shapes of shadows in the lighted side of the hat. Paint those shadows just as you see them in all of their complexity. Avoid symbolic shapes look for the *exact* shapes of the shadows. (Figure 11-7.)
- 8. Complete the ink drawing. The negative space behind the head may be painted as a dark shape or left the white of the paper. (Figure 11-8.)

Fig. 11-4.

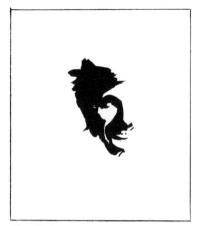

Fig. 11-6.

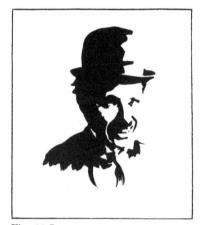

Fig. 11-7.

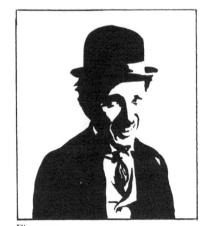

Fig. 11-8.

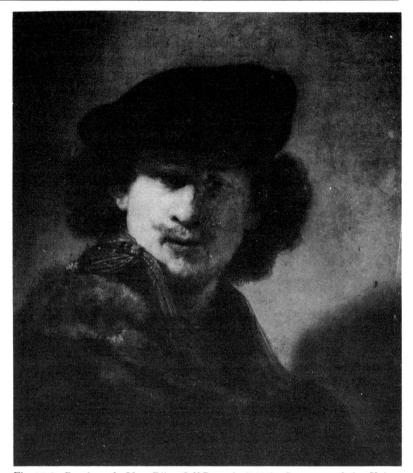

Fig. 11-9. Rembrandt Van Rijn, *Self-Portrait* (1634). Courtesy of the Kaiser-Friedrich Museum, Berlin.

After you finish: You may have felt a sense of surprise at the moment your drawing came into focus for you as a face. At that moment, the three-dimensional power of the drawing may have burst upon your consciousness. That seems to be the process: you paint several shapes that don't seem to add up to anything; then all of a sudden you "get" the image and perhaps exclaim to yourself, "It's working!" If this moment eluded you in this first drawing, try another. One efficient way to ease into this mode of drawing shadows is to copy an image such as Rembrandt's self-portrait in Figure 11-9. If your left brain is still resisting, turn the Rembrandt upside down and copy it in that orientation, using the brush and ink. Note that brush and ink are particularly

Fig. 11-10.

Fig. 11-11.

effective for learning how to perceive shadows. Since you can't erase you must look very intently at the shadow-shape before putting the brush to the paper.

CROSSHATCHING A LIGHTER SHADOW

When you feel that you have *seen* the shapes of shadows through using the ink-and-brush technique, you are ready to add tonal values other than white and black — the middle tones of gray. There are a number of techniques and media available to you. Crosshatching is one of the most useful. I'll briefly instruct you in the basic technique. Since crosshatching takes many forms, you will quickly develop your own style of hatching, just as you have your own style of line.

- 1. Crosshatching is done with short, rapid, parallel marks one set drawn over another, then another, until the lines pack up to the depth of value required. Begin with a single "set" (Figure 11-10).
- 2. Cross back over the original set with a second set of rapid parallel lines (Figure 11-11). Note that the angle is only slightly different from the first set.

Supplementary Exercises

11a. Using charcoal or pencil, copy the self-portrait by Kathe Kollwitz, Figure 11-15. Note the complex shadows around the eye. Be sure to image a triangle to place the ear.

11b. Using brush and ink, copy the self-portrait by Rembrandt, Figure 11-9.

11c. Observe the use of crosshatch lines in the still life by Morandi, Figure 11-13. Set up some objects for a still life. Shine a light from one side and use your own style of crosshatch lines.

11d. Draw a paper bag in pencil, as in the student example, Figure 11-14.

11e-g. See page 188.

Fig. 11-12.

- 3. Move your hand to a new position and cross back a third time.
- 4. Continue adding sets of parallel lines, gauging the depth of tone and smoothing the transitions between tones where necessary. (See Figure 11-12 for an example of the use of crosshatching to "shade" a sphere.) As you see, crosshatching creates a lively surface and a sense of air and light surrounding the form.

SUMMING UP

This chapter has been a brief introduction to the pleasures of drawing with lights and shadows. Exercises 11a through 11g will provide practice designed to deepen your skills and your ability to see and draw the effects of light on three-dimensional forms. For your future progress, it's important to note that the inkand-brush exercises lead you directly into painting and the incredible world of color. Your journey has just begun.

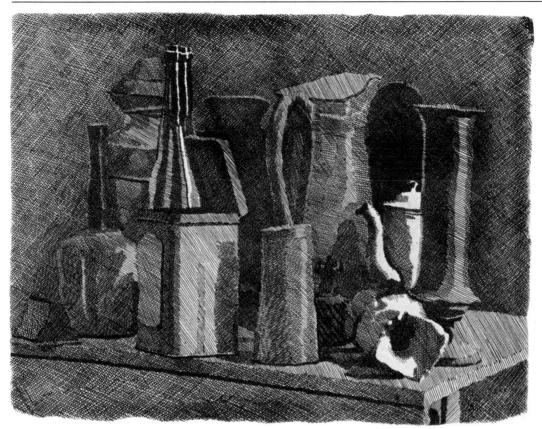

Fig. 11-13. Giorgio Morandi, Large Still Life with Coffee Can (1934). Courtesy of the Fogg Art Museum, Harvard University.

Fig. 11-14.

11e. Use a charcoal to draw a portrait as in Figures 11-15 and 11-17.

11f. Completely cover a piece of drawing paper with an even tone of charcoal. Draw a self-portrait using an *eraser* to remove the lighted shapes.

11g. Paint a portrait with india ink, thinned with water, to show the pattern of lights and shadows. See Figure 11-18.

Fig. 11-15. Kathe Kollwitz (1867-1945), *Self-Portrait in Profile*. Courtesy of Fogg Art Museum.

Fig. 11-16.

Ly Chen Sreng

Fig. 11-17.

Tom Nelson

Fig. 11-18.

G. Smith

The Zen of Drawing: Drawing Out the Artist Within

"To transform the world, we must begin with ourselves; and what is important in beginning with ourselves is the intention. The intention must be to understand ourselves and not to leave it to others to transform themselves. . . . This is our responsibility, yours and mine; because, however small may be the world we live in, if we can bring about a radically different point of view in our daily existence, then perhaps we shall affect the world at large."

—J. Krishnamurti "Self Knowledge," in The First and Last Freedom

"The life of Zen begins with the opening of *satori*. *Satori* may be defined as intuitive looking into, in contradistinction to intellectual and logical understanding. Whatever the definition, *satori* means the unfolding of a new world hitherto unperceived."

—D. T. Suzuki "Satori," in An Introduction to Zen Buddbism t the beginning of this book I said that drawing is a magical process. When your brain is weary of its verbal chatter, drawing is a way to quiet the chatter and to grasp a fleeting glimpse of transcendent reality. By the most direct means your visual perceptions stream through the human system — through retinas, optic pathways, brain hemispheres, motor pathways — to magically transform an ordinary sheet of paper into a direct image of your unique response, your vision of the perception. Through your vision, the viewer of the drawing — no matter what the subject — can find you, see you.

Furthermore, drawing can reveal much about you to yourself, some facets of *you* that might be obscured by your verbal self. Your drawings can show you how you *see* things and feel about things. First, you draw in R-mode, wordlessly connecting yourself to the drawing. Then shifting back to your verbal mode, you can interpret your feelings and perceptions by using the powerful skills of your left brain — words and logical thought. If the pattern is incomplete and not amenable to words and rational logic, a shift back to R-mode can bring intuition and analogic insight to bear on the problem. Or, the hemispheres might work cooperatively in countless possible combinations.

The exercises in this book, of course, encompass only the very beginning steps toward the goal of knowing your two minds and how to use their capabilities. From here on, having caught a glimpse of yourself in your drawings, you can continue the journey on your own.

Once you have started on this path, there is always the sense that in the next drawing you will more truly see, more truly grasp the nature of reality, express the inexpressible, find the secret beyond the secret. As the great Japanese artist Hokusai said, learning to draw never ends.

Having shifted to a new mode of seeing, you may find yourself looking into the essence of things, a way of knowing tending toward the Zen concept of *satori*, as described in the quotation of D. T. Suzuki. As your perceptions unfold, you take new approaches to problems, correct old misperceptions, peel away layers of stereotypes that mask reality and keep you from clear seeing.

With the power of both halves of the brain available to you and

the myriad of possible combinations of the separate powers of the hemispheres, the door is open to your becoming more intensely aware, more capable of controlling some of the verbal processes that can distort thinking — sometimes even to the extent of causing physical illness. Logical, systematic thinking is surely essential for survival in our culture, but if our *culture* is to survive, understanding of how the human brain molds behavior is our urgent need.

Through introspection, you can embark on that study, becoming an Observer and learning, to some degree at least, how your brain works. In observing your own brain at work, you will widen your powers of perception and take advantage of the capabilities of both its halves. Presented with a problem, you will have the possibility of seeing things two ways: abstractly, verbally, logically — but also holistically, wordlessly, intuitively.

Use your twofold ability. Draw everything and anything. No subject is too hard or too easy, nothing is unbeautiful. Everything is your subject — a few square inches of weeds, a broken glass, an entire landscape, a human being.

Continue to study. The great masters of the past *and* of the present are readily available at reasonable cost in books of drawings. Study the masters, not to copy their *styles*, but to read their *minds*. Let them teach you how to see in new ways, to see the beauty in reality, to invent new forms and open new vistas.

Observe your style developing. Guard it and nurture it. Provide yourself with time so that your style can develop and grow sure of itself. If a drawing goes badly, calm yourself and quiet your mind. End for a time the endless talking to yourself. Know that what you need to see is right there before you.

Put your pencil to paper every day. Don't wait for a special moment, an inspiration. As you have learned in this book, you must set things up, position yourself, in order to evoke the flight to the other-than-ordinary state in which you can see clearly. Through practice, your mind will shift ever more easily. By neglect, the pathways can become blocked again.

Teach someone else to draw. The review of the lessons will be invaluable. The lessons you give will deepen your insight about the process of drawing and may open new possibilities for someone else.

Develop your ability to image — to see with your mind's eye. Whatever you draw will etch itself into your memory. Call up

"From the age of six, I had a mania for drawing the form of things. By the time I was fifty, I had published an infinity of designs, but all that I have produced before the age of seventy is not worth taking into account. At seventy-three I have learned a little about the real structure of nature, of animals, plants, birds, fishes, and insects. In consequence, when I am eighty, I shall have made more progress; at ninety, I shall penetrate the mystery of things; at a hundred, I shall have reached a marvelous stage; and when I am a hundred and ten, everything I do, be it but a dot or line, will be alive."

—Written at the age of seventy-five by me, once Hokusai, today Owakio Rojin, old man mad about drawing

"One of the characteristics of great drawings is the artist's wholehearted acceptance of his own style and character. It is as if the drawing says for the artist, 'here I am.'"

> -Nathan Goldstein The Art of Responsive Drawing

"A monk asked his teacher, 'What is my self?' The teacher answered, 'There is something deeply hidden within your self, and you must become acquainted with its hidden activity.' The monk then asked to be told what this hidden activity was. The teacher just opened and closed his eyes."

-Frederick Franck

The Zen of Seeing

those images; see again the master drawings you have studied, the faces of friends you have drawn. Image also scenes that you have never viewed, and draw what you see through your mind's eye. Drawing will give the image a life and reality of its own.

Use your imaging ability to solve problems. Look at the problem from several viewpoints and different perspectives. See the parts of the problem in their true proportion. Instruct your brain to work on the problem while you sleep or take a walk or do a drawing. Scan the problem to see all of its facets. Image dozens of solutions without censoring or revising. Play with the problems in the antic/serious intuitive mode. The solution is very likely to present itself nicely when you least expect it.

Drawing on the capabilities of the right side of your brain, develop your ability to see ever more deeply into the nature of things. As you look at people and objects in your world, imagine that you are drawing them, and then you will see *differently*. You will see with an awakened eye, with the eye of the artist within you.

Postscript

FOR TEACHERS AND PARENTS

As a teacher and a parent, I've had a very personal interest in seeking new ways of teaching. Like most other teachers and parents, I've been well aware — painfully so, at times — that the whole teaching/learning process is extraordinarily imprecise, most of the time a hit-and-miss operation. Students may not learn what we think we are teaching them and what they do learn may not be what we intended to teach them at all.

I remember one clear example of the problem of communicating what is to be learned. You may have heard-of or gone through a similar experience with a student or your child. Years ago the child of a friend whom I was visiting arrived home from his day at school, all excited about something he had learned. He was in the first grade and his teacher had started the class on reading lessons. The child, Gary, announced that he had learned a new word. "That's great, Gary," his mother said. "What is it?" He thought a moment, then said, "I'll write it down for you." On a little chalkboard the child carefully printed, HOUSE. "That's fine, Gary," his mother said. "What does it say?" He looked at the word, then at his mother, and said matter-of-factly, "I don't know."

The child apparently had learned what the word *looked like* — he had learned the visual shape of the word perfectly. The teacher, however, was teaching another aspect of reading — what words mean, what words stand for or symbolize. As often happens, what the teacher had taught and what Gary had learned were strangely incongruent.

As it turned out, my friend's son always learned visual material best and fastest, a mode of learning consistently preferred by a certain number of students. Unfortunately, the school world is mainly a verbal, symbolic world, and learners like Gary must adjust, that is, put aside their best way of learning and learn the way the school decrees. My friend's child, fortunately, was able to make this change, but how many other students are lost along the way?

This forced shift in learning style must be somewhat comparable to a forced change in handedness. It was a common practice in former times to make individuals who were naturally left-handed change over to right-handedness. In the future we may come to regard forcing children to change their natural learning modes with the same dismay that we

now regard the idea of forcing a change in handedness. Soon we may be able to test children to determine their best learning styles and choose from a repertoire of teaching methods to insure that children learn *both* visually and verbally.

Teachers have always known that children learn in different ways and, for a long time now, people who have the responsibility for educating youngsters have hoped that the advances in brain research would shed some light on how to teach all students equally well. Until about fifteen years ago, new discoveries about the brain seemed to be useful mainly to science. But these discoveries are now being applied to other fields and the recent research that I've outlined in this book promises to provide a firm basis for fundamental changes in techniques of education.

David Galin, among other researchers, has pointed out that teachers have three main tasks: first, to train both hemispheres — not only the verbal, symbolic, logical left hemisphere which has always been trained in traditional education, but also the spatial, relational, holistic right hemisphere, which is largely neglected to today's schools; second, to train students to use the cognitive style *suited to the task at hand*; and third, to train students to be able to bring both styles — both hemispheres — to bear on a problem in an integrated manner.

When teachers can pair the complementary modes or fit one mode to the appropriate task, teaching and learning will become a much more precise process. Ultimately, the goal will be to develop both halves of the brain. Both modes are necessary for full human functioning and both are necessary for creative work of all kinds, whether writing or painting, developing a new theory in physics, or dealing with environmental problems.

This is a difficult goal to present to teachers, coming as it does at a time when education is under attack from many quarters. But our soci-

ety is changing rapidly, and the difficulties of foreseeing what kinds of skills future generations will require are increasing. Although we have so far depended on the rational, left half of the human brain to plan for our children's future and to solve the problems they might encounter on the way to that future, the onslaught of profound change is shaking our confidence in technological thinking and in the old methods of education. Without abandoning training in traditional verbal and computational skills, concerned teachers are looking for teaching techniques that will enhance children's intuitive and creative powers, thus preparing students to meet new challenges with flexibility, inventiveness, and imagination and with the ability to grasp complex arrays of interconnected ideas and facts, to perceive underlying patterns of events, and to see old problems in new ways.

What can you, as parents and teachers, hope to accomplish right now in terms of teaching both halves of children's brains? First, it's important that you know the specialized functions and styles of our hemispheres. Books such as this one can provide you with a basic understanding of the theory and also with the experience of making cognitive shifts from one mode to another. I believe that this personal experiential knowledge is extremely important, perhaps essential, before teachers try to transmit the knowledge to others.

Second, you should be alert to the effect of *specific tasks* on the activation of either hemisphere and you could begin to try to control which brain half the students use by setting up conditions or tasks that cause cognitive shifts from one mode to another. For example, you might have students read one passage for facts and ask for verbal or written responses. The same passage might then be read for meaning or underlying content accessible through imagery and metaphoric thought. For this learning

mode, you might require as a response a poem, painting, dance, riddle, pun, fable, or song. As another example, certain kinds of arithmetic and mathematics problems require linear, logical thought. Others require imaginary rotations of forms in space or manipulations of numbers, which are best accomplished by mentally producing patterned visualizations. Try to discover—either through noting your own thought processes or observing your students—which tasks utilize the style of the right hemisphere, which require the style of the left, and which require complementary or simultaneous styles.

Third, you might experiment with varying the conditions in your classroom — at least those conditions over which you have some control. For example, talking among students or constant talking by a teacher probably tends to lock students fairly rigidly into left-hemisphere mode. If you can cause your students to make a strong shift to R-mode, you will have a condition that is very rare in modern classrooms: silence. Not only will the students be silent, they will be *engaged* in the task at hand, attentive and confident, aiert and content. Learning becomes pleasurable. This aspect alone of R-mode is worth striving for. Be sure that you yourself encourage and maintain this silence.

As additional suggestions, you might experiment with rearranging the seating or the lighting. Physical movement, especially patterned movement such as dancing, might help to produce the cognitive shift. Music is conducive to R-mode shifts. Drawing and painting, as you have seen in this book, produce strong shifts to R-mode. You might experiment with private languages, perhaps inventing a pictorial language with which the students can communicate in your classroom. I recommend using the chalkboard as much as possible — not just to write words but also to draw pictures, diagrams, illustrations, and patterns. Ideally, all in-

formation should be presented in at least two modes: verbal and pictographic. You might experiment with reducing the verbal content of your teaching by substituting nonverbal communication when that mode seems suitable.

Last, I hope you will consciously use your intuitive powers to develop teaching methods and communicate those methods to other teachers through workshops or teachers' journals. You are probably already using many techniques — intuitively or by conscious design — that cause cognitive shifts. As teachers, we need to share our discoveries, just as we share the goal of a balanced, integrated, whole-brain future for our children.

As parents, we can do a great deal to further this goal by helping our children develop alternate ways of knowing the world — verbally/analytically and visually/spatially. During the crucial early years parents can help to shape a child's life in such a way that words do not completely mask other kinds of reality. My most urgent suggestions to parents are concerned with the use of words, or rather, not using words.

I believe that most of us are too quick to name things when we are with small children. By simply naming a thing and letting it go at that when a child asks, "What is that?" we communicate that the name or label is the most important thing, that naming is sufficient. We deprive our children of their sense of wonder and discovery by labeling and categorizing things in the physical world. Instead of merely naming a tree, for example, try also guiding your child through an exploration of the tree both physically and mentally. This exploration may include touching, smelling, seeing from various angles, comparing one tree with another, imagining the inside of the tree and the parts underground, listening to the leaves, viewing the tree at different times of the day or during different seasons, planting its seeds, observing how other creatures — birds, moths, bugs — use the tree, and so on. After discovering that every object is fascinating and complex, a child will begin to understand that the label is only a small part of the whole. Thus taught, a child's sense of wonder will survive, even under our modern avalanche of words.

In terms of encouraging your child's artistic abilities, I recommend providing a very young child with plenty of art materials and the kind of perceptual experiences described above. Your child will progress through the developmental sequence of child art in a relatively predictable manner, just as children progress through other sequential stages. If your child asks for help with a drawing, your response should be, "Let's go look at what you're trying to draw." New perceptions will then become part of the symbolic representations.

Both teachers and parents can help with the problems of adolescent artists which I discussed in the text. As I mentioned, realistic drawing is a stage that children need to pass through at around age ten. Children want to learn to see, and they deserve all the help they require. The sequence of exercises in this book — including the information on hemisphere functions in

somewhat simplified form — can be used with ten-year-olds. Subjects that suit the interests of adolescents (for example, well-drawn realistic cartoons of heroes and heroines in action poses) can be used for upside-down drawing. Negative space and contour drawing also appeal to children at this age, and they readily incorporate the techniques into their drawing. (See the illustration of a ten-year-old fourth-grade student's progress over four days of instruction.) Portrait drawing has a special appeal for this age group, and adolescents can do quite accomplished drawings of their friends or family members. Once they overcome their fear of failure at drawing, youngsters will work hard to perfect their skills, and success enhances their self-concept and self-confidence.

But more important for the future, drawing, as you have learned through the exercises in this book, is an effective way of gaining access to and control over the functions of the right hemisphere. Learning to see through drawing may help children to later become adults who will put the whole brain to use.

FOR ART STUDENTS

Many successful contemporary artists believe

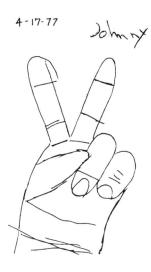

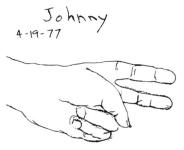

Drawings by a fourth-grade student: Three lessons, April 15 to April 19, 1977. Instructional period: four days.

that realistic drawing skills are not important. It is true, generally speaking, that contemporary art does not necessarily require drawing skill, and good art — even great art — has been produced by modern artists who can't draw. They are able to produce good art, I suspect, because their esthetic sensibilities have been cultivated by means other than the traditional, basic teaching methods of art schools: drawing and painting from the model, the still life, and the land-scape.

Since contemporary artists often dismiss drawing ability as unnecessary, beginning art students are placed in a double bind. Very few students feel secure enough about their creative abilities and about their chances for success in the art world to dispense altogether with schooling in art. Yet when they encounter the kind of modern art shown in galleries and museums art that doesn't appear to require traditional skills at all — they feel that traditional methods of instruction don't apply to their goals. To break the double bind, students often avoid learning to draw realistically and settle as quickly as possible into narrow conceptual styles, emulating contemporary artists who often strive for a unique, repeatable, recognizable "signature" style.

The English artist David Hockney calls this narrowing of options a trap for artists (see the quotation in Chapter One). It is surely a dangerous trap for art students, who too often force themselves to settle into repetitive motifs. They may try to make statements with art before they know what they have to say.

Based on my teaching experience with art students at various skill levels, I'd like to make several recommendations to all art students, especially beginning art students. First, don't be afraid to learn to draw realistically. The sources of creativity have never been blocked by gaining skills in drawing, the basic skill of all art. Picasso, who could draw like an angel, is a prime illustration of this fact, and the history of art is replete with others. Artists who learn to draw well don't always produce boring and pedantic realistic art. The artists who do produce such art would no doubt produce boring and pedantic abstract or nonobjective art as well. Drawing skill will never hinder your work but will certainly help it.

Second, be clear in your mind about why learning to draw well is important. Drawing enables you to see in that special, epiphanous way that artists see, no matter what style you choose to express your special insight. Your goal in drawing should be to encounter the reality of experience — to see ever more clearly, ever more deeply. True, you may sharpen your esthetic sensibilities in ways other than drawing, such as meditation, reading, or travel. But it's my belief that for an artist these other ways are chancier and less efficient. As an artist you will be most likely to use a visual means of expression, and drawing sharpens the visual senses.

And last, draw every day. Draw anything an ashtray, a half-eaten apple, a person, a twig. I repeat this recommendation given in the last chapter of the text because for art students it is especially important. In a way, art is like athletics: if you don't practice, the visual sense quickly gets flabby and out of shape. The purpose of drawing is not to put lines down on paper any more than the purpose of jogging is to get somewhere. You must exercise your vision without caring overly much about the products of your practice. You can periodically cull the best examples from your drawings, throwing out the rest or even throwing out everything. In your daily drawing sessions, the desired goal should be to see ever more deeply.

Glossary

Abstract Art. A translation into drawing, painting, sculpture, or design of a real-life object or experience. Usually implies the isolation, emphasis, or exaggeration of some aspect of the artist's perception of reality. Should not be confused with nonobjective art.

Awareness. Consciousness; the act of "taking account" of an object, person, or the surroundings. Possible synonyms are seeing or cognition.

Blank. An egg-shaped oval drawn on paper to represent the basic shape of the human head. Because the human skull, seen from the side, is a different shape than the skull seen from the front, the side-view blank is a somewhat differently shaped oval than front-view blank.

Central Axis. Human features are more or less symmetrical and are bisected by an imaginary vertical line in the middle of the face. This line is called the central axis. It is used in drawing to determine the tilt of the head and to place the features.

Cerebral Hemispheres. The outermost part of the forebrain, clearly separated into two halves on the right and left sides of the brain. Consists essentially of the cerebral cortex, corpus callosum, basal ganglia, and limbic system.

Cerebrum. The main division of the brain in vertebrates, consisting of two hemispheres. It is the last part of the brain to evolve and is of critical importance in all kinds of mental activity. Cognitive Shift. A transformation from one mental state to another, e.g., from L-mode to R-mode or vice versa.

Composition. An ordered relationship among the parts or elements of a work of art. In drawing, the arrangement of forms and spaces within the format.

Conceptual Images. Imagery from internal sources (the "mind's eye") rather than from external, perceived sources; usually simplified images; often abstract rather than realistic.

Contour Line. In drawing, a line that represents the edge of a form or a group of forms.

Corpus Callosum. A massive, compact bundle of axons connecting the right and left cerebral cortices. The corpus callosum allows the two halves, or hemispheres, of the cerebral cortex to communicate directly with one another.

Creativity. The ability to find new solutions to a problem or new modes of expression; the bringing into existence of something new to the individual.

Crosshatching. A series of intersecting sets of parallel lines used to indicate shading or volume in a drawing. Edge. In drawing, the place where two things meet (for example, where the sky meets the ground); the line of separation between two shapes or a space and a shape.

Expressive Quality. The slight individual differences in the way each of us perceives and represents our perceptions in a work of art. These differences express an individual's inner reactions to the perceived stimulus as well as the unique "touch" arising from individual physiological motor differences.

Eye Level. In perspective drawing, a horizontal line on which lines above and below it in the horizontal plane appear to converge. In portrait drawing, the proportional line that divides the head in half horizontally; the location of the eyes at this halfway mark on the head.

Foreshortening. A way to portray forms on a two-dimensional surface so that they appear to project from or recede behind a flat surface; a means of creating the illusion of spatial depth in figures or forms. Format. The particular shape of a drawing or painting surface — rectangular, circular, triangular, etc; the proportion of the surface, e.g., the relationship of the length to the width in a rectangular surface.

Grid. Evenly spaced lines, running horizontally and vertically at right angles, that divide a drawing or painting into small squares or rectangles. Often used to enlarge a drawing or to aid in seeing spatial relationships.

Hemispheric Lateralization. The differentiation of the two cerebral hemispheres with respect to function. Holistic. In terms of cognitive functions, the simultaneous processing of an array of information in a total configuration as opposed to sequential processing of its separate parts.

Image. Verb: to call up in the mind a mental copy of something not present to the senses; see in the "mind's eye." Noun: a retinal image; the optical image of external objects received by the visual system and interpreted by the brain.

Imagination. A recombination of mental images from past experiences into a new pattern.

Intuition. Direct and apparently unmediated knowledge; a judgment, meaning, or idea that occurs to a person without any known process of reflective thinking. The judgment is often reached as a result of minimal cues and seems to "come from nowhere."

Learning. Any relatively permanent change in behavior as a result of experience or practice.

Left Hemisphere. The left half (oriented according to your left) of the cerebrum. For most right-handed individuals and a large proportion of left-handed individuals, verbal functions are in the left hemisphere.

L-Mode. A state of information processing characterized as linear, verbal, analytic, and logical.

Negative Space. The area around positive forms which shares edges with the forms. Negative space is bounded on the outer edges by the format.

Nonobjective Art. Art that makes no attempt to reproduce the appearance of real-life objects or experiences or to produce the illusion of reality. Also called "non-representational art."

Perception. The awareness, or the process of becoming aware, of objects, relations, or qualities — either internal or external to the individual — by means of the senses and under the influence of previous experiences.

Realistic Art. The objective depiction of objects, forms, and figures attentively perceived. Also called "naturalism."

Right Hemisphere. The right half (oriented according to your right) of the cerebrum. For most right-handed individuals and a large proportion of left-handed individuals, spatial, relational functions are in the right hemisphere.

R-Mode. A state of information processing characterized as simultaneous, holistic, spatial, and relational.

Scanning. In drawing, checking points, distances, degrees of angles relative to vertical or horizontal, relative sizes, etc.

Sighting. In drawing, measuring relative sizes by means of a constant measure (the pencil held at arm's length is the most usual measuring device); determining relative points in a drawing — the location of one part relative to some other part.

Split-Brain Patients. Individuals who have been suffering from intractable epileptic seizures and whose medical problems were relieved by a surgical operation. The procedure separates the two hemispheres by severing the corpus callosum and is rarely done. Split-brain patients number only a few dozen.

States of Consciousness. A largely unresolved concept, consciousness is used in this book to mean the awareness, continually changing, of what passes in one's own mind. An alternate state of consciousness is one that is perceived as noticeably different from ordinary, waking consciousness. Familiar alternate states are daydreaming, sleep dreaming, and meditation. Symbol System. In drawing, a set of symbols that are consistently used together to form an image, for example, a figure. The symbols are usually used in sequence, one appearing to call forth another, much in the manner of writing familiar words, in which writing one letter leads to writing the next. Symbol systems in drawn forms are usually set in childhood and often persist throughout adulthood unless modified by learning new ways to draw.

Value. In art, the darkness or lightness of tones or

colors. White is the lightest, or highest, value; black is the darkest, or lowest, value.

Visual Information Processing. The use of the visual system to gain information from external sources and the interpretation of that sensory data by means of thinking.

Zen. A system of thought that emphasizes a form of meditation called zazen. Zazen begins with concentration, often on puzzles wholly impervious to solution through reason. Concentration leads to samadhi, a "state of oneness" in which the meditator gains insight into the unity of things in the world. The meditator strives to move through further stages to the final stage of Zen, satori, or "no mind," a brilliantly clear state of mind in which the details of every phenomenon are perceived, yet without evaluation or attachment.

Bibliography

- Argüelles, J. *The Transformative Vision*. Berkeley, Calif.: Shambhala Publications, 1975.
- Arnheim, R. Art and Visual Perception. Berkeley, Calif.: University of California Press, 1954.
- Ayrton, M. Golden Sections. London: Methuen, 1957.
- Berger, J. Ways of Seeing. New York: Viking Press, 1972.
- Bergquist, J.W. The Use of Computers in Educating Both Halves of the Brain. *Proceedings: Eighth Annual Seminar for Directors of Academic Computational Services*, August 1977. P.O. Box 1036, La Cañada, Calif.
- Bogen, J. E. "The Other Side of the Brain." *Bulletin of the Los Angeles Neurological Societies* 34 (1969): 73–105.
- Specialization." *U.C.L.A. Educator* 17 (1975): 24–32.
- Blakemore, C. *Mechanics of the Mind*. Cambridge: At the University Press, 1977.
- Bruner, J. S. "The Creative Surprise." In *Contemporary Approaches to Creative Education*, edited by H. E. Gruber, G. Terrell, and M. Wertheimer. New York: Atherton Press, 1962.
- York: Atheneum, 1965.
- Buzan, T. *Use Both Sides of Your Brain*. New York: E. P. Dutton, 1976.

- Carra, C. "The Quadrant of the Spirit." *Valori Plastici* 1 (April-May 1919): 2.
- Carroll, L., pseud. See Dodgson, C. L.
- Collier, G. Form, Space, and Vision. Englewood Cliffs, N.J.: Prentice-Hall, 1963.
- Connolly, C. The Unquiet Grave: A Word Cycle by Palinurus. New York: Harper and Brothers, 1945.
- Corballis, M., and I. Beale. The Psychology of Left and Right. Hillsdale, N. J.: Lawrence Erlbaum Associates, 1976.
- Critchley, M. *Music and the Brain*. Springfield, Ill.: Charles C Thomas, 1977.
- Dodgson, C. L. [pseud. Carroll, L.] The Complete Works of Lewis Carroll, edited by A. Woollcott. New York: Modern Library, 1936.
- Edwards, B. "Anxiety and Drawing." Master's thesis, California State University at Northridge, 1972.
- Drawing." Ph.D. dissertation, University of California, Los Angeles, 1976.
- Edwards, B., and D. Narikawa. Art, Grades Four to Six. Los Angeles: Instructional Objectives Exchange, 1974.
- Ernst, M. Beyond Painting. Translated by D. Tanning. New York: Wittenborn, Schultz, 1948.
- Ferguson, M. *The Brain Revolution*. New York: Taplinger Publishing, 1973.

- Flam, J. Matisse on Art. New York: Phaidon, 1973. Franck, F. The Zen of Seeing. New York: Alfred A. Knopf, 1973.
- Franco, L., and R. W. Sperry, "Hemisphere Lateralization for Cognitive Processing of Geometry," *Neuropsychologia*, 1977, Vol. 15, 107-14.
- Friend, D. Composition: A Painter's Guide to Basic Problems and Solutions. New York: Watson-Guptill Publications, 1975.
- Gardner, H. The Shattered Mind: The Person After Damage. New York: Alfred A. Knopf, 1975.
- Gazzaniga, M. "The Split Brain in Man." In *Perception: Mechanisms and Models*, edited by R. Held and W. Richards, p. 33. San Francisco, Calif.: W. H. Freeman, 1972.
- Gladwin, T. "Culture and Logical Process." In Explorations in Cultural Anthropology, edited by W. H. Goodenough, pp. 167-77. New York: McGraw-Hill, 1964.
- Goldstein, N. *The Art of Responsive Drawing*. Englewood Cliffs, N. J.: Prentice-Hall, 1973.
- Gregory, R. L. Eye and Brain: The Psychology of Seeing. 2nd ed., rev. New York: McGraw-Hill, 1973.
- Grosser, M. *The Painter's Eye.* New York: Holt, Rinehart and Winston, 1951.
- Hadamard, J. An Essay on the Psychology of Invention in the Mathematical Field. Princeton, N. J.: Princeton University Press, 1945.
- Hall, E. T. *The Silent Language*. Garden City, N. Y.: Doubleday, 1959.
- Henri, R. *The Art Spirit*. Philadelphia, Pa.: J. B. Lippincott, 1923.
- Herrigel, E. Quoted in *The Joy of Drawing*. London: The Oak Tree Press, 1961.
- Hill, E. *The Language of Drawing*. Englewood Cliffs,N. J.: Prentice-Hall, 1966.
- Hockney, D. *David Hockney*, edited by N. Stangos. New York: Harry N. Abrams, 1976.
- Huxley, A. *The Art of Seeing*. New York: Harper and Brothers, 1942.
- James, W. The Varieties of Religious Experience. New York: Longmans, Green, 1902.

- Jaynes, J. The Origin of Consciousness in the Breakdown of the Bicameral Mind. Boston: Houghton Mifflin, 1976.
- Jung, C. G. Man and His Symbols. Garden City, N.-Y.: Doubleday, 1964.
- Kipling, R. Rudyard Kipling's Verse. London: Hodder & Stoughton, 1927.
- Koestler, A. *The Sleepwalkers*. London: Hutchinson, 1959.
- Krishnamurti, J. *The Awakening of Intelligence*. New York: Harper and Row, 1973.
- Row, 1972.
- Levy, J., "Differential Perceptual Capacities in Major and Minor Hemispheres," *Proceedings of the National Academy of Science*, Vol. 61, 1968, 1151.
- Asymmetry." In *Hemisphere Function in the Human Brain*, edited by S. J. Dimond and J. G. Beaumont. New York: John Wiley and Sons, 1974.
- Levy, J., C. Trevarthen, and R. W. Sperry, "Perception of Bilateral Chimeric Fegures Following Hemispheric Deconnexion," *Brain*, 95, 1972, 61-78.
- Lindaman, E. B. *Thinking in Future Tense*. Nashville: Broadman Press, 1978.
- Lindstrom, M. Children's Art: A Study of Normal Development in Children's Modes of Visualization. Berkeley, Calif.: University of California Press, 1957.
- Lord, J. A Giacometti Portrait. New York: Museum of Modern Art, 1965.
- Lowenfeld, V. Creative and Mental Growth. New York: Macmillan, 1947.
- Matisse, H. Notes d'un peintre. In La grande revue. Paris, 1908.
- McFee, J. *Preparation for Art.* San Francisco, Calif.: Wadsworth Publishing, 1961.
- McKim, R. *Experiences in Visual Thinking*. Monterey, Calif.: Brooks/Cole Publishing, 1972.
- Nicolaides, K. *The Natural Way to Draw*. Boston: Houghton Mifflin, 1941.
- Ornstein, R. *The Psychology of Consciousness*. 2nd ed., rev. New York: Harcourt Brace Jovanovich, 1977.

- Orwell, G. "Politics and the English Language." In *In Front of Your Nose*. Vol. 4, *The Collected Essays of George Orwell*, edited by S. Orwell and I. Angus, p. 138. New York: Harcourt Brace and World, 1968.
- Paivio, A. *Imagery and Verbal Processes*. New York: Holt, Rinehart and Winston, 1971.
- Paredes, J., and M. Hepburn. "The Split-Brain and the Culture-Cognition Paradox." *Current Anthropology* 17 (March -1976): 1.
- Pascal, B. Pensées: Thoughts on Religion and Other Objects, edited by H. S. Thayer and E. B. Thayer. New York: Washington Square Press, 1965.
- Piaget, J. *The Language and Thought of a Child*. New York: Meridian, 1955.
- Pirsig, R. Zen and the Art of Motorcycle Maintenance. New York: William Morrow, 1974.
- Ponomarev, L. *In Quest of the Quantum*. Translated by N. Weinstein. Moscow: Mir Publishers, 1973.
- Rock, I. "The Perception of Disoriented Figures." In *Image*, *Object*, *and Illusion*, edited by R. M. Held. San Francisco: W. H. Freeman, 1971.
- Rodin, A. Quoted in *The Joy of Drawing*. London: The Oak Tree Press, 1961.
- Samples, B. *The Metaphoric Mind*. Reading, Mass.: Addison-Wesley Publishing, 1976.
- _____. The Wholeschool Book. Reading, Mass.: Addison-Wesley Publishing, 1977.
- Samuels, M., and Samuels, N. Seeing with the Mind's Eye. New York: Random House, 1975.
- Shah, I. *The Exploits of the Incomparable Mulla Nasrudin*. New York: E. P. Dutton, 1972.
- Shepard, R. N. Visual Learning, Thinking, and Com-

- munication, edited by B. S. Randhawa and W. E. Coffman. New York: Academic Press, 1978.
- Sperry, R. W. "Hemisphere Disconnection and Unity in Conscious Awareness." *American Psychologist* 23 (1968): 723–33.
- Sperry, R. W., M. S. Gazzaniga, and J. E. Bogen, "Interhemispheric Relationships: the Neocortical Commissures; Syndromes of Hemisphere Disconnection," *Handbook of Clinical Neurology*, P. J. Vinken and G. W. Bruyn, eds., Amsterdam: North-Holland Publishing Co., 1969, 273-89.
- Stein, G. Picasso. London: B. T. Batsford, 1938.
- Suzuki, D. "Satori." In *The Gospel According to Zen*, edited by R. Sohl and A. Carr. New York: New American Library, 1970.
- Tart, C. T. "Putting the Pieces Together." In *Alternate States of Consciousness*, edited by N. E. Zinberg, 204–06. New York: Macmillan, 1977.
- Taylor, J. *Design and Expression in the Visual Arts.* New York: Dover Publications, 1964.
- Walter, W. G. *The Living Brain*. New York: W. W. Norton, 1963.
- Wittrock, M. C., et al., *The Human Brain*. Englewood Cliffs, New Jersey: Prentice-Hall, Inc., 1977.
- Zaidel, E., and R. Sperry. "Memory Impairment after Commisurotomy in Man." *Brain* 97 (1974): 263–72.

Index

effects on artistic development, 63–64, 99 Artistic Development childhood, 57–59, 62–83 Bogen, Joseph, 29 Boucher, François, 104 Brain, 26–43. See also Commissurotomy, Corpus Callosum, Information Processing, L-Mode to R-Mode Shift, Lateralization, Left Brain, Right Brain Hemispheres, 26–28, 30–31 Brevil, 2 Cézanne, Paul, 101 Childhood artistic development, 57–59, 62–63 stages, 64–76 teaching, 195–200 Chin, 159 Corpus callosum, 28–30 Cranach, Lucas, 167 Creativity, 5–7, 26 Degas, Edgar, 121 Delacroix, Eugène, 15, 120 Double brain. See Brain— Hemispheres Drawing ability, 2–3, 200–201 contour, 84–87, 88–93 faces, 155–164, 166–171, 172– 175 in right-hemisphere mode, 48–49 materials, 8–9 negative space, 100–105, 106– 107, 108–109 perspective, 122–123 realistic, 7–8, 200–201 skills, 192–194 preinstruction, 10, 14 release of, 20–22 teachable skill, 3, 195–200 upside-down, 50–55	Adolescence	Corners, 125–127
63–64, 99 Artistic Development childhood, 57–59, 62–83 Bogen, Joseph, 29 Boucher, François, 104 Brain, 26–43. See also Commissurotomy, Corpus Callosum, Information Processing, L-Mode to R-Mode Shift, Lateralization, Left Brain, Right Brain Hemispheres, 26–28, 30–31 Brevil, 2 Brevil, 2 Cranach, Lucas, 167 Creativity, 5–7, 26 Degas, Edgar, 121 Delacroix, Eugène, 15, 120 Double brain. See Brain— Hemispheres Drawing ability, 2–3, 200–201 contour, 84–87, 88–93 faces, 155–164, 166–171, 172– 175 in right-hemisphere mode, 48–49 materials, 8–9 negative space, 100–105, 106– 107, 108–109 perspective, 122–123 realistic, 7–8, 200–201 skills, 192–194 preinstruction, 10, 14 release of, 20–22 teachable skill, 3, 195–200	effects on artistic development,	Corpus callosum, 28–30
Artistic Development childhood, 57–59, 62–83 Bogen, Joseph, 29 Boucher, François, 104 Brain, 26–43. See also Commissurotomy, Corpus Callosum, Information Processing, L-Mode to R-Mode Shift, Lateralization, Left Brain, Right Brain Hemispheres, 26–28, 30–31 Brevil, 2 Creativity, 5–7, 26 Degas, Edgar, 121 Delacroix, Eugène, 15, 120 Double brain. See Brain— Hemispheres Drawing ability, 2–3, 200–201 contour, 84–87, 88–93 faces, 155–164, 166–171, 172– 175 in right-hemisphere mode, 48–49 materials, 8–9 negative space, 100–105, 106– 107, 108–109 perspective, 122–123 realistic, 7–8, 200–201 skills, 192–194 preinstruction, 10, 14 release of, 20–22 teachable skill, 3, 195–200	•	1
Degas, Edgar, 121	Artistic Development	Creativity, 5-7, 26
Bogen, Joseph, 29 Boucher, François, 104 Brain, 26–43. See also Commissurotomy, Corpus Callosum, Information Processing, L-Mode to R-Mode Shift, Lateralization, Left Brain, Right Brain Hemispheres, 26–28, 30–31 Brevil, 2 Cézanne, Paul, 101 Childhood artistic development, 57–59, 62–63 stages, 64–76 teaching, 195–200 Chin, 159 Degas, Edgar, 121 Delacroix, Eugène, 15, 120 Double brain. See Brain— Hemispheres Drawing ability, 2–3, 200–201 contour, 84–87, 88–93 faces, 155–164, 166–171, 172– 175 in right-hemisphere mode, 48–49 materials, 8–9 negative space, 100–105, 106– 107, 108–109 perspective, 122–123 realistic, 7–8, 200–201 skills, 192–194 preinstruction, 10, 14 release of, 20–22 teachable skill, 3, 195–200		
Bogen, Joseph, 29 Boucher, François, 104 Brain, 26–43. See also Commissurotomy, Corpus Callosum, Information Processing, L-Mode to R-Mode Shift, Lateralization, Left Brain, Right Brain Hemispheres, 26–28, 30–31 Brevil, 2 Cézanne, Paul, 101 Childhood artistic development, 57–59, 62–63 stages, 64–76 teaching, 195–200 Chin, 159 Delacroix, Eugène, 15, 120 Double brain. See Brain— Hemispheres Drawing ability, 2–3, 200–201 contour, 84–87, 88–93 faces, 155–164, 166–171, 172– 175 in right-hemisphere mode, 48–49 materials, 8–9 negative space, 100–105, 106– 107, 108–109 perspective, 122–123 realistic, 7–8, 200–201 skills, 192–194 preinstruction, 10, 14 release of, 20–22 teachable skill, 3, 195–200		Degas, Edgar, 121
Boucher, François, 104 Brain, 26–43. See also Commissurotomy, Corpus Callosum, Information Processing, L-Mode to R-Mode Shift, Lateralization, Left Brain, Right Brain Hemispheres, 26–28, 30–31 Brevil, 2 Cézanne, Paul, 101 Childhood artistic development, 57–59, 62–63 stages, 64–76 teaching, 195–200 Chin, 159 Double brain. See Brain— Hemispheres Drawing ability, 2–3, 200–201 contour, 84–87, 88–93 faces, 155–164, 166–171, 172– 175 in right-hemisphere mode, 48–49 materials, 8–9 negative space, 100–105, 106– 107, 108–109 perspective, 122–123 realistic, 7–8, 200–201 skills, 192–194 preinstruction, 10, 14 release of, 20–22 teachable skill, 3, 195–200	Bogen, Joseph, 29	
Brain, 26–43. See also Commissurotomy, Corpus Callosum, Information Processing, L-Mode to R-Mode Shift, Lateralization, Left Brain, Right Brain Hemispheres, 26–28, 30–31 Brevil, 2 Cézanne, Paul, 101 Childhood artistic development, 57–59, 62–63 stages, 64–76 teaching, 195–200 Chin, 159 Hemispheres Drawing ability, 2–3, 200–201 contour, 84–87, 88–93 faces, 155–164, 166–171, 172– 175 in right-hemisphere mode, 48–49 materials, 8–9 negative space, 100–105, 106– 107, 108–109 perspective, 122–123 realistic, 7–8, 200–201 skills, 192–194 preinstruction, 10, 14 release of, 20–22 teachable skill, 3, 195–200		
surotomy, Corpus Callosum, Information Processing, L-Mode to R-Mode Shift, Lateralization, Left Brain, Right Brain Hemispheres, 26–28, 30–31 Brevil, 2 Cézanne, Paul, 101 Childhood artistic development, 57–59, 62–63 stages, 64–76 teaching, 195–200 Chin, 159 Drawing ability, 2–3, 200–201 contour, 84–87, 88–93 faces, 155–164, 166–171, 172– 175 in right-hemisphere mode, 48–49 materials, 8–9 negative space, 100–105, 106– 107, 108–109 perspective, 122–123 realistic, 7–8, 200–201 skills, 192–194 preinstruction, 10, 14 release of, 20–22 teachable skill, 3, 195–200	and the second control of the second control	Hemispheres
Information Processing, L-Mode to R-Mode Shift, Lateralization, Left Brain, Right Brain Hemispheres, 26–28, 30–31 Brevil, 2 Cézanne, Paul, 101 Childhood artistic development, 57–59, 62–63 stages, 64–76 teaching, 195–200 Chin, 159 ability, 2–3, 200–201 contour, 84–87, 88–93 faces, 155–164, 166–171, 172– 175 in right-hemisphere mode, 48–49 materials, 8–9 negative space, 100–105, 106– 107, 108–109 perspective, 122–123 realistic, 7–8, 200–201 skills, 192–194 preinstruction, 10, 14 release of, 20–22 teachable skill, 3, 195–200		
L-Mode to R-Mode Shift, Lateralization, Left Brain, Right Brain Hemispheres, 26–28, 30–31 Brevil, 2 Cézanne, Paul, 101 Childhood artistic development, 57–59, 62–63 stages, 64–76 teaching, 195–200 Chin, 159 Contour, 84–87, 88–93 faces, 155–164, 166–171, 172– 175 in right-hemisphere mode, 48–49 materials, 8–9 negative space, 100–105, 106– 107, 108–109 perspective, 122–123 realistic, 7–8, 200–201 skills, 192–194 preinstruction, 10, 14 release of, 20–22 teachable skill, 3, 195–200		
Right Brain 175 Hemispheres, 26–28, 30–31 in right-hemisphere mode, 48–49 Brevil, 2 materials, 8–9 negative space, 100–105, 106– Cézanne, Paul, 101 107, 108–109 Childhood perspective, 122–123 artistic development, 57–59, realistic, 7–8, 200–201 62–63 skills, 192–194 stages, 64–76 preinstruction, 10, 14 teaching, 195–200 release of, 20–22 Chin, 159 teachable skill, 3, 195–200		
Right Brain 175 Hemispheres, 26–28, 30–31 in right-hemisphere mode, 48–49 Brevil, 2 materials, 8–9 negative space, 100–105, 106– Cézanne, Paul, 101 107, 108–109 Childhood perspective, 122–123 artistic development, 57–59, realistic, 7–8, 200–201 62–63 skills, 192–194 stages, 64–76 preinstruction, 10, 14 teaching, 195–200 release of, 20–22 Chin, 159 teachable skill, 3, 195–200	Lateralization, Left Brain,	faces, 155-164, 166-171, 172-
Hemispheres, 26–28, 30–31 in right-hemisphere mode, 48–49 materials, 8–9 negative space, 100–105, 106– Cézanne, Paul, 101 107, 108–109 Childhood perspective, 122–123 realistic development, 57–59, 62–63 skills, 192–194 preinstruction, 10, 14 release of, 20–22 Chin, 159 teachable skill, 3, 195–200		175
Brevil, 2 materials, 8–9 negative space, 100–105, 106– Cézanne, Paul, 101 107, 108–109 Childhood perspective, 122–123 realistic, 7–8, 200–201 skills, 192–194 stages, 64–76 preinstruction, 10, 14 release of, 20–22 Chin, 159 teachable skill, 3, 195–200		in right-hemisphere mode, 48-49
Cézanne, Paul, 101 107, 108–109 Childhood perspective, 122–123 artistic development, 57–59, realistic, 7–8, 200–201 62–63 skills, 192–194 stages, 64–76 preinstruction, 10, 14 teaching, 195–200 release of, 20–22 Chin, 159 teachable skill, 3, 195–200		
Childhood perspective, 122–123 artistic development, 57–59, realistic, 7–8, 200–201 62–63 skills, 192–194 stages, 64–76 preinstruction, 10, 14 teaching, 195–200 release of, 20–22 Chin, 159 teachable skill, 3, 195–200		negative space, 100-105, 106-
artistic development, 57–59, realistic, 7–8, 200–201 skills, 192–194 stages, 64–76 preinstruction, 10, 14 release of, 20–22 teachable skill, 3, 195–200	Cézanne, Paul, 101	107, 108–109
62–63 skills, 192–194 stages, 64–76 preinstruction, 10, 14 teaching, 195–200 release of, 20–22 Chin, 159 teachable skill, 3, 195–200	Childhood	perspective, 122–123
62–63 skills, 192–194 stages, 64–76 preinstruction, 10, 14 teaching, 195–200 release of, 20–22 Chin, 159 teachable skill, 3, 195–200	artistic development, 57-59,	realistic, 7-8, 200-201
teaching, 195–200 release of, 20–22 Chin, 159 teachable skill, 3, 195–200		skills, 192–194
Chin, 159 teachable skill, 3, 195–200	stages, 64–76	preinstruction, 10, 14
	teaching, 195-200	release of, 20-22
Collar, 160, 171, 174–175 upside-down, 50–55	Chin, 159	teachable skill, 3, 195-200
	Collar, 160, 171, 174-175	upside-down, 50–55
Commissurotomy, 29, 30–32 Dürer, Albrecht, 6, 77, 101, 115,	Commissurotomy, 29, 30–32	Dürer, Albrecht, 6, 77, 101, 115,
Composition, 98–100 117–119, 142, 167	Composition, 98–100	117-119, 142, 167
Consciousness, altered state, 4–5	Consciousness, altered state, 4-5	
Contour drawing, 84–87, 88–93 Ear, 160–161, 170	Contour drawing, 84-87, 88-93	Ear, 160-161, 170
Corinth, Lovis, 146 Edges, 83–84, 105–106	Corinth, Lovis, 146	Edges, 83–84, 105–106

```
contour drawing, 84-87, 89-93
  corners, 126-127
  human head, 140-141, 143-145
  negative-space, 101-103, 108-
      109
  perspective drawing, 122
  profiles, 155-156, 167-171,
      172 - 175
  shadows, 182-184, 185-186
  vase-faces, 46-48, 49-50
  viewfinder, 105-106
Eyes, 156, 169, 173
Faces, 154. See also Chin, Collar,
      Ear, Eyes, Glasses, Hair,
      Mouth, Neck, Nose
  frontal view, 172-175
  profile, 155-156, 164
  three-quarter view, 166-171
Format, 98-100
Fuseli, Henry, 180-181
Galin, David, 31, 35, 196
Gazzaniga, Michael, 29
Glasses, 159
Hair, 162-163, 170-171, 174
Handedness, 43-44
Handwriting, 20-22
```

Exercises

Head. See Human Head Hockney, David, 200 Hokusai, 192 Homer, Winslow, 113 Human head, 137–139 drawing, 140–141, 143–145, 147–150 proportion, 141–142

Imaging, 37–42 Information processing, 35–36 right hemisphere, 35–37

Klee, Paul, 74 Knowing two ways of, 34–35 Kokoschka, Oskar, 149

L-mode to R-mode shift, 42–43, 50–51, 55, 90

Landscape, drawn by children, 68–70

Language and the brain, 32–34

Lateralization, 57–58

Left brain, 37, 39, 54–55, 77–78, 100–101, 106–107, 142

Levy, Jerre, 29, 30

Line

use of, 20–22

Looking. See Seeing

Materials. See Drawing—Materials Matisse, Henri, 4, 100, 141 Miró, Joan, 99 Modigliani, 141 Morandi, Giorgio, 187 Mouth, 158, 170, 173–174 Myers, Ronald, 26

Neck, 159, 171, 174-175 Negative-space drawing, 100–105, 106–107, 108–111 Nicolaides, Kimon, 83 Nose, 157, 168, 170, 173

Ornstein, Robert, 31, 32, 78

Perspective, 107, 116-123

Nebes, Robert, 29

Perspective drawing, 122–123
Picasso, Pablo, 20, 21, 52, 58, 74,
141, 201
Portraits, 8, 138, 155-175
Preinstruction drawings, 10, 14
Profiles, 147–150
Proportion, 134–137

Realism, 7–8, 72–76 Rembrandt, 23, 184 Right brain, 48–49, 55–57, 78–79, 107, 180–182 imaging, 37–42 information processing, 35–37 Rodin, Auguste, 5 Rubens, Peter Paul, 113

Sandys, Anthony Frederick Augustus, 162
Seeing
drawing and, 2–4, 23
symbol-system influence, 76–83
Shadows, 180–186
Sharrington, Charles, 41
Sighting, 119–121, 123–125, 128
Signature. See Handwriting
Size, 123–125. See also Perspective,
Proportion
Sperry, Roger W., 28–31, passim
"Split-brain." See Commissurotomy
Symbols, 65–66, 76–83

Tart, Charles, 42 Tiepolo, Giovanni Battista, 51 Toulouse-Lautrec, Henri de, 100 Trevarthen, Colwyn, 26, 29

Upside-down drawing, 50-55

Van Gogh, Vincent, 16–17, 142, 146 Vase-faces drawing, 46–48, 49–50 Viewfinder edge forming, 105–106 Vogel, Phillip, 29 Chart comparing R+L brain p.40